Further praise for

HOW TO SEE

"Lovely to read. . . . [How to See] is serious but never solemn, alert to pleasure, a boulevardier's crisp stroll through the visual world."

—Dwight Garner, *New York Times*

"We feel we are reading the latest from a commentator who has been at it for a lifetime and yet is still making discoveries and sharp, new distinctions . . . observations that can be funny, warm, offhandedly erudite, arch, or simply commonsensical, and that intensify the part played by art in our lives and the life of art itself."

—Sanford Schwartz, *New York Review of Books*

"[Salle] writes about art that he admires with passion and a discerning eye. . . . [I]lluminating." —Glen Roven, *Los Angeles Review of Books*

"A trenchant and light-on-its-feet collection of critical essays . . . about art, artists, fame, and, if you read it closely enough, what it's like to have been David Salle for all these years."

—Carl Swanson, *New York Magazine*

"A remarkable painter whose writing is as fresh, vital, and startling as his canvases, Salle . . . talks about artists and their work in witty, jargon-free, and eminently accessible prose."

—Tirdad Derakhshani, *Philadelphia Inquirer*

"*How to See* is an exhilarating and cathartic experience[,] . . . an offering of passion and generosity, and a pulsing invitation to the reader to find the same in the act of seeing."

—Simone Grace Seol, *National Book Review*

"[A] rare mix of eminently readable art criticism and close scrutiny of process and technique. His admiring descriptions . . . [allow] the reader to momentarily inhabit the consciousness of an artist and to rediscover painting through his eyes."
—Rachel Corbett, *Vulture* 10 Best Art Books of 2016

"David Salle is widely known as one of our most daring and intelligent painters, but he is also an eloquent critic. *How to See* is a marvel of incisive and intimate observation. For all his audacity as a painter, Salle seems touchingly proud to be a part of the family of art and to derive his pictorial forms from what he calls the 'the shared DNA of art,' raising the possibility that all masterworks are in fact a group project."
—Deborah Solomon, author of *Utopia Parkway: The Life and Work of Joseph Cornell*

"David Salle's thoughtful, intelligent, beautifully written essays inspire us to think about, and look at, art in wholly new ways. He makes difficult subjects (and artists) seem effortless, transparent, and he wears the depth and breadth of his knowledge of art and art history so lightly that we hardly notice how much we are learning. *How to See* is a pure pleasure to read."
—Francine Prose

"David Salle writes about art with a joyous lucidity that is both bracing —nothing, absolutely nothing, escapes his notice—and utterly disarming. He guides his readers through the complex world of contemporary art with a rare generosity of spirit, a dazzling skill at description, and a radiant honesty that are as challenging as they are irresistible."
—Ingrid Rowland

"David Salle asks of other art not, 'where does this belong?' but, 'what does this make me feel and think about?' Salle subtly and persuasively

reminds us that all art, even the most seemingly recalcitrant, is there to be looked at, and that what artists do is, exactly, teach us how to see."

—Adam Gopnik

"David Salle has a sharp, thrilling eye and an uncanny ability to reorder and make new the act of seeing. These perceptive, far-ranging essays are drawn from deep knowledge and experience—reading this book feels like having a conversation about art with the smartest person in the room."

—Emma Cline

"Wonderful."

—Joan Juliet Buck

"A breath of fresh air. . . . Salle is the perfect art tour guide: literate, thoroughly entertaining, and insightful."

—*Kirkus Reviews*, starred review

"Sharp insights and an affable tone make this collection equivalent to a hearty discussion with a mentor—recommended for anyone interested in visual arts."

—*Publishers Weekly*

HOW TO SEE

Looking, Talking, and Thinking about Art

DAVID SALLE

W. W. NORTON & COMPANY
Independent Publishers Since 1923
NEW YORK LONDON

For information about permission to reproduce selections from this book,
write to Permissions, W. W. Norton & Company, Inc., 500 Fifth Avenue,
New York, NY 10110

For information about special discounts for bulk purchases, please contact
W. W. Norton Special Sales at specialsales@wwnorton.com or 800-233-4830

Manufacturing by LSC Harrisonburg
Book design by Helene Berinsky
Production manager: Louise Mattarelliano

Library of Congress Cataloging-in-Publication Data

Names: Salle, David, 1952– author.
Title: How to see : looking, talking, and thinking about art / David Salle.
Description: First Edition. | New York : W. W. Norton & Company, 2016. |
 Includes index.
Identifiers: LCCN 2016025215 | ISBN 9780393248135 (hardcover)
Subjects: LCSH: Art, Modern—20th century. | Art, Modern—21st century. |
 Art appreciation.
Classification: LCC N6490 .S178 2016 | DDC 709.04—dc23
LC record available at https://lccn.loc.gov/2016025215

ISBN 978-0-393-35496-6 pbk.

W. W. Norton & Company, Inc., 500 Fifth Avenue, New York, N.Y. 10110
www.wwnorton.com

W. W. Norton & Company Ltd., 15 Carlisle Street, London W1D 3BS

1 2 3 4 5 6 7 8 9 0

For Alex and for John.

CONTENTS

CONTENTS

How to See

INTRODUCTION

William de Kooning, who, in addition to being de Kooning, was a genius with the English language, once likened a painting by Larry Rivers to "pressing your face in wet grass." Alex Katz is another master describer; his off-the-cuff observations are fearless and precise. A failed painting might be diagnosed as "having no inside energy"; a painter afflicted by grandiosity is "a first-class decorator," while a well-known player of the international scene makes "pizza parlor art." Not all artists are so verbally gifted, or so forthright, but most of the ones I know are pretty good talkers—except on panel discussions, where their fear of seeming insufficiently educated can make them sound dull. I know because I've done it myself.

The idea for this book is to write about contemporary art in the language that artists use when they talk among themselves—a way of speaking that differs from journalism, which tends to focus on the context surrounding art, the market, the audience, etc., and also from academic criticism, which claims its legitimacy from the realm of theory. Both are macronarratives, concerned with the big picture. Artists, on the other hand, talk to determine what works, what does not, and why. Their focus is more on the micro; it moves from the inside out. The great contrarian film critic Manny Farber succinctly

1

characterized the difference in his essay "White Elephant Art vs. Termite Art." *White elephant art* was Farber's term for the self-conscious masterpiece, draped in big themes and full of content. Antonioni's *L'Avventura*, for example. The *termite artist* was incarnated as the director Samuel Fuller, who made several dozen low-budget, rough-and-tumble films in the 1950s and '60s. A former cartoonist, Fuller worked from his own scripts, using real locations, mostly B actors, and whatever else was at hand. The crazy beauty of his films seems almost to be a by-product of impatience. Needless to say, Farber was on the side of the diggers. His preference was for artists who burrow along, often in the dark, toward their objective, more or less unconcerned about what's happening aboveground.

Ever since Duchamp decoupled art from retinal experience early in the last century, there has been a misapprehension about the relationship between means and ends. Critical writing in the last forty or so years has been concerned primarily with the artist's intention, and how that illuminates the cultural concerns of the moment. Art is treated as a position paper, with the artist cast as a kind of philosopher manqué. While that honorific might in some instances be well earned, the focus on intention has led to a good deal of confusion and wishful thinking. A visit to any of today's leading art schools would reveal one thing in common: The artist's intent is given far greater importance than is his or her realization, than the work itself. Theory abounds, but concrete visual perception is at a low ebb. In my view, intentionality is not just overrated; it puts the cart so far out in front that the horse, sensing futility, gives up and lies down in the street. "Intent" is very elastic in any case; it can stand for a variety of aims or ambitions. What has a greater impact on style is how an artist stands in relationship to his or her intention. This may sound complicated, but it's not. *How* someone holds the brush will determine a lot. Intention does matter, but the impulse guiding the hand often differs, is even of a different type, from that described in the wall text. Call it

pragmatism. As Frank O'Hara wrote with characteristic ebullience in *Personism: A Manifesto*, "It's just common sense: if you're going to buy a pair of pants you want them to be tight enough so everyone will want to go to bed with you. There's nothing metaphysical about it."

Artists have long been involved with all manner of ideas, but really big ideas are few and far between. George Balanchine, whose choreography bristles with ideas—about modernity, musicality, tempo, fashion, abstraction, faith, the new woman, etc.—didn't much like to talk about any of them. He famously told his biographer to imagine he was writing the story of "a race-horse." The ideas came out in his style. In our own era, average-sized ideas, that is to say most ideas, are easy. Frank again: "They're just ideas." Often what passes for an idea is, on closer inspection, really propaganda—someone *wants* something, wants to promote something. The hard part is finding a form. The most convincing works tend to be those in which the thinking is inseparable from the doing.

The big-idea people will always be among us, but are more often to be found talking to credulous collectors, or to themselves. Nothing *wrong* with big ideas, but they aren't especially relevant to figuring out how something works—or doesn't. I doubt if anyone ever loved a painting because of the ideas it supposedly contains, though there are plenty of examples of the reverse. And being able to explain a work of art, to spin a narrative around it, does not make it good. Good intentions don't help much either. Would that it were so easy. The late sculptor Ken Price put it best: "Nothing I can say is going to improve how it looks."

Sometimes what we call an idea is really more of an *enthusiasm*, the passing intellectual weather. Artists are *curious*, they pursue all kinds of obscure knowledge. Some like to do research, and art seems like as good a place as any to show off one's interests. The ideas with staying power are those that intersect with an artist's inclination for form, causing it to deepen and expand, like a paper flower that

blooms when you put it in water. The right idea, one that is in productive sync with one's talents, can unlock a whole worldview. If that idea is also part of a sensibility that is forming and spreading in the larger culture, or *zeitgeist,* a multiplier effect comes into play, and the art will resonate strongly with the viewing public. We will feel that it expresses *us.*

A desire to feel that synchronicity has led some artists, as well as critics, to seek out the big idea in advance. In practice, achieving that resonance is virtually impossible to map out ahead of time—too many factors are involved. I am by temperament a little wary of art that too directly tries to express its cultural moment. Besides, what is left once that moment has passed? Most art that projects a sense of vitality responds to, indeed is part of, the situation—cultural, historical, intellectual—in which the artist finds herself; it could hardly be otherwise. But the correspondence is seldom one-to-one. Art that shores up an already ratified position, or illustrates today's headlines is likely to have a brief shelf life. If good art illustrates anything at all, it's likely to be a story you didn't even know needed telling.

What is art anyway? Do we need to know? Can't we just be satisfied with John Baldessari's dictum "Art is anything an artist does," and let it go at that? It's a little *broad.* The essays in this collection start with the premise that art is something someone made. *Art in Things* was the architect Charles Voysey's credo for the Arts and Crafts movement around the turn of the last century, and it still has a nice ring to it. Because art, even what's known as conceptual art, is also a thing. Someone made something—or caused it to be made—that has certain qualities. Those qualities are related to the artist's intention but, because they reside in material form, speak a different language.

If that strikes you as anti-intellectual, I would point out that there are many different kinds of intelligence among our species (as well as other creatures, for that matter)—and the kinds of intelligence that one finds in a poet's use of meter, a painter's inflections of the brush,

or a musician's phrasing are not of a lesser sort—they are just more difficult to describe. Making the effort to describe just those sorts of perceivable effects enlarges our feeling for art generally. Art is more than a sum of cultural signs: It is a language both direct and associative, and has a grammar and syntax like any other human communication. The act of paying close attention to what someone made, in all of its particulars, is what stimulates an authentic, as opposed to a conditioned, response.

Since the advent of modernism in the nineteenth century, the accelerated rate of change in the visual arts has necessitated the use of broad, formal-sounding categories to account for the problem of style. Like a scorecard at the ball game, it's a way to keep track of the players. Sometimes the names were chosen by the artists themselves, like futurism, or constructivism. But whoever wanted to be called a *fauve*—a wild beast? And that goes double for "neo-geo," or "institutional critique," which has all the appeal of castor oil. Most of the art talk one hears today navigates by categories derived from a kind of historical determinism, which assumes that style is the more or less conscious, and partisan expression of ideas about the changing nature or function of art. We have had the royal procession of styles, each one supplanting those that preceded it: nonobjectivism, expressionism, abstract expressionism, minimalism, conceptualism, neo-expressionism—the list goes on. There are in addition the many nonvisual categories currently in use, the ones derived from French critical theory and its many variants: poststructuralism, postcolonialism, queer theory, etc. If the art is a noun, the theory words are the adjectives. Any one of these categories might be useful, even illuminating, but none tells us anything in particular about what Alex Katz would call art's *inside energy*, which can only be accessed by taking note of a work's specificity—tight pants and all.

So ingrained are these broad definitions of style, it's a little hard to imagine an alternative. How does one talk about art without invok-

ing the "isms," or resorting to generalities? Where does one turn to find a vocabulary that conveys the savor of looking? In a 1928 essay about that great paradigm shifter Gertrude Stein, Katherine Anne Porter observes that narrative is not the driving force in Stein's fiction. Porter takes this to be a point of interest. Stein's concern is with what she calls the *bottom nature* of people; a quality that exists underneath other attributes and is of importance to the writer because it will, to a large extent, determine how a person acts in the world. Porter, in a brilliant gesture of critical free-association, goes on to compare Stein to the sixteenth-century German alchemist and theologian Jacob Boehme, who categorized people in terms of their essential elements. He placed humanity along a kind of early periodic table, giving each character trait a counterpart in physical matter. "Boehme knew people as salt, or mercury, as moist or dry, as burning or smoking; as bitter, sour or sweet." Four hundred years later, Stein describes people as "attacking or resisting, as dependent or independent, as having a core of wood, or of mud." Good and bad, right and wrong are *attributes* to her, like girth, or a weak chin; strength and weakness are real things that live inside people. Stein's writing is based in a highly personal form of observation, and her judgments are extrapolations from a life of observing how people behave, of seeing how things work: the butterfly *will* be pinned to the board. There is slight difference between the way one wears a hat and the kind of person one is. Only a "pushy one" would wear such a hat. Only a "clever one" would make a painting like that. I think Stein's way of describing character has relevance for talking about art.

Thirty years later, the painter and exemplary critic Fairfield Porter (no relation) put this in sharper focus: "A genuine and ordinary reaction to paintings and sculpture, like one's first impression of a new person, is usually very much to the point." Porter wrote that in 1958, and it's still valid today. We often describe certain paintings as old friends, for good reason. What is this thing about art that

speaks to us? How to account for the feeling of recognition we have with art, almost as if the work were waiting for us, anticipating our engagement with its deeper music? It has to do with something you can intuit, as you would with any person you meet. One way to look at a painting—and I use that word as shorthand for visual art in general—is to notice as you take its measure what it is you actually find yourself thinking about, which may differ from what you imagine you're *supposed* to be thinking about. Many people who write and talk about art have no particular visual fluency, something I used to find surprising but no longer do. Extravagant claims are routinely made about what art has to tell us; one learns to sift through them. The wall label might inform you that the work is about the artist's investigation into the semiotics of performative strategies, while you find yourself wondering if the cafeteria food is any good. We need to pay attention to what a work of art actually does—as distinct from whatever may be its supposed intention. How does one learn to make these kinds of distinctions? Most of what I've learned about art has been on the run, from looking, making, and looking again, and also from listening to the very bright talk that has always enlivened the art-world air.

In 1975, the year I came to New York, I started out writing as a way to pay the rent. Following in the path of artists like Donald Judd before me, I wrote short reviews for a now defunct publication called *Arts Magazine*. The pay was $30 per review; my rent was $125. You could do a few reviews a month, pick up some work doing Sheetrock, and just about get by. The magazine was edited by a man named Richard Martin, who bore a passing resemblance to Yves St. Laurent: three-piece suit, aviator glasses, shag haircut. He went on to become a curator at the Fashion Institute of Technology, where he made some groundbreaking exhibitions, including the first museum show devoted to Claire McCardle, the designer who pioneered sportswear for American women. Richard was encouraging, and treated me like

a grown-up (I was twenty-two). The magazine wasn't really *edited,* just compiled. I could review whatever I chose, and I don't remember my copy ever being marked up. The writing was pretty bad, labored, convoluted—only one piece from that time, about Vito Acconci, has been included here—but those reviews were my earliest attempts at finding an independent way to talk about art.

For most of the '80s and '90s, I approached interviews as a kind of lazy person's form of writing—that's what I told myself—but it's a very limited form. Eventually, I started writing in the old-fashioned way—that is, without the benefit of an interlocutor. I found that writing about something helped me to understand what I really thought about it. Writing completed the circle, in a way. Eventually it became a habit that proved hard to shake. (I must have somewhere had a secret longing to be a *columnist*—one of several childish and absurd, out-of-the-question romantic fantasies, like my ambition at age eight to be a concert pianist. I had, at that point, never even been in the same room with a piano.) Then one morning I woke up to find that I was a columnist, with a deadline to prove it. It is, in a way, a strange ambition—to write about the work of other artists, especially one's contemporaries. Unlike in the literary life, where it's almost de rigueur, there have been few takers in the visual arts since Giorgio Vasari tried his hand in 1550. Needless to say, when an artist sits down to write about another artist, he is also writing about himself. He is inevitably writing from his own sensibility, and must, if he is honest about it, place himself somewhere in the story.

Most of these pieces were written for magazines: *Town & Country, The Paris Review, Interview, ARTNews,* and *Artforum.* Others were written for exhibition catalogs. The notes grouped under the heading, "pedagogy"—the classroom exercises, as well as various lectures—are published here for the first time. No matter the venue, I have tried to give access to a work's core of feeling and meaning as I experience them, and to draw a parallel between what artists do and the kinds

of experiences we all have in life—to the kinds of emotional trans-actions we can all recognize or imagine. The essays ask, in various ways: what makes a work of art tick, what makes it good, what makes it interesting? Again, it doesn't have to be that complicated. I know some people experience the world of contemporary art as a minefield of jargon designed specifically to trip them up. My hope is that the "general reader," that is, anyone with even a passing interest in the subject, will find in these essays the counterargument: that a core of art's meaning can be accessed without a lot of specialized equipment.

A Note on the Organization

The subjects in this collection range from *compass points* like John Baldessari and Alex Katz to historical figures like André Derain and Francis Picabia. Many of the pieces are about my contemporaries, artists I have known for decades in some cases. Some I went to school with, some are friends. (I don't see any reason not to write about the work of people I know well.) The book is organized into four sec-tions: "How to Give Form to an Idea," "Being an Artist," "Art in the World," and "Pedagogy and Polemics." The last section, which might also be called "Advice to the Young Artist," contains a number of exercises that can be done as part of a class or on one's own. They are designed so that a reader may discover the pleasure to be had from making her own connections, descriptions, and analogies. Why not?

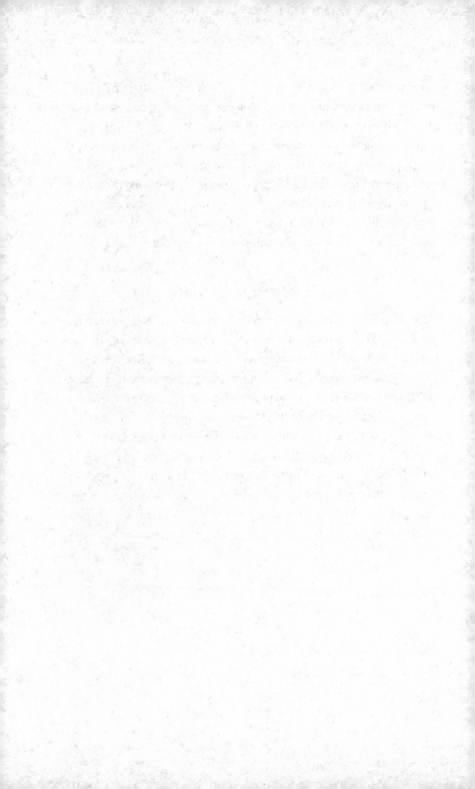

ACKNOWLEDGMENTS

Many people had a hand in launching this book. A number of these pieces were first published in *Town & Country* magazine, and I am grateful to Jay Fielden, then editor in chief, for the opportunity to present my ideas before a broad audience. It was something of a leap of faith on his part. This being New York, the meeting came about in an interesting way. Over a glass of wine at the Odeon one night (yes, I still go there), I mentioned to my friend the poet Frederick Seidel that I might like to do a bit of writing. Just about that dilettante-ish. He in turn said something to his friend Gemma Sieff, who had recently come on board as culture editor at *T&C*. After I explained what I wanted to do—impressionistic reviews, no jargon—Gemma was intrigued and walked me into Jay's office, where a deal was struck on the spot. Gemma greatly improved the writing and has become a close friend as well.

I am grateful to Sarah Douglas, the editor of *ARTNews*, who encouraged me to write more long form. Thanks also to Scott Rothkopf, formerly of *Artforum*, now a curatorial powerhouse, and to Lloyd Wise, also of *Artforum*, as well Michelle Kuo, the magazine's editor in chief. Thanks as well to Christopher Bollen of *Interview* magazine. I wish to specially thank Lorin Stein, editor in chief of *The*

Paris Review, whose invitation to contribute to that storied journal jump-started the current cycle of work that resulted in this book. Both the piece on Amy Sillman and "Questions without Answers for John Baldessari" first appeared in the *PR*.

This book would not exist without the efforts of David Kuhn, a longtime friend who became my literary agent, and who set himself the task of seeing these essays between hard covers.

This book—as a book—is the product of my collaboration with Tom Mayer, senior editor at W. W. Norton. I am deeply indebted to Tom, and to his associate editor Ryan Harrington, who together helped give the book a coherent structure.

Thanks as well to my studio manager Mary Schwab, who wrangled the images and permissions, and coordinated logistics.

Still more people helped as readers and responders. In no particular order, I would like to thank David Wallace-Wells, Alex Katz, Michael Rips, Dan Duray, Peter Schjeldahl, Sanford Schwartz, Frederick Seidel, Rob Storr, Ben Lerner, Hal Foster and Emma Cline. Two people in particular deserve special thanks as the most patient of readers, in some cases enduring multiple drafts as well as endless questions. They are writer and editor Sarah French and novelist Frederic Tuten, great friends both. Their enthusiasm along the way made the effort seem worthwhile. Finally, I would like to thank my wife, Stephanie Manes. Her objectivity, as well as her encouragement to do better, and her delight when something hit the mark, have been invaluable.

Thank you, Dear Ones, thank you all.

PART I

How to Give Form to an Idea

Alex Katz. *Black Hat 2*, 2010.

ALEX KATZ

The How and the What

1.

The focus on the *what* in art has been going on forever, or at least since 1865, the year Édouard Manet provoked the audience with *Olympia*—a painting of a reclining, dark-haired courtesan, skin pale as chalk, adorned with only a pair of "come hither" mules and a black choker. You can imagine the dialogue in the cafés, over a glass of absinthe: "He painted *what*?" Subject matter—the what—can of course be a big deal. It's also easy to talk about. But more to the heart of the work, the thing that reveals its nature and quality, is the *how*, the specific inflection and touch that go into its making. To take a work's psychic temperature, look at its surface energy. Like syntax and rhythm in poetry, it's the mechanics that reveal an artist's character. They determine the way that art will get under our skin, or fail to.

2.

I've been friends with the painter Alex Katz for over thirty-five years. During that time we've had hundreds of conversations about the art of painting and the history of the avant-garde, conversations that

often veer off into considerations of moral philosophy and cultural history; the macro in the micro, so to speak. In addition, Alex has maintained a running commentary about society and social manners, fashion and style, politics, and the dramatic arts including theater, movies, and dance, as well as most known forms of literature. Should you be interested, he can also talk knowledgably about military history, the best way to renovate a loft cheaply, how to buy a suit that you actually look good in, and innumerable other things. Over the course of all that talk, I don't remember ever being bored. Alex once said it was bad manners to bore your friends; you wouldn't want to make a boring painting—it's a form of rudeness.

Eighty-eight years old as of this writing, Katz seems to be only gaining in energy, intensity, and clarity. (I'll have whatever he's having.) His possession of the life force comes straight through to the paint itself. Paying close attention to his work is like attending a one-man art school: all the basics are illuminated. Katz is very, very good at the *what*—that is to say, he's always on the lookout for a dynamite image, an image that makes of its subject something iconic; the *enduring* part of his art, however, lies in the *how*. He can paint a swath of landscape—a white pine silhouetted against a late-afternoon sky, its sweeping horizontal branches made with very wide brushstrokes that arch upward to finish in satisfying, meaty points—repeatedly, and come up with different results every time because of the specific physical energy and tempo brought to bear on each iteration. His ease with a big brush, the way it arrives at the image, is akin to the unerring way Miguel Cabrera's bat *finds* the ball.

3.

Katz is also a great colorist. In painting, as in ophthalmology, color is relational. A color is seldom experienced autonomously; we always see one color against another, and those two against a third, and so

on. There are dozens of other factors that influence our perception of color, such as value (how light or dark something is) and saturation (how dense a color seems) but what counts most is the *intervals between colors*, precisely chosen. The way colors work in contiguity creates a powerful chain of response from eye to brain. Just think about putting together an outfit: Does pink "go" with gray, or is it best set off with another color altogether? In painting, the specificity of color is everything. *That* orange next to *this* brown, with a tiny bit of *that* exact shade of celadon as a bridge. It's analogous to the combination of notes that make up a musical chord: it's the *intervals* that work directly on our emotional core. A good example of what I mean is Katz's *Black Hat 2*, in which the colors of the face and the background—pinks, tans, oranges, and yellows in close proximity—form an assertive counterpoint to the jump the eye must take to the dense black of the hat and sunglasses. It's the visual equivalent of a tenor reaching for a high note. This rare alloy of sensibility and materiality is, I think, what enables some artists to transform dross into gold.

A friend of mine once observed that you could recognize a Katz if it fell out of an airplane at 30,000 feet. Although always on the lookout for an image of killing glamour—the woman in a big hat and sunglasses mentioned earlier, the shadow a pine tree casts on a country lane, an umbrella in the snow—Katz will sometimes take unpromising or even unlovely subjects and, as if to once again demonstrate the relationship between form and style, distill them through the familiar Katzian stylistic laboratory: an almost completely black night sky; someone's feet in clunky black shoes; the edge of a building disappearing in the mists. Everything is form—we recognize it as such when it's divided into shapes, or planes, of different colors. Think about the edge of this book you're reading: the color of one side is different—lighter or darker—than the top. It's the painterly equivalent of a physical law: where the plane changes, so does

the color, and where two planes meet, there is, naturally enough, an edge. How a painter treats this edge is the real subject of realist painting; how the brush behaves in the vicinity of an edge gives a painting its present-tenseness, the feeling of the eternal present. Years ago, over lunch in a Soho restaurant, the late art critic John Russell proclaimed, with his aristocratic, British stammer: "Alex, . . . you are the master . . . of the . . . *edge*."

<p style="text-align:center">4.</p>

There's a story, possibly apocryphal, about the origin of Jasper Johns's famous sculpture of two Ballantine's Ale cans that percolated for years through the sediment of art-world culture; it defined, with some efficiency, the nature of competition among artists, as well as the tidal pull of the generations, each one supplanting the other in waves. As the 1950s came to a close, so goes the legend, the then-upstart dealer Leo Castelli—a suave, European semi-snob—offended the sensibilities of some of the old-guard abstractionists by his ability as a salesman. This assertion, if you happened to know Leo, as later on I did, was actually pretty funny. (Leo, as far as I could tell, never gave the impression of trying to sell anything.) But at that time, when the hard-core art world saw itself as resolutely noncommercial, a dealer who could actually sell pictures to Park Avenue swells—and, moreover, do so without seeming to break a sweat—was the cause of some grousing and grumbling among the painters who had, well into their forties and beyond, survived on cafeteria food and cheap bourbon. For this band of not altogether happy campers, the market's indifference was proof of one's authenticity. No, in the summer of 1958, the mood was not good at Georgica Beach, for years the meeting place of the Hamptons artist community, the site of innumerable quarrels and reconciliations, killing hangovers, and bruised egos. Now, one could feel the winds of change, so wanted for so long, start to blow,

but in a not altogether congenial direction. In those halcyon days, one fine summer afternoon, Willem de Kooning was getting all worked up over this Castelli thing. Draining his Ballantine's, de Kooning crushed the can and violently flung it into the sand. "That son-of-a-bitch Castelli," he shouted. "I bet he could sell a couple of beer cans!" This uttered by a man who had spent one entire summer using the porch of Leo's house in East Hampton as his studio. So much for gratitude. But no matter; the remark soon enough found its way to the ear of the young Jasper Johns, who recognized its prophetic urgency. Never one to *not* take something at face value, Jasper made a striking, and strikingly literal, rendition of "a couple of beer cans"—actually cast bronze, their surfaces meticulously painted with oil. And Leo did indeed sell them. The rest, as they say, is history, just the way it always is. At this point you may be wondering what in hell this story has to do with Alex Katz. Only this: it was Katz who understood the nature of the change that blew in on that wind some sixty years ago and, moreover, understood that the new freedoms meant turning not to the blandishments of popular culture but rather to an older idea of art based on direct observation of form. *Form* is the raw material, and *style* is the forge.

5.

One subject has occupied Katz especially over the last twenty or so years: a section of stream or brook in his beloved Maine woods; it features a fallen tree, an irregular path of rocks, and the rushing water that foams all around them. This subject, known simply as *Black Brook*, has been rendered at morning, midday, and dusk; it has been made luscious, and also dryly, nearly abstract. In a 2015 exhibition of Katz's landscape paintings at the High Museum of Art in Atlanta, there were eighteen different versions, both studies and full-on paintings, and together they gave a large measure of the attainments of

Katz's famous technique. Two paintings from 2011 in particular are like close-ups of the rocks found in that familiar brook; nothing else is in the picture but a line of rectangular stones running horizontally across the painting. They could be enlargements of the stones in the famous black brook, but without the enlivening splash of water, the sense of minute-by-minute *life* going by. These rocks aren't doing much, just breaking up the picture plane, separating foreground from back. Somehow Katz makes them a compelling pictorial event—pure form, like Morandi's bottles. The paintings are simply titled *Rocks*. When I saw them in the studio, a thought, largely unbidden, came to me: "I'll bet the son-of-a-bitch can even make a painting of a couple of rocks!"

<center>6.</center>

Every major artist is an amalgamation or synthesis of diverse sympathies and influences. De Kooning, for example, combined, among other things, cubism and surrealism, Ingres, Dutch still-life painting, the nudes of Rubens, Picasso's line, Mondrian's structure, the Accabonac landscape, jazz, and the energy and angst particular to his time, place, and personality. There is a fairly direct line from de Kooning to Katz himself. They share some traits, such as a workmanlike approach to the practice of painting, a lack of sentimentality, and ferocious intelligence. With Katz, the bouillabaise includes Jackson Pollock, Matisse, billboard advertising, the movies, Japanese screens and woodcuts, modern dance, fashion, and poetry. Once asked to name his favorite artists of all time, Alex started his list with Jackson Pollock and ended with "the guy who made Nefertiti."

As a painter, Katz is more Thoreau than Emerson. His paintings espouse self-reliance; they are the pictorial equivalent of David Mamet's dictum to get into the scene late and leave early. The ingredients in Katz's art are always firsthand and immediate, and looking at

one of his paintings leaves one with a feeling of reality refreshed. He works fast and, armed with a clear analytic structure, keeps the paint itself unfussy. The painting either gels or it doesn't, but most often it does. His paint surface is thin, at times almost delicate, but it rests on a firm foundation. There's a quality some painting has when you work from the shoulder, moving your whole arm, the brush loaded with paint, working wet into wet, so that the traces of the brush are legible—that is so *solid*. What seems almost like a contradiction is part of the performative aspect of painting: material so fluid finally coming to rest in a way that will remain *just so,* forever. You can feel the wonder of it even if you've never made a painting.

Solidity out of movement, permanence out of controlled spontaneity. Painting can also be compared to the ceramist's art; if you've ever tried throwing on a potter's wheel, the wet clay doing just about anything other than what you want it to do, you will be close to the feeling of mild astonishment at even a simple form perfectly executed. I once asked Katz, a serious devotee of modern dance, what he admired in a certain dancer's work. We had been talking about *lifts*—the step that requires the man to hoist his female partner in the air, holding her lightly at the waist, arms extended—sometimes rotating her in space, forming a pivot point for her extensions, and then setting her back down again at exactly the right tempo and emphasis. Consider the strength required: even a ballerina weighs more than a sack of oranges. About this particular dancer, known for his partnering, Katz's reply was simple and to the point: "He doesn't wobble."

Amy Sillman. *My Pirate*, 2005.

AMY SILLMAN

A Modern-Day Action Painter

What makes a picture? Is every painting pictorial, or is it a quality only some paintings possess? The answer rests on how forcefully a painting evokes the strangeness of the visual world, and the arrangements that have to be in place for something to be pictured—the interconnectedness of the image-source, the rectangle, and the manner in which the paint comes to rest on the canvas. Amy Sillman is a modern-day action painter who is finely tuned to the problem of pictorial staging: What is this thing I am making, her work asks, and how can it represent me in all my complexity? Her paintings are composed of ungainly, off-kilter blocks of color that are cobbled together into a kind of improvisational architecture; the paintings feel like memories of houses you never actually lived in. Though Sillman's approach to picture making is rooted in abstraction, most of her paintings are populated with figures and figurative, gestural marks. She accomplishes that long-sought-after thing: a true reciprocity between image and abstraction, one emerging out of the other. Over the course of her career Sillman has refurbished, one by one, the formal elements of painting—color, line, shape, and texture—so that her work feels both classically modern and also very much of this moment. When I first got to know her work, sometime around 2003,

I was taken aback by how "out of time" it felt; the color sense was new, but structurally her pictures could have walked out of the late '50s. Paintings like *Them* or *Psychology Today*, both from 2006, or *Regarding Saturna*, from 2005, look as though they might have been painted in San Francisco around 1962; sophisticated "coffeehouse" modernism. As a person Sillman is warm, *gemutlich*, vibrant, and charismatic—all qualities that you can see in her work.

Sillman's paintings emerge from her extremely confident and descriptive drawing. Her many portraits of friends and couples combine lyricism with psychological acuity. She draws with her whole arm, not just the wrist, and her line is strong, descriptive, and sure. The structure, too, is remarkably self-assured; her pictures are solidly built, like a ship that's been reconfigured and repainted but still retains all the original rivets and portholes. These paintings are built not for speed but rather for durability on the long voyage. Still, Sillman's paintings don't feel heavy; the hulking, buttressed forms are leavened with drawing of great ingenuity and immediacy. They don't shy away from the anecdotal, "a funny thing happened" feeling for life. Sillman has the most assertive and surprising sense of color of any painter working today—lemon yellows, tangerine orange, cobalt purple, teal blue, yellow ochre, grayed greens, frothy pinks—and it infuses her paintings with buoyancy and humor; in a number of paintings, such as *Plumbing*, from 2006, or *Shade*, from 2010, an arm emerges from an accumulation of planes and geometric forms, the blunt, flat brushstrokes yielding to a linear, outline-y appendage/arm/hand that offers up an object as if to say, "Look at this!" That gesture, which can be traced back to the goofy, self-deprecating world of cartoons, goes right to the heart of pictorial mystery—the painting is showing us something. How generous!

Sillman works in two distinct modes anchored in her choice of tools: one involves all manner of marks executed with traditional brushes, from slapping to fanning to line drawing; the other is

achieved by scraping, dragging, and drawing with a palette knife and soft oil-stick crayons. The work has tremendous breadth that ranges from the fortresslike solidity of *Purple Thing* to the ethereal flutter of *My Pirate*. These agile works, which might be called her aviary paintings, are built from a procession of shapes with the lilting, fluttering quality of banners and flags moving with the wind. The shapes themselves are the result of an arching, wrist-inflected brush mark, with an upward finish like the point of a falling leaf. These paintings are lighter than the "solid" works, and more elusive, and in place of architecture, they evoke dreams of flight, a sense of elation that danger has been momentarily averted. These basic elements of painting, the strangeness of the visual world and the surprise of picturing it—*what a lot of pleasure is to be had there.*

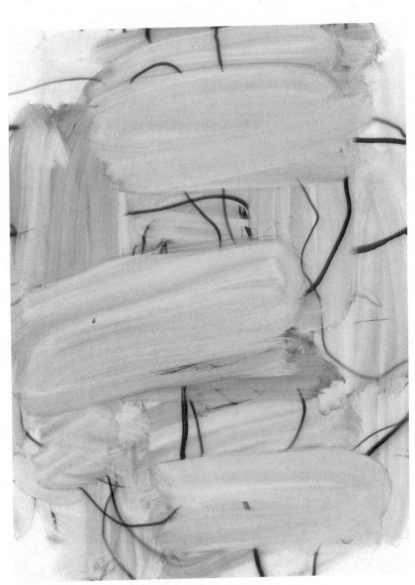

Christopher Wool. *Untitled*, 2006.

Christopher Wool

Painting with Its Own Megaphone

Two critics of opposing viewpoints, discussing a controversial painter:

> 1st Critic: His work is like a car with the engine taken out, but it runs anyway.
>
> 2nd Critic: That's because people like you pick it up and carry it.

This verbatim dialogue, which appeared in a story by Veronica Geng, was actually in reference to my own work, but it could just as easily apply to the work of Christopher Wool, who, though he emerged a bit later, is close to my age. Could it be a generational thing? I don't know about the second part, but the first part is true enough: Wool's pictures run like a stripped-down racer.

It's a mistake to ask a work of art to be all things to all people; the question is how little we can ask of art and still have it fill the space of our longings. By which I mean a state of open awareness like a gravitational field that pulls other things into itself and, in turn, releases quantities of unaccounted-for emotion into the light of day. That is, of course, only one kind of art. Another kind operates more like criti-

cism itself, in which the artist takes up and defends a certain position, and tries to convince us, as Edmund Wilson describes the critic's role, "by the superior power of his argument." The first type is vulnerable; the second tries to limit the artist's exposure to that vulnerability. It's cool—almost by definition if not intent. Black leather jacket cool. This is the type of art Christopher Wool makes—or made, that is, until, apparently, he experienced an epiphanic conversion: the kind that turns the artist into a believer of sorts—less defended, and open to life's indeterminacy.

For most of the '80s, Wool made words—how they sound as well how they look—the primary element of his visual style. Simple phrases or single words were rendered as brutalist, sans serif black letters on white grounds. The letters have the look of enlarged stencils and give the appearance of having been painted quickly, much the way Franz Kline's black-and-white paintings look "fast" but were, in fact, painstakingly produced.

WORDS—long, *long* history in modern art. Picasso and Braque, of course; Picabia, even Gerald Murphy; the whole of Russian constructivism; on to the Americans: Stuart Davis and the precisionists; onward to Rauschenberg and that great stenciler, Jasper Johns, followed closely by Warhol and Ruscha (both former graphic artists); to the more philosophical wordsmiths like Lawrence Weiner, John Baldessari, and Bruce Nauman, after which the baton passed to the more literary Jean-Michel Basquiat. Every generation since 1910 has its exemplars. So already full is this lineage that an artist starting out might have thought twice before planting a flag in that terrain. But a good artist often has the instincts of a gambler, and against these steep odds, Christopher Wool blithely doubled down, Lucky Pierre style, excluding everything from his paintings *but* typography.

Like a few of his forebears, Nauman most importantly, Wool aligned the act of looking with that of reading; to look is to read, and back again.

But that's not quite it. The experience of a Wool painting starts with reading but is more like being read to; as we look, a voice other than one's own intrudes. Wool's paintings directly address the viewer: to look is to be harangued; these paintings come with their own megaphone. The *New Yorker* cartoon version would have a small man standing in front of a Wool painting meekly pointing to himself with the caption "Who, me?" Their tone is declarative, often accusatory. Wool's paintings have something in common with certain radical works of the theater; their closest stylistic relative is Peter Handke's ravishing indictment of bourgeois mendacity, *Offending the Audience*.

Black enamel letters pushed to the edges of white grounds: the paintings are highly energized and, with so few elements, handsome and elegantly resolved. RUN DOG RUN, HELTER SKELTER, and the iconic, SELL THE HOUSE SELL THE WIFE SELL THE KIDS—phrases pulled from the popular unconscious. Wool's painted words enact as well the fraternal comingling, and at times struggle, between painting and printing—which, as much as words themselves, has been a highly rewarding subject for much art of the last hundred years. Where does one stop and the other begin? Though cool and dry, there is a rewarding physicality to these pictures, a painterliness that derives in part from a feeling for scale and proportion; Wool makes lovely shaped rectangles. You might think this to be so elementary as to not warrant notice, but try it—it's harder than it looks. He is a master of scale as well as gesture and rhythm, three elements that establish an intuitive connection with the act of painting. Through a combination of that intuited grace and critical intelligence, Wool has invented a most ingenious type of painting machine in which the process and the image that result are reciprocal; the image defines the terms of its own making with such overwhelming conviction that, when it's working smoothly, you feel some of what you get from a Pollock—the near-impossibility of making a mistake.

Though visually as well as literally expansive, their surfaces covered with spilt, propulsed images, Wool's paintings hew to a narrow bandwidth. His color is restricted to black, white, and gray, with the occasional red or orange. I'm reminded of how rock 'n' roll songs recycle the same slender means: three, maybe four chords, a plaintive lyric repeated over and over in strict 4/4 time. It may not be much compared to Hindemith, but the sound of an electric guitar played rhythmically can be so riveting that it's the only thing you want to hear.

A spirit of childish refusal runs through the center of the avant-garde impulse; in adults it's called resistance. *No, I won't use color; I won't make beautiful things; I won't entertain.* There are reasons for the lasting appeal of this negation, which stem from the art world's love affair with a utopian vision. It is partly the Bauhaus legacy—banish ornament, and sentimentality will follow it out the door—and is also a desire for art to get in front of its complex relationship with mechanization. Into this long history of how to make painting matter in the mechanical, and now digital, age, Wool's paintings appeared as naturally as the butterfly from the caterpillar.

An artist sometimes has to make a sharp turn in order to go straight ahead. I'm reminded of a story about the young Frank Stella, who initially wished to paint like Velázquez but, since that was not within his ability, opted for black stripes instead. The stripes were his Velázquez. Let me explain the connection. Some years ago, I visited the Courbet retrospective at the Met: paintings of stunning breadth and heft, all sinewy, lean, oxygenated muscle; paintings like the tremendous nights with one's first real love, the feeling that everything is possible, nothing shall be withheld. Ahhh . . . this is painting! In one of the last rooms hung three enormous paintings of hunted stags—stand-ins for the artist himself—caught in the agonized throes of death. These paintings stop you in your tracks—that is, if you don't laugh out loud at their wounded grandiosity. As I rounded the cor-

ner, I was momentarily surprised to see Christopher there, too, as I wouldn't have thought him susceptible to such high-purposed melodrama. In that moment I realized that his work is also the dying stag, that he reaches for the same talismanic power to enchant, to confront head-on whatever representation of the sublime the culture will accept. It just looks different today.

I can't say what, if anything, precipitated the shift, but sometime around the start of the new century, Christopher Wool entered a phase of such expansiveness and expressivity that it was hard to find the continuity with his earlier work; he no longer engaged with words as such, but with the language of abstract painting. Just as Peter Handke himself evolved from enfant terrible to elegiac memoirist, seemingly all at once Wool started making paintings full of complexity and ambiguity with the feel of high modernism, once removed. It was as if, from one show to the next, this *sandwich-board writer* commenced his version of *The Waste Land*. Wool seemed to open up everything about the way he makes a painting, engaging with a number of formal elements that exponentially complicate the pictorial space. The result is a kind of picture that is less tethered to the artist's intention; you still strongly feel the artist's presence, but now there is more room for the viewer's eye—and mind—to roam. These paintings ask, and risk, a lot; they're still cool, but only just. Wool's paintings show that "cool" works best when it's a matter of temperament, not a strategy. In addition to the industrial silk screen, two important elements entered Wool's painting vocabulary around this time: freehand lines made with a spray gun, and its opposite formal trope, Ben-Day dots—the pattern that makes half-tones reproducible on a printed page. The dot pattern, so graphically seductive, like a magic ingredient, is to painting what anchovy reduction is to cooking: it deepens the relationship of all the other flavors. The visual combinations made available by these new elements and procedures, laid as they were on top of the

rigorous formal terms of engagement established in his earlier work, unleashed one of the most prolific and visually rewarding periods in recent memory.

Christopher Wool is a doggedly urban painter. Some of the paintings of the early and mid-2000s have de Kooning's late figures in the landscape as their understructure; one even has a de-Kooning-esque title, *Woman on a Bicycle*. But in Wool's hands, the exuberantly watery colorations come out as variations on gray, white, and black. And not the elegant grays of Jasper Johns, but the way Chinatown looks in the rain: the thin, chalky grays of faded signs for parking lots, yesterday's newspaper blowing in the gutter, or the look of a car windshield that's been wiped by a squeegee guy.

In this second phase, Wool became a painter of erasure. Looking at a recent painting, which arrives at its fullness through an accumulation of removals, additions, erasures, spray-painted lines, sweeping gestural wipes, overprintings, and other procedures, it's very difficult to tell what is first layer and what is last, what is painted and what is printed. From time to time the ingredients don't gel, with the result that we can see a little too much behind the curtain; and, although I can tell you which pictures I find affectless, I can't tell you why they fail. Many, if not most, of the pictures have tremendous verve and gravitas; they anchor the wall with the conviction of classical abstract art, and their feeling for rhythm, weight, and balance, the specific velocity of gestures and marks, a meandering line on top of a purposeful back-and-forth full-arm scrub, is highly energized and fully first-rate. They embody much of what abstract painting can aspire to at this moment. Wool's pictures have a pleasantly confusing, shmushed-up feeling, and the different colors of gray and silver and red are lyrical and beautiful; they're structured/vaporous and ironic/sincere in a way that is circular, declarative, and open-ended all at once. Wool's paintings don't easily yield to formal analysis; they work

largely due to the artist's conviction, his belief in the stripped-down means he has chosen. Of course, all artists believe that what they are doing is meaningful, but there are different depths of belief tied to different levels of talent. Wool's pictures have an "it was all a mistake but what the hell" kind of quality—cheerily nihilistic. He has the great gift of knowing when to stop.

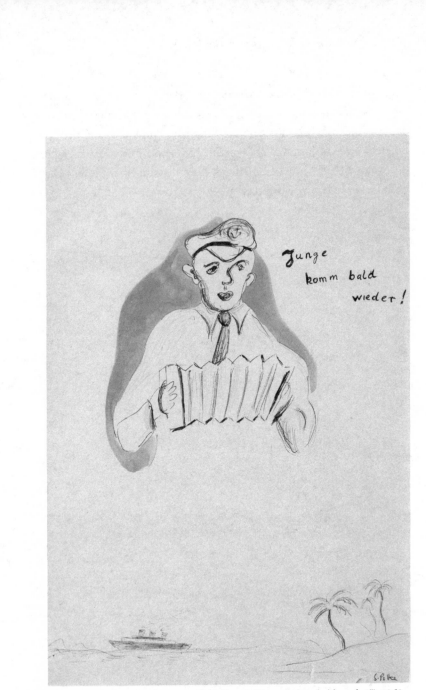

Sigmar Polke. *"Young Man Come Back Soon!"* (*"Junge komm bald wieder!"*), 1963.

THE GERMAN MIRACLE

The Work of Sigmar Polke

Times of great achievement in art are often a matter of slippage; social and aesthetic histories scrape against one another like tectonic plates, generating friction that releases little tremors of energy that push art forward. German painting was propelled onto the international stage in the late '70s and early '80s with the resurrection of a narrative graphic style that combined Germanic mythology with chunky, visceral drawing. Younger artists decisively turned their backs on the prevailing internationalist aesthetic of angst-free abstraction that was officially sanctioned in the late '50s, as well as the overblown conceptual variants that swept through art in the '70s. Think global, paint local. The standard-bearers for this unabashedly expressionistic painting were Georg Baselitz, Jörg Immendorff, A. R. Penck, and Markus Lüpertz. The old well of expressionism was far from dry. This renegade action came shortly after German artists of a slightly older generation embraced the pictorialism of American pop art—its use of imagery from advertising rather than history—but purged of the Americans' sugar. (The waning dominance of New York abstraction, which had gone uncontested for so long, had something to do with the consolidation of Germany's economic power, but that's a longer story.) The two titans of painterly sophistication associated with the

pop-inflected postwar ethos are, of course, the existential skeptic Gerhard Richter and his boho, wild-man, alchemist, joker pal, Sigmar Polke. The return to a more self-consciously German identity rooted in expressionist drawing (Baselitz et al.), and the somewhat jaundiced appropriation of the latest American import (Polke and Richter—*capitalist realists*, as they were known at the time), were the two main tributaries feeding into German painting in the final years of the twentieth century: one was unapologetically European in outlook, while the other sought to renegotiate the terms dictated by the Americans.

There were other important goings-on in the German art world of the '60s and '70s, the work of Joseph Beuys principal among them. (Beuys was older than Richter and Polke—he had been a fighter pilot in the war—but his influence was felt by a slightly younger generation.) But it was the tension between the two opposing temperaments of German painting—cool versus warm, ironic distance versus heroic gesture—that created a drama of aesthetic persuasion and led to an incandescent period in art history. Nothing lasts forever. With the death of Sigmar Polke in 2010, the miracle that was postwar German art feels like a narrative completed. Richter, Baselitz, Penck, and Anselm Kiefer, as well as the younger Albert Oehlen, are all alive and well, but with the deaths of the prophetlike Polke, the political activist Immendorff, and the charmed gadfly fuck-up Martin Kippenberger, a revelatory period in German painting came to a close.

Polke's art is formally advanced, humanistic in a vaguely cynical way, and often hilarious. You can feel that he loves humanity, so long as it doesn't impinge on his freedom of movement. Polke's sensibility was a rare combination of elements that allowed him to function like a kind of medium: that is, he was someone who could channel this or that stylistic trope while allowing life's imagistic flotsam to flow, planktonlike, through his system. In contrast to the dour Richter, Polke was a sardonic clown; he enjoyed posing as a kind of holy

fool. In the flesh, Polke resembled a character drawn by Hergé—a grown-up Tintin. His endearing gap-toothed grin, the little topknot of hair, and his laughing eyes are what I chiefly remember about him. He gave the appearance of a disinterested eccentric mounting a rearguard action on the pretensions of late modernism, while simultaneously creating some of the most visually ravishing paintings of the last forty years. Alone among his tribe, Polke continued to enlarge not just his field of operation, as many do, but his formal vocabulary and very orientation to picture making. You sometimes feel that he took painting apart with a screwdriver, looked at the pieces lying on the floor, and got bored before he could put them back together. His work is tied to the spirit of Dada, surrealism, pure anarchistic negation, irreverent fun (often at the expense of "the people"), and constructivist high-style design.

Polke's work is a lifelong essay on the theme of freedom—what it looks like, and what it takes to achieve and maintain it. He gave form, discipline even, to a way of being in the world that one would think to be too evanescent, too mercurial, for mimesis; he caught the butterfly in his grasp, so to speak, without damaging its wings. Again in contrast with Richter, who takes himself so seriously that you sometimes feel beaten over the head by his work, Polke cultivated casualness as an antidote to pomposity; he made art that seemed to promise very little. In fact, however, there is enormous range in his work, from the cocktail-napkin humor of the early and mid-'60s to the jewellike, lapidary quality of the poured, alchemical paintings of the '90s, with a cascade of variants and detours in between.

A retrospective exhibition of Polke's art presented by New York's Museum of Modern Art, in 2014, was the largest one to date in the United States, and its curators worked hard to give a sense of the breadth and formal daring of his art. It included a large selection of Polke's irresistible works on paper that allowed the viewer to hear the artist thinking out loud, as it were. Drawing as daydream, sketch

comedy, diary, pure design—everything except drawing's traditional function of rendering objects in space. There were no portraits from life here, only life itself. You could feel the presence in the drawings of artists as diverse as Max Beckmann, August Macke, Oskar Kokoschka, Kurt Schwitters, Joan Miró, and Paul Klee, as well as James Thurber, but mostly Polke's drawings feel unprecedented and free. His lyrical way with line has been the single biggest influence on the last forty years of German art, and just as de Kooning's brushwork was a given for second generation abstract expressionists, Polke's angelic line has become almost a birthright for younger German artists.

In the earliest drawings and paintings—works like *Sausage Eater*, *Socks*, *Young Man Come Back Soon*, and *Cabinet*, all from 1963—the tone is efficiently set out: gently mocking, self-effacing, and careful to put that little bit of icing on the cake. What makes it art is Polke's ability to locate the absurdist humor that resides within the *form*, and that operates like a kind of substructure in the images themselves. Think of it as the visual equivalent to the deep linguistic structures buried in everyday speech, or as high-grade visual camp—suddenly seeing the cockeyed logic at work in an innocuous-seeming ad. Whereas another artist might see only an advertisement ripe for parody, Polke's visual straight-man act unlocks the absurdity of the compositional idea lurking beneath the surface. *Socks* is a "portrait" of three men's socks painted in brown silhouette against a blue background; they are displayed in parallel diagonal lines that read as a kind of faux-classicism, the diagonals exuding an energy evocative of high-class abstraction—a *Blue Poles* of hosiery. A shape is just itself, except when it's a sock. Part of what Polke does in this period is to give the viewer access to the deep pleasure that comes with seeing the familiar as something irrationally *strange*. It's as if the artist known as Sigmar Polke came to us as a munificent gift from another galaxy oddly similar to our own. These pictures are substantially different in tone from the coolness of American pop art; there's less belief in the

vitality of the commercial object, the images are treated with more whimsy, and the results feel more personal. And always, that hand, the drawing casual and unstudied, the compositions lyrical, loose, and just right.

Starting in the late '60s, Polke became interested in the relationship, which is often vampiric, between painting and photography, both as a generator of images and as a chemical process. For an artist of Polke's cast of mind, the darkroom must have seemed a place of revelation. His use of photography is mercurial, silvery, and vaporous; images are made in the dark, from treated papers, acid baths, and bursts of light. The images mushroom and coagulate; they thin out and cloud up like tinted viscera, a phosphorescent jellyfish glimpsed in dark water.

The paintings of the '80s and '90s developed in two general directions. First, there was the classical: the maximal, large-scale, multipanel works comprised of found fabric, silk screen, cartooning, and every conceivable manner of overpainting and printing. Here we find works like *The Living Stink and the Dead Are Not Present*, from 1983, a collage-like painting close in spirit to early Rauschenberg, though Polke easily had the greater gift for purely graphic communication. Less narcissistic than Rauschenburg, Polke is the more insouciant painter. His paintings have a much greater imagistic range and structural complexity. But he's so cool about it that you don't always notice how many things he's doing at once. He is the Oscar Wilde of painting.

The other side of Polke's output is the more experimental work that occupied him from the late '80s until the end of his life. *Fear-Black Man*, from 1997, is a good example of these more unitary paintings that feature a square format, with a centralized image, and poured, colored resin. The picture is enormous, sixteen vertical feet and nine feet wide, and it has the appearance of a giant shadow cast by some bogeyman upon a melting brick wall, while outstretched arms reach

up from the bottom of the picture plane—to do what? Beg the mad creature for mercy? Cheer it on as it stomps on its victims? I'm giving the picture a scary interpretation, which I think it allows for, but it can also be seen as the result of a spill; it's just viscous liquid pooling up on a flat surface and nothing more. It's like seeing the figure in the carpet as a child; there's pleasure to be had both from scaring yourself by perceiving the image and from watching it dissolve back into an abstract pattern. The ability to make a painting that is simultaneously image and pattern, and to make both readings intensely pleasurable, is the measure of Polke's art. He was never strictly a realist—he was never strictly anything; rather, Polke balanced the representational with the banana peel on which it was meant to slip.

Polke's pictorial inventiveness is so generous, so viewer-friendly it makes you feel that, on a good day, you too could do it. His painting gets at something elemental about how to live today, and seems to whisper, "You are not locked into your story. You could be otherwise." The strength of that conviction, the sheer vitality of it—I can't think of anything more that we could ask from art. Like all great artists, Polke was in pursuit of ravishment, and he wanted to stun, but only on his terms. His work asks, "Can this be enough? What are you afraid of?" Immerse yourself in his art and weep for the diminished spirit of our present age.

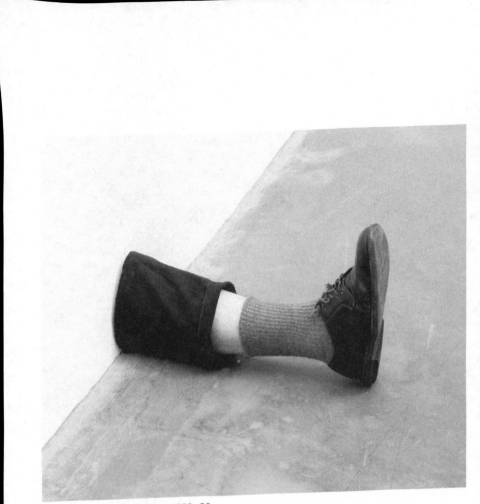

Robert Gober. *Untitled Leg*, 1989–90.

ROBERT GOBER

The Heart Is Not a Metaphor

The elegant and elegiac sculptor Robert Gober is the poet of drains. Unlike the readymade urinal by a certain R. Mutt, Mr. Gober's drains and the sinks that would house them are lovingly, one wants to say achingly, crafted by hand from wood, plaster, and paint. When they first appeared in the early 1980s I did not know what to make of them; what kind of new animal had suddenly appeared at the watering hole? Like a warthog nudging aside the larger and noisier beasts, the wall-mounted variations on the standard white porcelain shop sink had a presence both modest and stubborn. Over the years, the sinks, such as *Untitled* from 1984 (Gober gives his work no titles, only dates), have retained those two qualities and have come to seem exceedingly beautiful as well.

One of the big questions facing young artists in the late 1970s and the first years of the '80s was how to join the aesthetic of postminimalism—the truth-to-the-materials, process-centric attitude embodied most eloquently in the work of early Bruce Nauman, Eva Hesse, or Keith Sonnier, among a host of others—with a somewhat furtive embrace of imagery, and the theatricality that lay just underneath it. For the generation that came to be known as "postminimalist," the idea was to take the geometric forms favored by min-

imalism, the cube or square, for example, as well as the penchant for things in series or grids, and subject them to some *disturbance.* There was a tendency to draw in space with materials like string, hay, wood beams, and so forth, but these forays into drawing never approached imagery as such. It was up to the next generation—artists born in the early and middle '50s—to find their way toward a use of images, and the linkages between them. For where there is imagery, a story—implicit or explicit—is not far behind. The rhythmic *thrum* of narrative constantly unspooling in the brain was for decades thought to be at odds with art's desired state of autonomy. *Why* art had to be autonomous we as a culture can no longer even remember, but trust me, it was important. Art could not point to or represent things; it had to *be* something—period. This separation of *being* and *representing* was itself an odd cul-de-sac in the history of modernism, though no one questioned it at the time—as if the two things could ever really be separate.

For a generation brought up on the rectitude of minimalism—all grids and boxes, and the like—all the while yearning for some way to put a personal sensibility back into their art, the conflict was dramatized as the "theatrical," that is, everything personal, subjective, and symbolic—at war with the literal. The anecdotal was suspect; art needed to be a *fact.* Frank Stella's rather smug formulation "What you see is what you see" informed much of the art of the late '60s. Seeking some deeper truth was for mystics. Pop art was given a pass; it was serious but somehow not relevant. Looked at through a very wide lens, from an Archimedean vantage point some light-years away, you can see this was just another example of the Apollonian or classical temperament versus the romantic. The romantics insist on the larger meaning of their individual, personal experience, while the classicists respond, "Not interested." As usual in art, there are the originators and the enforcers. The originators are singular and can't really be used to set standards for others, while the enforcers do just that. Man Ray

was an originator; André Breton was an enforcer. One can sometimes be both. The enforcers can't prevail forever (though they seem to be having a very long run at the moment); real life eventually shows up. In 1978, an early semi-jailbreak was staged at the Whitney in a show called "New Image Painting," by the much-missed curator Richard Marshall. Marshall put together a group of artists who had come of age in the waning years of abstraction's hegemony and had made tentative stabs at depiction, at the recognizable world. Imagery as such, if it were not to be ironic or graphic, as in the manner of pop, was not serious but an admission of weakness; real men did not use images. Oh, but some do. In this landscape of exhaustion, another heretic appeared: Joel Shapiro, whose miniaturized houselike forms of cast bronze sat on the floor rather than on pedestals, and so were almost kosher, but they were, it had to be admitted, *houses*, not just ingots. More than forty years later, the lingua franca of world art, or one of them anyway, is verisimilitude—the appropriating and re-creating of all manner of objects and images from the real world. That is one swinging pendulum.

Out of this stew, with the postminimalists starting to retreat and the imagists starting to come out of hiding, emerged the young Robert Gober, first with meticulously executed dollhouses, followed by the white sinks in 1985. I thought for a moment, when he first emerged, that Gober might be the kind of artist to stay with his embodied image—the white plaster sink in dozens of variations— and that would be that. Like many artists before him, one finds a *thing*—a horse, a lemon, a bather, a procedure, erasure, or black oil stick crayons—and takes it as far as one can. But it was soon clear, as his imagistic vocabulary and manner of using space began to enlarge rapidly, that Gober was much more ambitious; both his humanity and his sense of outrage expanded to the point of challenging the dominant culture. As I have written elsewhere, this all took place in a time of what George Trow called "collapsing dominants," and

Gober's challenge to the cool, and very straight, art world came at a time when it might have been blown down by a feather. The sensibility embodied in his work became one of the principal replacements for the old straight, white cultural hegemony. The outsiders were the new dominants, in addition to which, everyone with any sensitivity at all was deeply, guiltily disturbed by the seeming inability to do anything about AIDS.

Children's beds, or cribs whose sides are tilted; wallpaper printed with images of lynching; a fireplace with logs made to resemble men's legs, complete with shoes; the legs of other men, clad in cheap pants and shod in worn shoes jutting out from the baseboard, some with candles attached to the shin; a replica of a bag of kitty litter—things a young boy would see, fixate on. And the materials: to the wood and plaster were added wax, human hair, light bulbs, leather, silk screens, *running water*—the materials of the wax museum, the fun house, the morgue. The work is creepy, liturgical, precious, and, one feels, full of bristling critique; if it were a person, it would be the sort who is quick to take umbrage.

Gober's bold stroke was to combine the handmade, process- and materials-oriented postminimalism aesthetic with the symbolism and preciousness of surrealism—no mean feat, and one that took a lot of guts. Like de Chirico with the shadows removed, Gober's work resembles an adolescent's dream of surrealism's power to enchant. What had not been possible a generation before—to take the kinds of drawings that might be found in a precocious high schooler's note-book, the limp noodle arms, jackets with breasts, and legs inset with drains—and incorporate them into big-league aspirations realized in three dimensions. That's more or less the point at which Gober comes into the story. His work has precedents in certain marginalized fig-ures from the '60s, most notably Paul Thek, and certainly Gober's ascent, the extremely high seriousness and quality of the work a given, has a lot to do with timing. Linking images, sometimes bizarre ones,

with a postminimal procedural mentality is also the foundation of Matthew Barney's art, along with that of dozens of other younger artists; the lineage continues. What differentiates Gober is his attitude toward media. Barney is a full-on showman; he's comfortable making a spectacle that can be broadcast globally. It's easy to imagine that Gober still has a black-and-white TV, if he has one at all.

Gober, along with Kiki Smith and Jeff Koons, two artists at opposite ends of the aesthetic spectrum, relegitimized surrealism for the post-pop-art world. It is in Gober's work that I find the strongest presence of real psychological insight; his work delivers the shock of recognition that we recall from reading Freud—the psychopathology of everyday life. When people say that surrealism borrows from the logic of dreams, what they mean is that objects, people, *things* undergo transformations without going through any visible transition. In surrealism, as in dreams and cartoons, things turn into other things without any preamble. Just the other night I dreamed that my wife was an exotic (imaginary) breed of shaggy-haired dog, about five feet tall, lithe and elegant, with the same soulful eyes as in real life, plus a dainty black muzzle. Then she was joined by six more of the same, all trying to tell me something that, in the dream, I failed to understand. A pack of wife/dogs trying to get my attention. What does it mean—who the hell knows? This kind of transformational syntax is one in which Robert Gober is liltingly fluent.

At the beginning of the '90s, as the art world and art market were frozen in a kind of paralysis, Gober's art took a giant leap into large-scale installations. Wall-sized murals of forest scenes, painted or silk-screened, became the backdrop for multiple sinks in various configurations, eerie lighting effects, and amplified sound. I don't mean this to detract from their effectiveness as art in any way, but the installations, so a priori theatrical in themselves, almost beg to accompany a play or an opera. Staged in front of a Gober backdrop, productions of Ibsen or Strindberg or Genet would be in dazzling

equipoise with the art. MoMA has restaged several of Gober's large-scale pieces, and they have the scale and intensity to stun. Perhaps the show's centerpiece, *Untitled* from 1992, first seen at the old DIA space on Twenty-second Street, today seems like fully arrived classical art, and it makes similar efforts by others seem like small beer. The work represents a singular moment—one of failure, enervation, defeat, exhaustion—and makes of it something exhilarating. As with all effective art, the greatness is partly a matter of the imagination behind it and partly a matter of style. The specific value contrasts in the painted forest backdrops, the touching verisimilitude of the facsimile newpapers, the texture and level of the sound—Gober touches on the mania for facsimile, replication, re-presentation, but a simplistic critique of consumer fetishism is not the point. These collections of objects are more like fetishes themselves, and they care little for the world of manufactured desire. As in the world depicted on the TV show *Mad Men*, what first seems like a sophisticated and knowing set piece turns out to be a child's view of what the grown-up world must be like, of the child's intersection with it. It's the opposite of Koons in this regard. Kitty litter, drains, candles, men's legs, buttocks, cribs—the adult world viewed from various stages of childhood, not the other way around.

The theme of Gober's work is men, their torments, desires, shames, and failures, as well as their occasional tattered triumphs, which are usually heralded by a maternal or celestial female image. As I read it, his work is about the retreat, or defeat, of the father, the remains of which, or whom, are seen only from the waist down, often on their face, candles lit in memoriam. In sculptures like *Untitled Leg* (1989–90) and its many variations, I feel like I'm coming face-to-face with a kind of shroud, but one that has been turned inside out. These body-cast sculptures ignite the strange desire to see oneself after death, and still remain as oneself. They have the specific vibration of the gravesite; they are low on humor. The space between the top of the

sock and the pants cuff—that ultra-vulnerable, exposed whiteness—
is as chilling a glimpse at the fallen father as we are likely to have.

Gober is also an original and sensitive curator, in which role he
seeks to discover—sometimes by keeping discreetly covered—the
DNA that links together artists of seemingly disparate temperaments.
He understands instinctively, as no institutional curator can, that
what binds artists together is not style or generation but something
deeper: the motivating psychic structures impacted by a specific time
and place. Gober would no doubt have made a probing psycho-
analyst, adept at countertransference, and I'm not sure he isn't a new
type of analyst in artist's clothing.

Albert Oehlen. *Untitled (Composition)*, 1992.

ALBERT OEHLEN

The Good Student

Albert Oehlen is a terrific painter who flirts with disaster and gets away with it. Part of the generation of German artists who matured in the wake of Sigmar Polke and Gerhard Richter, Oehlen had the good sense to capitalize on the rule-breaking freedom their work represented; he snatched the ball and ran. His work has grown in accomplishment as well as stature over the last twenty years; recently, he has been more or less successfully jockeying for the slot of Europe's top painter. In 2015, the New Museum gave Oehlen a survey show, and though it was hampered by being too small to give a sense of the range of his achievement, it was a chance to see a handful of major paintings. Oehlen works through indirection and indecision, which he elevates to an aesthetic principle. He makes all kinds of rookie "mistakes," but the paintings don't suffer. His work is full of undifferentiated bits of stuff—brushmarks, splashes of paint, images, patterns—splayed all over the canvas, with no focal point and too many similar-sized shapes, but the pictures work anyway. His surfaces are often diffuse, slack, or awkward, but the pictures work anyway. And his color is often muddy, soupy, unpleasant, but . . . you get the picture. It sometimes seems like there is nothing that Oehlen cannot make work to his advantage.

In the late '70s, Oehlen studied with Sigmar Polke at the famed Dusseldorf Kunstakadamie, and the encounter was fortuitous. Although it's heretical to say so, sometimes the student surpasses the teacher. "Surpass" might not be exactly the right word—but sometimes an older artist will set out the terms for an approach to materiality (or immateriality) that the younger artist can apply to a more complex or startling degree of resolution. The older artist is a furnace, throwing off a lot of sparks, and the implications of all his protean forging open up more paths than can be explored in his own lifetime. Sigmar Polke bequeathed to painting a new idea of composition that seemed to mirror a mental disorder, or that of society; it was collage taken to the level of Schwitters' *Merzbau*—the total environment. Everything is material. His painting is a whole course in styling, so to speak—style as attitude, style as awareness. Polke's work engaged capitalist kitsch—advertising art—as well as obscure, philosophical leanings, from alchemy to the kabala. His work could be maximal, occasionally overfull, but his sense of humor and innate elegance always pulled the painting back from the brink.

Such was the legacy that Albert Oehlen absorbed, channeled, and ultimately transcended. It must have been the right time in Oehlen's development to be exposed to the master's subversive, liberated way with materials, images, art history—with context generally. *When the student is ready*, and all that. I don't mean to overemphasize Polke's role; there must have been dozens if not hundreds of talented students passing through the Kunstakademie in the 1970s, but you can't spin gold out of just anything. In art, the teacher/student relationship is more one of bringing to flower something the seeds of which were already planted. The propensity for flowering needs to come before; then the climate has to be right. Oehlen worked under the older artist's protective camouflage, so to speak. Looking at Oehlen's work, you feel Polke's influence most clearly in the way nonart materials, printed fabrics and other mementos of middle-class striving, literally

remnants, can be used to create a foundation on which to paint—to make a structure, something to react to while in the act of painting. It was an exercise at which Oehlen excelled. It's not that Oehlen is *better* than Polke—do we need to rank them?—it's that what Oehlen is able to achieve with the assist, the push-off, from Polke's audacity takes painting into deeper waters. Compared to Polke's subversive, lilting, satirical, quixotic restlessness, the younger artist's work is more sober, inwardly directed, and visually complex. And it opens up more space for other painters to follow—it shows a way forward. It's as if Polke did the demolition work and laid the foundation, and then Oehlen came along and raised the building.

One thing Oehlen added to the conversation is the *veil*—drippy, drapey washes and skeins of thin, liquid color. The veils obscure the painting underneath, partly nullify it, but in places allow the boldly, absurdly printed fabrics to poke through and reassert themselves. To these washy paint scrims are added crisp-edged blocks of color that are nearly imagistic; the colored bands and bars and chevrons are reminiscent of circuitry or city-planning diagrams, like an enlarged detail of a subway map rendered in freehand paint. Oehlen also uses other devices: signs and symbols like quotation marks, grids of dots, and passages of fluid, slashing brush marks "bundled" like kindling, or rubbish. This contrast of urban faux-sophistication (the fabrics) with the rural and anecdotal (brushwork), is one way Oehlen animates his work. The veils, which are often made from dirty turps and some interesting, jewelescent earth tones, give the paintings the feeling of being seen from inside a sock. Why is that a good thing? Like I said, Oehlen can make anything work.

Oehlen uses a lot of commercial imagery, sections of ads digitally enlarged to heroic scale, and the results are without equal among today's painters. Unlike some of his contemporaries who start with art and end up with something that has the emotional shallowness of a billboard, Oehlen, like Rosenquist before him, starts with bill-

boards and ends up with art. I can't think of anyone working today who can squeeze as much poetry from an expanse of commercially printed flesh—the field of Ben-Day dots—as Oehlen. Duality is hard to paint, even harder to sustain. Integrating commercial imagery in its raw form with pure painting is more challenging than it looks— one or the other usually gets the upper hand, one impulse more or less negating the other. Oehlen makes both sets of visual codes feel necessary to the painting's structural integrity. Everyone gets a chance to sing.

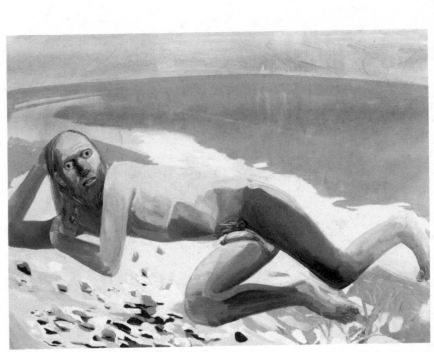
Dana Schutz. *Reclining Nude*, 2002.

Dana Schutz

A Guy Named Frank

Remember talent? A person who is said to have talent can *do* something; it's often physical, like throwing a football or playing the cello. Then there is imagination; the difference between it and talent is often misunderstood. Imagination fuels talent and funnels into it, but on its own lacks body. Today talent is easily confused with knowingness or a desire for attention, and what passes for imagination is often nothing more than a reshuffling of cultural signs. That's fashion. Occasionally an artist comes along with both talent and real imagination, as well as the ability to combine them—to cast an original narrative idea into pictorial form. An early career survey at the Neuberger Museum in 2012 shows that Dana Schutz can do all of those things. Her paintings depict weird, funny characters in scenes cut from whole cloth, and her imaginings are inseparable from the way she renders them in paint. She handles the brush as an extension of herself, and the connection between her arm, shoulder, wrist, and fingers is more convincing than that of any other painter her age.

Visceral and surprising, her painting advances the role of imagination in art in a way that is specific to the medium: it's one thing to see this or that image in the mind's eye, but it's another thing to paint it, and Schutz does this in a way that feels natural and unforced. She has

an impressively confident hand and works in a direct, unconflicted manner, laying down medium-wide brushstrokes in close-valued colors of intensity and saturation. What she can do with a brush is real enough to her that it becomes real for us, too. Paintings of people sneezing, yawning, being poked in the eye, shaving their pubic hair, or vomiting—as far as I know, none of these has been the subject of a painting before. Schutz doesn't make a big deal about them; a few descriptive marks, a little shading, and voilà—the image comes to life without being the least bit cartoony.

Schutz seldom loses her sense of humor; her confidence allows for improvisation and perversity. She takes obvious pleasure in fucking up the surface of her paintings, breaking down the image at the same time that she's building it. I feel she can make a painting out of anything; she reminds me of a child who can amuse herself with any material at hand—an empty spool of thread, a cardboard box, or an iPad—and yet the paintings are formally demanding. Her images, especially some of her backgrounds, are constructed in a curious way, often built from what looks like cascades of fractured shapes heaped on top of each other. It gives her paintings a feeling of novelty, of a pictorial problem solved in an original way. Schutz often paints in the inquisitive mode; her paintings seem to answer bizarre offscreen questions whispered from the wings: "What if you could eat your own face? What if a face had wheels?" Her painting mind goes places few, if any, have gone before.

Schutz's color sensibility has a '60s period feel to it. Acidic green, purple, tan, orange, pure blue, and turquoise are presented without a lot of blending, as if they belong together. She's especially adept at handling a range of greens that aren't found in nature but are often used to describe it, and she has a no-nonsense, unfussy way of building images—what used to be called plasticity. The scale of her brushstrokes is almost always right—the marks suit what they describe, and gesture is most often harnessed to the painting's internal archi-

tecture, not just surface decoration. Schutz is a picture builder, not an illustrator. Her style is first of all addressed to a workmanlike sense of form; it's never arbitrary. She doesn't just draw with the brush; she's a constructor. She makes good use of a first principle of representation; where there's a change in plane, there is always a change in value, the lightness or darkness of a form. Look at a three-dimensional form—a coffee cup—in the light: one side is dark and one light. Shifts of value define the edge of a plane in space, and when a plane changes direction, a dark shape next to a lighter one, it creates a sense of form. Exploiting this simple principle allows Schutz to barrel through densely packed scenes efficiently, using a big brush, and not getting caught up in illustrational details. Maybe it's her midwestern upbringing—there is plenty of *fancy* in her work, but no nonsense.

Schutz is also a sophisticate; she's grounded enough in her own manner of painting to allow in a wide range of influences. In larger compositions such as *Presentation*, from 2005, the presiding spirit seems to be James Ensor; for smaller, more focused paintings, her closest stylistic neighbor is David Park. Both of them are American symbolists who can be taken for realists. Other sources resonate in Schutz's work, from muscular '60s abstractionists like John Hultberg to atmospheric pattern painters like I. Rice Pereira to nineteenth-century social realists like Gustave Courbet.

As for the poignant, social-satiric dimension she achieves in her most ambitious paintings, I think we have to go all the way back to Francisco Goya to find a similar combination of pure painting, drama, and unsheathed, scabrous satire. I refer here not to the Goya of the despairing, late Black Paintings but to the Goya of the tapestry cartoons that gave Spain's newly emergent middle class, at the turn of the eighteenth century, a chance to see themselves reflected in art's mirror. The resonances and influences extend even further. *Abstract Model* of 2007, for instance, recalls the Vache paintings of Rene Magritte, as well as the final, deeply nihilistic phase of Francis Picabia's

career. These paintings may be even more subversive than Schutz's better-known images of self-cannibalization; the perversity resides not only in the what but also in the how.

Realist painters usually work with a handful of themes: the nude, the racetrack, the portrait, the life of the street—alternating between public and private subjects, and Schutz returns again and again to the theme of men as *the other*. She paints them singly and in groups, and, with a combination of wit, disbelief, and sympathy, catches their physical awkwardness, social infantilism, and self-regard. Schutz is our preeminent painter of cluelessness. A particular favorite of mine is a modestly scaled painting from 2002, *Reclining Nude*, that depicts a naked guy (a recurring character named Frank, whom the artist identifies as the "last man on earth") lying on a beach with an ultraviolet sunburn over his entire body, genitals included. What makes it all work is the specifics of the pose; Frank looks back over his shoulder to meet our gaze with a completely relaxed, comfortable-with-himself expression, and Schutz gets the gravity of the floppy dick just right. He stretches out across the picture plane, and his body runs off the vertical sides of the canvas, loosely rendered without a trace of preciosity. Working within a limited but vivid palette, Schutz creates the background for the picture with a wrist-inflected, semiarabesque wash of thin color to define water, sky, and pebbly beach. It's a work that has grown in singularity and reach since it was painted—a rare thing.

What I especially value about Schutz's sensibility is her ability to pluck images from the lurid absurdity of the recent past—men's sensitivity retreats, Michael Jackson, PJ Harvey—subjects that might in someone else's hands feel au courant, or even dated, and make out of them something that doesn't rely only on popular culture for its identity. Even when referring to a television banality, as she does in the 2008 work *QVC (I'm into Minimalist Tattoos)*, the painting transcends television consciousness—it doesn't seem to need or particularly care about TV for its life pulse. Schutz's work has more in

common with art made before the ubiquity of contemporary media, when paintings were a way to think about recent history, not just send it up. As with Daumier or Manet before her, the energy in her work is more painterly than reportorial. She understands that a work of art can be more than a bunch of cultural signs, and this will allow her work to live beyond its immediate cultural moment.

Sometime after 2006, Schutz's work became more fragmented, with a range of painterly approaches made to coexist on a single canvas. She began cutting holes in her paintings and treating depictive space with an attack so fast and loose as to feel at times a little daft. Some of the paintings of this period are rescued from surrealist kitsch only by the aplomb with which a painterly problem is solved: like how to rein in her use of pattern and let the paintings have some downtime. But the last thing she could be accused of is laziness; she seems to have the energy and stamina of ten painters. Sometimes, the desire to try *anything* can lead Schutz down blind alleys; nonetheless, her wish to take greater license in her work is a good thing. She's like one of her swimmers taking a big gulp of air.

This try-anything approach can also produce astonishing work. One such unmoored picture is *Man Eating Chicken*: a man sits at an elaborately grain-painted table, his face and arms mostly eaten away by a black-edged devouring "absence," with a few cleanly picked chicken bones on the table. Standing upright, as though occupying a different space altogether, a giant wishbone is painted in a lovingly sure hand: one perfect brushstroke per rib of bone. Behind the man is a pattern of irregularly spaced gray dots over a washy, light gray background, while an enormous, crudely rendered, canary yellow sun, like something a child would draw, hovers above. Radiating from this wobbly orb are yellow rays that manage to be limp and assertive at the same time, and they give the painting a watery, "what the hell—it's all gone anyway" quality.

Schutz makes heroically scaled paintings, and for the most part

they're aging very well. Less well known than MoMA's *Presentation* is another masterpiece, *Civil Planning* (2004), that balances the grandiosity of its conception with an abundance of cleanly rendered detail. Over a huge surface teeming with figures and full of action, one finds a lovingly painted garden spade discreetly planted at the bottom edge of the picture, as if to say, "This is a real place, there's real digging going on here." Is it a scene of dystopian future? A femdom utopia? The composition of this very large picture has the complexity and control of classic abstraction; looking at it I found myself thinking about Jackson Pollock's landmark painting from 1952, *Blue Poles*. Like the Pollock painting, *Civil Planning* intercuts top-to-bottom, full-arm gestural forms with tiny notational marks that pull the eye back into deep illusionistic space; in Schutz's hand this visual manipulation feels unforced, something done for sheer pleasure, and it pulsates with the sense of wonder at what paint can embody. It seems to say, "I can do this—and this."

Schutz's paintings often seem to respond to a question posed offstage, a kind of cosmic *what if*? What if someone in a group of middle-aged men on a sensitivity retreat—the painting is evocative of *Le déjeuner sur l'herbe*, but with the edges damaged by fire—is caught midsneeze? The result is a self-portrait as pachyderm. Schutz's images can be critical, sometimes hilariously so, but they aren't bleak or cruel. Rather, they are feelings made external, and they convey the exhilaration and freedom of mind at the core of painting.

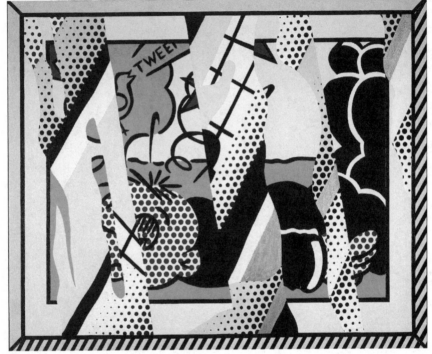

Roy Lichtenstein. *Reflections (Wimpy III)*, 1988.

ROY LICHTENSTEIN

Change Is Hard

Anyone who knew Roy Lichtenstein even casually—and there was a time in the '80s and '90s when I enjoyed his company fairly regularly—can tell you that he was one of the great wits of his age. His sense of humor was extremely subtle, and Roy could deliver the coup de grace in the most oblique and unexpected ways. "Deadpan" is what people say, but Roy's version of it was very advanced, always perfect in tone, and devastating in impact. That kind of delivery is part of what he brought to painting, and one measure of his achievement was his unlikely pairing of the literal with dynamic pictorial expression.

I don't think I understood the complexity of Roy's *Reflection Paintings* when I first saw them in his studio in the late '80s. Paintings that reprised some of his earlier motifs—the girl with the beach ball, Wimpy, etc., with the conceit that we were now seeing them through glass, hence the *reflections*—they seemed a little overcomplicated, a lot of trouble to go to. But paintings within paintings, whether from art history or from his own history—in a way it was Roy's big theme. I also wasn't crazy about the illusionist frames that were part of the compositions; it felt a bit wan as visual puns go, and this particular one had been in common usage for at least a hundred years. When

they were shown at the old Castelli Gallery, on West Broadway, some people uncharitably thought that the raison d'être for the paintings was that collectors could buy classic pop paintings of Roy's at much lower prices than they'd be obliged to pay for work from the '60s. I never thought for a second that that had been Roy's intention, because he was ruthlessly serious and selective about his work. Nonetheless, such is the power of the framing device of the commercial gallery, and the "variations on a theme" approach to the installation, that lent the exhibition the air of a collector's dream.

My initial assessment of the paintings was wrong, of course, and I've come to understand Roy's later work as another chapter of his relentless exploration of and self-revealing journey through pictorial representation. This isn't to suggest that the paintings are dry; in terms of emotion, their tone is wised-up, even a little bit rueful. They're paintings made by someone who took the long view of life and was somewhat, but not completely, forgiving of its infelicities. The work of someone who'd seen many things, with a more overt presence of the artist than in much of Roy's oeuvre.

His enormous *popularity*; it's easy to lose sight of just how conceptual a painter Roy was. There's a lot of loose talk today, just nervous chatter really, about conceptual painting, the idea that painting should be the result of an off-site decision-making process—but the buzz usually boils down to someone unwilling to make much of a commitment to the materials and exigencies of painting. Metapainting, or sort-of painting, or things that mimic painting but still hold something back, are all right as far as they go, but the results tend to be a kind of aesthetic or moral version of wanting it both ways, and coming up snake eyes instead. Roy's work is all about painting; only by working from the inside out—from immersion in the mechanics of how a painting is constructed—can the right degree of self-awareness be baked into the work. That is to say, it may look as though a paint-

ing, especially one as tidy as Roy's, is the result of a set of decisions, but those decisions are made at the end of a brush.

Beneath the glamor and wit, what we feel when we look at Roy's work has to do with history, with having a history to begin with. The radicalism of Roy's approach to the problem of representing *the new* was that it remembered the old position and the old history. Roy was the oldest of the pop artists, and the one who had the longest gestation period, and the longest layover in abstract-expressionist-town. He had to wait a while to find the key that would unlock his painting; he needed that key, too, in order to overcome the fatalism and diffidence bred into someone raised in proper New York bourgeois style, someone who had gone to war, and seen Paris in the '40s (which was essentially not very different from Paris in the '20s).

Part of what made Roy's work new and potent was that he was a '40s/'50s guy standing a little bit on the sidelines when the truly new mind at the beginning of the '60s started to eclipse all the older forms—the complexity, ambiguity, and existential drama. Roy was very good at impersonating that gee-whiz American type: I think it gave him great pleasure to do so, too. He could express the essential gee-whizness of the new as someone who still remembered the old rules, and could register his—and our—astonishment at being liberated from the old ways of making meaning. A certain social contract was removed, and it resulted in the collapse of the hierarchies around which meaning had come to be codified.

Roy's early pop work had the effect of almost instantly deactivating the power mechanisms of the old-rules gravitas machine. You could look at a Warhol *Soup Can*, or more likely a *Marilyn*, and not be disturbed in your reverence for, say, Clyfford Still, because the two artists were seen as having nothing to do with one another. But once you'd seen a painting by Roy depicting a tire, a growling dog, a torn window screen, or Wimpy, the old moral structures of Still, or Rothko, or even

de Kooning, started to have a horse-and-buggy kind of distance to them. One reason Roy was able to achieve this, I think, is because he grew up with the horse-and-buggy boys and girls, or he knew people who did, and he remembered, or wanted to remember, and wanted *you* to remember or imagine what that world might have been like. To feel the distance of just how far we'd come from that place. He expressed a kind of wonder at the modern, liberated world without being at the amoral heart of it, without any of the excess or decadence of it, and we all loved him for it. It was just irresistible, really.

In the '80s and '90s Roy achieved another kind of distance and made work that seemed to simultaneously honor and dismantle art history. He was confronted, as is every mature artist, by the very different challenge of keeping the work moving forward without sacrificing its pictorial identity and, beyond that, of making the internal pressure of one's own evolution somehow reflect the social forces at work in the culture. The mechanized future of early pop art had become the present, and the liberation from the old values it promised had come to be seen for what it was: an emptying-out process of jumped-up consumer stimulation that left you with very little in the way of tangible values. If pop started out as a way of "liking things," as Andy said, probably quite sincerely, its legacy in the '70s and '80s was more complicated; you can like things all you want, but they will not like you back. In fact, when you're not looking, they will rob you. It's now more or less agreed that the great liberation that was supposed to flow from the new industrial society never actually took place, and even if it did, it ushered in another set of problems. The great leveling of social codes that followed the breakdown of the 1950s order only led to more anxiety. By the '70s, pop art started to look like an embrace of this new consumer-driven social order; it felt a touch corrupt and compromised, and integrated a little too easily into the middle-high strata of public taste. Think of Warhol's portrait of the shah of Iran (which was never actually made); collapsing ironies, indeed.

But these were not Roy's problems, because this was not Roy's beat. Despite his enormous regard and affection for his pop brother, Roy was really the un-Andy. From the '70s onward, Roy expressed his distance from the collapse of social codes he'd helped bring about by advancing—or retreating, I'm not sure which—into an increasingly pure classicism. While he might say to me, artist to artist, that we should never forget that we're essentially making baubles for the rich, he never let his awareness of other people's motives or limitations interfere with what was, for him, a very long-term research project having to do with the age-old and fundamental effort of every artist to reconcile form and content. Roy's project would not have seemed unfamiliar to Titian or Velázquez, and certainly would not have raised an eyebrow in the cafés frequented by Monsieur Manet and company.

What was Roy up to in the *Reflection Paintings*? How do these paintings work? What kind of structures are they? How different are they from what they initially appear to be? In the world of a serious artist like Roy, the progression from the bald, early statement of intent to the reflexive, ruminating, deconstructive, corrective attitude of the late work is a visual metaphor for the getting of wisdom and knowing what to do with it. The progression from his painting of the cartoon character Wimpy, a figure Roy first painted in 1961, to the three *Wimpy* variations that are part of the *Reflection Paintings* of 1988, is as succinct and clear an embodiment of the idea of self-critique as we're likely to see among what Manny Farber called the big painting tycoons of the '60s. Every long and serious career is a movement toward greater freedom and dissolution (think of Monet); in Roy's case, the desired freedom, which was a long time coming, had to do with undoing the very thing that defined his style and allowed him to move so deftly, so stealthily, through much of the last hundred years of art history. I refer here, of course, to the black outline.

If you've staked your artistic identity, as Roy had, on a refutation of that most personal component of artistic syntax, the brush-

stroke, it's a little hard—even thirty years later—to go for broke with a spontaneous, unpremeditated action of hand-wrist-arm and believe that the resultant smear of paint is going to mean anything. If you put a black outline around the brushstroke, you might be able to have it both ways, which is pretty much what Roy did throughout the '60s and '70s. The seeming brushstroke was really, in the best trompe l'oeil, Johnsian sense, a *picture* of a brushstroke. But starting in the '80s, Roy began a recall of the black outline, the very thing that had held his pictures together, and also what had allowed him to put all manner of visual citations into quotes, so to speak. If you remove the outline and let the thing, the brushstroke, the painted image, stand on its own, both independent of and also subservient to the architectonic precision of the rest of the picture, then maybe the paintings will convey a sense of vulnerability, and of life lived. Without even leaving home, the painting becomes a visual marker for all the traveling we've done. As human activities go, change is hard; for an artist to depict it is even harder.

The *Wimpy* paintings are an eloquent illustration of what I'm talking about. On one level they're paintings of a cartoon character, and they give off something sweet and nostalgic that puts maximum emphasis on the oddities of the conventions of graphic symbols. (Roy is all about graphic symbols: you have to go back almost to Altamira, to cave painting, or the pyramids to find art that is more purely about symbolic representation.) The stars, spiraling lines, and little birdies that connote Wimpy's comatose state are just too much; who could resist them? But the painting has other levels, too, not the least of which is the identification of the painting's protagonist, the hapless, knocked-out Wimpy, a dreamer who's seeing stars and hearing the little birdies go tweet. It's not much of a stretch to say that the artist is identifying with—or better yet, casting himself as—the Wimpy/Dreamer, because that's what artists *are*, dig?

Whether or not you buy that little riff (and I think you should,

just trust me on that one), our job here is to compare the original 1961 *Wimpy* with the three variations on this theme that Roy painted in the *Reflections* series of 1988. In comparing them side by side, one just thinks: *Where has Wimpy gone?* Because here's the thing: every language has a secret moral history, and pictorial language is no different. In these pictures Wimpy still dreams his cartoon dream, but he now lies practically buried beneath the caved-in house of modernism Roy brought crashing down on top of him. That first *Wimpy*, from 1961, is now in a big frame, under glass, and is likely in a museum or an apartment on a certain stretch of Park Avenue; the reflections of his new environment on the glass meant to protect him are just about killing him. And you know what? He's never going to make it out of there; he'll never be back on the street, able to be seen simply as Wimpy again. And you know what else? All those jagged, obfuscating reflections that block our view of the charming and lovable Wimpy/ Dreamer? We caused them while we were editing our history to make it more palatable and more in line with the heyday of pop. The only problem is that those days aren't here anymore, if they ever were, and all the record auction prices in the world aren't going to bring them back.

In the version from 1961, Wimpy was never going to wake up and enjoy another hamburger, because he was in the painting. In these later versions, Wimpy is not only never going to wake up; he is, for all practical purposes, shattered beyond recognition into broken, jagged shards of depiction. I'm sorry to be the one to tell you this, but Wimpy will never be made whole again. Pop art? What was that? The innocence and glamour of the '60s? Fame? What do they all mean now? Wimpy is history, a part of a history you probably weren't there to see.

It's sadder than you thought it was going to be, isn't it? Consider the painting *Reflections on Sure!* By all rights it shouldn't be such a lovable work, because this is a painting that says: "You think you

want pop art? Well, forget about all of that now because it's over, it's long gone." The painting is also quite thrilling, of course. It's brilliant, actually, and is one of Roy's most masterful dramatic pictorial organizations. The picture's brilliance is rooted in the way it equates the erasure of the pop image—which simply must be erased, because it's no longer true—with the release of the artist into wider, and wilder, uncharted territory.

The golden-haired girl who appeared repeatedly in Roy's work is just about out of here, too. You can still hear her voice, but you can't see much of her anymore. And what she has to say is the distillation of all the ambiguity, equivocation, and uncertainty of the last twenty-five years. She has one farewell word for us: "*Sure!?*" Not so sure after all. It's fantastically brilliant, really. A little slapstick and formalist sleight of hand are transformed into a very poignant piece of pictorial symbolism. The artist throws up a smoke screen of abstract shapes and hilarious, intractable forms that just about obscures his movement, and while we're trying to figure out how to "enter" the painting, the artist, elegant and refined as ever, makes his escape.

Jeff Koons. *Puppy*, 1992 or 1997.

The Art of Childhood

Jeff Koons at the Whitney

The task of representing happiness, both as a state of mind and a national pastime, periodically gets reassigned between the various arts. John Updike once wrote, with only minimal irony, that he considered America a vast conspiracy to make him happy. One of Updike's fellow Pennsylvanians has done more than anyone else to make middle-class American happiness a legitimate subject, as well the guiding aesthetic principle of his art. That artist is, of course, Jeff Koons.

I first met Jeff in 1979 when a mutual friend took me to his studio. He was polite, affable, and earnest. You could sense the hidden depths: his deep love for and identification with art, high art, which is, I think, the source of much that is good in his work. It's the reason he's better than those who would try to be like him. Art is everything to Koons; he has internalized its essence, which for Jeff is linked to striving to be better, as a person, I mean. Koons is a synthesizer; he's keenly aware of his artistic forebears, and his art is a combination of all the great things he has ever seen.

The pop culture part of his art would be flimsy, almost weightless, but for this awareness of the past. Without being slavish about it, that is to say, without quoting directly, Koons manages to convey his place

in the great chain of art; you feel that he measures himself against more than just Warhol. He is also an astute observer of other artists' work, as well as a thoughtful, contrarian collector. Looking back to that meeting thirty-five years ago, I realize Koons also possessed a quality I had not often seen: wit without irony. Despite the passage of a large chunk of our lives, and the complications that follow in the wake of almost unimaginable success, I don't think he has changed at all.

In 2014, the Whitney Museum gave over the entire Marcel Breuer building (its final show there) to the first full-scale retrospective of Koons's art in his own country. This comprehensive survey, sensitively curated by the human dynamo Scott Rothkopf, gave full measure of Koons's diverse output, placing his iconic works in the context of an intellectual and emotional—as well as technological—development.

Koons's art represents the conflation of the readymade with the dream of surrealism. Major artists are often a combination of unlikely pairings, derived from the intertwining of two or more previously unreconciled sources. Think of de Kooning (Ingres and house-painting); Jackson Pollock (Veronese and Navajo sand painting); Roy Lichtenstein (Leger and technical drafting); or Bruce Nauman (Duchamp and funk art). Koons's art (like that of Sherrie Levine, or any number of other artists of his generation) also begins with the legacy of Duchamp but combines the Frenchman's contrarian irony with the perverse, sexualized emotionality of Salvador Dalí. Critics, and for that matter Koons himself, seem to want to locate his art as a continuation of the "Andy Mind," but it is really more a late flowering of the "Dalí Mind." All major art expresses something true about the society in which it was produced. If abstract painting expresses the idea "You are what you do," and pop art expresses "You are what you like," then Koons's art says, "You are what other people like."

Koons's use of the literal—the thing is what it is—is not in fact literal minded; he has always dwelt in the realm of metaphors, parables

even, and has no trouble conflating a cartoon character with a whole mythology. When Roy Lichtenstein painted Mickey Mouse or Donald Duck, the subtext was just *America*—and the kind of dumbed-down, gee-whiz entertainment that it amused Roy to impersonate. When Koons paints or sculpts the Hulk, or Popeye, he's invested in the mythology of the characters themselves; he's pushing them forward as dramatic personae. At the time I met him, Koons was making sculptures from cheap inflatable toys: brightly colored, globular, cartoony-shaped flowers set in front of mirrors. The pieces were of modest size, twelve to eighteen inches tall, sometimes sitting on the floor in the corner of a room. That was *it*—an inflatable nothing, looking at itself in a mirror.

The work was so goofy, and so effortlessly hit the sweet spot between delirious kitsch and self-aware, logically honed critique— and the man himself was so winningly sincere, so *in it*—that whatever doubts I may have had evaporated. It takes someone with a very open heart to feel "expressed" by a blow-up vinyl flower. It's worth noting that while so much of his generation has come to be associated with the grandiose and the overblown, the origins of his sensibility, like that of others of his time, were derived from an attraction to the marginal and the overlooked. Several of these primal works were in the Whitney show, and they retain most of their original oddness. I remember feeling concern that the work seemed so slight, with so little physical *anything*, that Jeff might have a less than welcoming time of it in the art world. Which turned out to be true—for a while.

Andy is also part of the story. More than a quarter century has passed since Warhol, one more Pennsylvanian, left the stage, and a measure of how much art culture has changed is to revisit the *Times* obituary from 1987. John Russell, the paper's lead critic at the time, somewhat sourly wrote that in Warhol, "the culture got the artist it deserved." That may have been the last time someone in a position of authority questioned the validity, as opposed to the ubiquity, of

Warhol's contribution. The next twenty-five-plus years have seen a continual elevation of his legacy, to the point where young artists today have simply to use any one of the Master's tongue-in-cheek pronouncements as a ready justification for whatever it is they're doing. To paraphrase Charles Bukowski: "Anybody can be sober. It takes stamina to be a drunk." A lot of young artists may have their Andy fling, but few have the steely determination or the stamina to take life on Andy's terms—the absolutism of his contrariness would crush a mere poseur. Only one artist in my generation was unfazed by the stringent entrance requirements: Jeff.

We won't even get into Warhol's piñata effect on the art market—candy everywhere!—but it is perhaps fitting that an artist who, when he was alive, borrowed a protective carapace of glamour from fashion, or society, or wherever he could find it, has been used to confer that same two-dimensional validation on every marketable thing. Warhol made commodification itself glamorous, as opposed to merely inevitable. And what of the counterculture? The Left? They can just go in a closet and suck eggs, as Steve Martin memorably said, in a somewhat different context. That's all been taken care of—by the market. It's not so much that capitalism triumphed as that it reset the terms by which we establish value in art.

The line in art between the good, the accomplished, and the popular has been more or less erased in the national mind. The new mind has it that what's popular—by definition that which has attracted a sizable audience, or the most attention in the press—is, ipso facto, the best. In other words, the market is always right. Or, in the words of one of the leading auctioneers of our moment, "The market is just so smart." If you believe that, there's nothing I can do for you. How much can one hold a single artist, or even a generation, responsible for this turn of events? The answer is not much. Where then to lodge one's protest? It does no good whatsoever to fulminate against the consumers of contemporary art; the most you can do is hurt some artists' feelings.

The critic Clive James wrote of Cocteau, "He was dedicated not to the private experience of art but to its public impact." That shift has now become an aesthetic principle for artists of a certain generation. When Andy said, "I'm just like you—I like the same things you do," no one believed him because it was only partially true. Liking Coca-Cola and movie stars didn't ameliorate his painful singularity. When Jeff says, "I'm just like you," we have no reason to doubt him. Alone among artists I know, when Jeff talks about his art, he uses a civic—rather than an aesthetic or even a critical—language. I've seldom heard him talk about his art in a technical way; it's all about what it does for the people who look at it. Worldly people, Europeans, initially considered him a charlatan, someone manipulating the hayseeds, until they realized he wasn't kidding.

Technology has given Koons the ability to make replicas of astonishing verisimilitude. Interestingly, his work of the last ten or fifteen years uses sophisticated means to make stainless steel enlargements of the same kinds of inflatable toys that in the '70s were taken as is. I am at a loss to explain the fever for replication and verisimilitude in the art of the new millennium—Charles Ray, Urs Fischer, Adam McEwen, et al. I suppose we do it because we can. Koons takes the idea of replication and increases the scale to the point where objects can compete with architecture. In a time when overreaching has become an aesthetic principle, Koons is the biggest of the big.

Every postmodern artist is first of all a "noticer": she notices images in the world that have the capacity to resonate—we can all do that—and, if she's any good, effects a kind of transference or linkage to the realm of imagination. That's the art part, the poetry of transferrence. In our postindustrial landscape, we all "choose," and artists anoint their choices with visual significance. They accomplish this by giving their choices an upgrade in form—by ramping up the specificity of an image, by customizing it, if you will. Jeff's work is highly democratic—which, however, just as in politics, is not a sim-

ple thing. Democracy makes everything small—it works from the middle, bringing people down, or up, to a common denominator—and art makes things big again, but only for a while. Jeff's work is caught in an endlessly repeating loop of "larger and smaller"; it plays into the conundrum of whether the artist or the audience is what matters. Clive James again: "Whether we like it or not, individuality is the product of a collective existence." Few non-Marxist artists have understood this seeming paradox more instinctively than Koons, and his choice of images that everyone recognizes but few have noticed—the balloon dog, for one—has left him vulnerable to charges that he flatters his audience. It didn't work in quite the same way with Warhol, because, though Andy chose Mao as a subject because his face was known to more of the earth's population than any other figure, it was still a surprising choice in the West. And Andy so clearly *wasn't* like everyone else that whatever he chose—even the most innocuous panda bear—became slightly weird in his rendering.

As an artist, as distinct from a *personality*, Koons is essentially devoted to the expressive capacities of the human form. Figurative painting and sculpture has been, with a relatively brief detour, the classical mode in Western art for centuries. Koons seems to want to be a new kind of Renaissance sculptor, giving not just art people but *hoi polloi* something to rally round, to identify with. He wants to give people something that will make them gasp, to make monuments of figurative sculpture. I'm not sure what it says that his subjects are images from the world of childhood, but maybe it's not important to know.

As technological marvels, the gigantic balloon animal sculptures in Koons's last show at the Gagosian Gallery were audacious. Why then did they somewhat bore me? They felt like a joke repeated too many times, spoken through a PA system; they lacked the intimacy of their briskly attentive balloon-dog antecedents. They had become remote monuments, merely something to be photographed in front of—the downside, the emptying-out that goes with being popular.

What kind of artist is Koons exactly? Is he a *form-giver* or just an appropriator? Are the sculptures readymades or bespoke? He certainly aspires to be a form-giver but sometimes falls short. It is instructive to compare one of Koons's elaborately baroque, demonic even, stainless steel bourbon decanter sculptures—there were several in the Whitney show—to works made in the '60s by a now little known pop artist named Robert Watts. Watts made polished chrome versions of Coke bottles, and at the time they must have had all the logic and inevitability of other visual critiques of consumer culture. It turned out that a Coke bottle was not such an interesting form, once the signifier part of the work was used up.

So much has been made of Koons's embrace and deliberate seeking out of celebrity—the art world has never known anything like it before. (Even Andy was regarded as a weirdo by mainstream America.) Though the cult of celebrity is part of Jeff's art, and his thinking, I think his celebrity must be separated from his measure as an artist. For the latter, we need to ask, are the objects themselves, his forms, more interesting than, larger than, their interpretations, their use—value in the media? The answer, again, is yes and no, but more often yes. In a time when the work of so many artists is congruent with its interpretation—no more, no less—Koons succeeds in making something that, though perfectly obvious, transparent even, continues to resonate. The best pieces are not always the ones that photograph to best advantage—partly a matter of scale, partly that phantom quality known as presence. Paradoxically, some of the recent pieces that have left me feeling indifferent, like the blue stainless steel *Metallic Venus*, look utterly transformed in reproduction; like a fashion model, they come to life in front of a camera.

Among his most realized and moving works are a series of polychrome carved wood sculptures, executed by Bavarian master carvers in 1988. Several are in the Whitney: *Cop with Bear*, *Blue Puppies*, and the magisterial *Buster Keaton on a Donkey*. These are the last works

Koons made before embracing wholeheartedly the perfectionism of stainless steel. Maybe it's because an expressive hand was involved, but these works to my mind come closest to locating themselves within the deep pathos of American life at the end of the last century. They focus your attention even as they expand it; the detailed and textured surface requires your gaze to slow down, which in turn leaves you more vulnerable to the totality of the work's effect as an image. The relationships between the image, the scale, and the form (itself a result of technique)—its materiality—are all perfectly aligned. Koons has repeated this impacted, collapsed-telescope, Russian-nesting-doll-like integration of form and content in other works, but not often, and never again with such dark emotionality.

Although relentlessly productive in a wide range of materials, media, and imagery, Koons is best known for a handful of instantly recognizable works: *Rabbit*, *Michael Jackson and Bubbles*, *Balloon Dog*, and the career-defining *Flower Puppy*. Notice this list includes no paintings. Though at times radically beautiful in terms of space, color, and composition, his paintings don't have the iconic sticking power of the object, the *noun*. His collage paintings from the late 2000s have the problem that all collage-type paintings share: how to resolve the edges—where one image meets another. How much thickness does an image have? What is the space behind it? The lobster, the pin-up nude, the kernels of corn—are they decals applied to a painted surface, or are they meant to be volumetric? This is a problem specific to painting that uses collaged, mashed-up images; there is no convention of realism to deal with how one thing would come in contact with another. The very act of collaging negates, to some extent, the illusionism. Koons doesn't solve it exactly, but he manages to sidestep it in the paintings from the early 2000s. Later on, the "edge problem" creeps up on him and flattens the paintings out.

When his work succeeds, Koons makes the thingyness of modern life, that is, the way we bond and identify with products-as-images,

coherent; he takes the iconic or mythic and makes it local: Popeye, the Hulk, the pin-up. And he also does the reverse. The corn kernels, the doughnuts, the mule, the pool toys: they're like the playthings of the gods. It's something art can do, and it's what gives Koons's art a feeling of ebullience, but one that's also slightly toxic. His paintings ask the question, *"Is this good for me? This can't be good for me."* Whether or not you think any of this represents a high-level achievement, or is even worth striving for, it's very difficult to make something with strong graphic appeal that gives access to complicated, even contradictory feelings. For a measure of just how difficult, look at how the shock of Damien Hirst's work has faded—his vitrines and glass specimen cases now look academic and dusty, tokens of a kind of junior high school humanism. Museum basement, next stop. So what's the difference, exactly? Maybe Hirst didn't have enough art inside himself; he was in too big a hurry.

Public sculpture in the open air is very difficult—it can't often compete with nature, or architecture. Koons's *Flower Puppy*, from 1998, is the single greatest work of public sculpture made after Rodin that I've seen. I once spent ten days in Bilbao, Spain, where the second of the litter permanently resides, its flowered tongue delicately dangling out of its mouth in front of Frank Gehry's Guggenheim. During a stressful week when I was installing a show in the museum, I approached the building on foot each day and experienced a kind of fraternal joy on seeing the puppy—first just a shape in the distance, then gradually the realization: it's a *dog*!—that I'm not sure I had ever felt before. I was so grateful for its being there; it was such *a gift*. I never tired of seeing it; I just was happy that it existed. What more can an artist do?

A suitcase flies out of a window of a
tall building. It hits the ground and
splits open. It is full of money. It
has landed in the front of MARGE and
BILL who are having lunch outside.

They have been discussing a painting
they want to buy. It depicts a table
with various objects upon it. There
are flowers in the background.

 MARGE

My god, the price is astronomical! But
in today's art world one must act
quickly...

 BILL

Let's take the money and go back to
the gallery.

John Baldessari. *Movie Scripts / Art: . . . One must act quickly . . .* , 2014.

John Baldessari's
Movie Script Series

"In today's art world one must act quickly." That is Marge's line; *Marge*—a character who makes a brief appearance in a gnomic fragment of drama, a bit of movie dialogue that is part of a work by John Baldessari. The story involves a suitcase thrown from a window, which, as it hits the ground, is revealed to be full of money. *Of course* the suitcase is full of money. As long as I have known John, that which has most often coaxed a gleeful or at least knowing smile out of his bearded countenance is the propensity for narrative to get tangled up with coincidence. Coincidence is in fact the screenwriter's stock-in-trade; one doesn't leave home without a briefcase full of them.

There is another character in the scene as well, a fellow named Bill seated in the garden next to Marge, who clocks the falling suitcase as it splits open, releasing the wads of cash. It's not in the script proper, but one imagines a close-up of his widening eyes. Money will do that. Bill then offers this immortal line: "Let's take the money and go back to the gallery." *Cut!* But this is not really a movie—only half of a work of art. This neatly typed scenelet is paired with another fragment: a detail of an odd-looking still-life painting of hard-to-place origin. Some fruit in a bowl, a white table, some irises in the background; decorative, charming, clumsy, and a little weird. The effect of the jux-

taposition is uncanny—the image *falls* into the work, like something caught in a net. It's a little jarring to realize how much we know about these two characters from such a patently gauzy bit of impersonation. However briefly, they have motive, they *live*; and having lived once, they always will. The piece, simply titled *One Must Act Quickly*, is from John's 2014 *Movie Script* series. This binary combination—a fragment of painting paired with a bit of screenplay—is the template for all the works in the series. The image fragments are sourced from paintings in the Stadel Museum, artists and periods diverse, largely unrecognized, at least by me. The dialogue is from found scripts that John has doctored. (They do call it script-*doctoring*.) Taken as a whole the works are funny, knowing, a bit jaded, and fast. They are among the most clear, distilled, and satisfying of John's long career, and they make the tenuous, often absurd connection between word and picture something intended, inevitable, and true. In an act of sustained ventriloquism, John makes the old pictures speak our own contemporary thoughts. The older art feels refreshed; it is brought up to our own time by a laying on of hands, one after another, all the way to the present. John has often used other art as part of his own, but in my long years of knowing his work, the appearance of older art has never been as poignant or enlivening. These *glimpses* of paintings are used lovingly; they are illuminated, enhanced; we care about the pictures more as fragments than we did when they were whole.

Words and pictures; pictures and words. One way or another, John has spent his career putting them together, testing their stickiness and elasticity, using one to unravel, or to gather up, the other.

The fragment, the oblique clue, hiding in plain sight, punch lines without jokes as well as their opposite, obscurantism yielding to obviousness, playing possum, feigning ignorance, and generally being one's own straight man—these are all Baldessari specialties. Do not belabor the joke. Get out of the scene early. And, even if they put a gun to your head, always answer a question with another question.

But let's go back to the script. Marge is right—in art, one must act quickly. *Quickly and slowly*, as Frank O'Hara once wrote. A gem of pure Baldessari-esque irony can be coaxed out of this little speech. Consider the notion of art-world time—inconsistent, irrational, hopped up or drawn out; it is, like life, never metronomical. In the language of movies, a little flashback: many years ago, sensing my impatience, my longing to get *on* with it (I was twenty-two), John offered this advice, "Don't worry, David. Art is long, life is long." A twist on the old chestnut in which only art is long, in contrast with life's brevity. In fact both are long; a lot happens to one. Forty years have passed. As we know, the art world was *not* so quick to see, to act; John was for many years that undervalued thing—the artist's artist, or worse, the revered teacher. The public did come around eventually, hugely so, but as John never was in any particular hurry, it had little effect on his art or his life.

What took so long? The answer, which may also account for the swelling tide of popular acclaim on which it currently rides, lies with how very different John's work is from that of his peers. Consider the dominant figures of his generation, the conceptualists of high standing: Joseph Kosuth, Lawrence Weiner, Douglas Huebler, Robert Barry, Dan Graham, et al. Good artists for the most part, one or two built to last, but, to varying degrees, all with something dour, cranky, grandiose, or hectoring about their work—you feel you should listen to them, it is improving to do so, but you can't remember at this stage exactly why. Only Lawrence Weiner, who turns out to be a punchy graphic designer, seems to have a present-tense role to play.

John's art, in its attitude and affect, seems of another time and place altogether. For the most part, the work of the foundational generation of conceptualists is objective, external; art is meant to resemble a verifiable proposition, or to illustrate a tenet of perceptual psychology, or demonstrate a bit of game theory. Very edifying. John, alone among his cohort, is a humanist, albeit slightly gimlet-eyed; he

makes narrative art that reflects his curiosity about what's going on in other people's lives. It points you back to why we go to art in the first place. People have to live in it, so to speak. John's work can be ironic or obscure, but it is full of human warmth. To look at his work is to be connected to the kinds of questions that run through our heads all the time: Why is that woman looking down? Why is that man pointing? What are all those people doing over there? *What is she thinking?*

John's approach to narrative has a sanguine, "the world as it is" feel to it; while not uncritical (what fools we can be!), it is for the most part indulgent and sympathetic. Like the good screenwriter he is, John creates art of concision and misdirection (look over there!) that turns out to be the right direction after all. He is a late modernist, and his art is one of fragments. How appropriate to John's sensibility is the screenplay form: flickers of images, words with pictures, bits of narrative spliced end to end; fragments imprinting on each other, forming memory—now we *know*. It's how we feel our lives. Here is the great English prose sylist Sybille Bedford, writing about her own life: "To every fragment there had floated up another—this phrase had been the key to a remembered look, . . . this tale resurrected the mood of a whole winter. . . . In a sense this is my story."

Wade Guyton. *Untitled*, 2006. Rosemarie Trockel. *Lucky Devil*, 2012.

THE SUCCESS GENE

Wade Guyton and Rosemarie Trockel

Painter Wade Guyton and sculptor Rosemarie Trockel have little in common outwardly: different generation, nationality, gender; different talents and aims for their work. But, occasioned by their simultaneous museum shows last fall, I found myself thinking about how each represents a response to the "collapsing dominants," to quote the late George Trow—the demise of conventions and the underlying assumptions that governed the look of modern art for sixty-odd years and finally ran out of steam sometime around the end of the '70s. Although a generation (or two) apart, both artists inherited a kind of antitradition, an absence of a dominant style to either embrace or reject. How each one responded to that collapse and the resultant vacuum is a matter of their respective cultures and personalities. Although Guyton is primarily a painter and Trockel's art takes many different forms, at least as reproduced in the catalogs the work of both artists can appear to mine the same formal language: both make large monochromatic paintinglike things using unconventional materials or processes—but their attitudes are markedly different. The work of one—young, American, narrowly focused—bristles with self-confidence; it has the success gene. The work of the other—older, European, feminine—is complex, inclusive, and tinged with mel-

ancholy. In other words, one is classical and the other romantic in temperament.

In October of 2013, the Whitney Museum's energetic young curator, Scott Rothkopf, mounted the first survey of Wade Guyton's terse and glamorous paintings. Guyton is just forty, and his work has the force of inevitability. If he hadn't made it, someone else would have had to. The "it" in this case results from complete indifference to what a paintbrush can do in favor of the humble but sturdy Epson digital printer. Guyton makes paintings by feeding canvas through the printer, often multiple times, and the slight hesitations, shudders, misalignments, and overprintings that occur in the machine all contribute to the image. The mostly monochromatic results are handsome and oftentimes more. If you are inclined to see painting in these terms, they can even feel elating; they seem to shift your gaze upward. Guyton had first flirted with a career in graphic design, and at some point the intense connection he felt looking through design books propelled him from the page onto the canvas. Viewed a certain way, a page of a book, laid out with intelligence and integrity, *was art already*; one had only to realize its potential. While not the first artist to make paintings of book covers, he's the first one to do it in a way that transcends the obvious. Guyton's love of the clean, well-thought-out graphic look happened to coincide with the new printing technology; he early on recognized the Epson printer's capacity to transform the printed page into printed art. Guyton's restrained, sometimes almost blank canvases have a surprising emotionality, which I think results from just this feeling of romance and longing that young people, especially boys, experience poring over books of the great midcentury architects. Those purpose-full-looking men in their black eyeglasses! His paintings take as their starting point an identification with the glamour of what is now a much earlier time; the achievements of that heroic generation of *form-givers* hover in the background. In the souk that is contemporary art, some things work by giving viewers a more

complex or complete way to ingest what it is they already like but weren't conscious of liking as much as they do. Guyton's paintings give us a way to really like, that is, to imagine ourselves in the company of, certain somewhat chilly and removed figures like Le Corbusier or Mies—their talismanic names alone send chills.

His paintings, derived as they are from graphic models, have the virtue of *clarity*—Guyton has removed any extraneous painterly intervention—and being in the presence of such a clear and logical development, and seeing how the crowd at the show's opening *hungered* for that clarity, made me aware of just how muddled much art of the recent past feels, as if it had been unsure of what to ask for. Actually, what it has been unsure about is its relationship to popular culture, but we'll save that for another day.

Although his aesthetic has nothing much to do with Warhol, the paintings overlap conceptually with Andy's silk screens: they are prints that are also paintings, paintings that are printed. They speak to the undervalued visual pleasure of *printing* as opposed to painting: printing is straightforward, almost workmanlike, and it takes care of a lot of painting decisions, like what to do about the edges. Guyton's paintings are pleasingly complicated, even slippery to think about, while being easy to look at. At times I felt like I was looking at X-rays of paintings by Clyfford Still, or maybe Barnett Newman—close to the thing without being it exactly. This is either unnerving or liberating depending on your point of view or age group. The faintly secondhand aura either feels consistent with the moment or feels, well, secondhand. People seem to want them to have something to do with Duchamp and the readymade and all that, but I don't see it. They are *made*, even crafted, but in a way more akin to artisanal baking than painting: you mix up a few basic ingredients and the oven does the rest. The results are cool, well mannered, and sophisticated. They hold the wall with ease. Except for a few pictures, they are not especially moving as a drama of "painting reclaimed." They

have, incorrectly I think, been compared to Frank Stella's black paintings of 1958–59. To the gestural-painting cohort at that time, Stella's work represented the end of art. If he was right, everything they were doing was wrong. Guyton's work doesn't have that feeling at all—at least not to me. Stella's black paintings were, and remain, icons of an effort to express an existential condition while revealing only minimal evidence of that struggle. The bands of black paint feel *extruded* under great pressure; they are messages in a bottle flung out by a young man with nothing much to lose, pretending to not even care if the bottle is ever found.

Guyton's pictures have no such angst. Walking through the show, I was reminded of the feeling I had as a teenager wandering through the high-end preppy haberdashery in my town. Long before Ralph Lauren, college towns all across America had stores that outfitted the college man, or the boy about to go off to become one. My hometown's version of that store, the Gentry Shop, was a deeply sensual shrine to a much older idea of masculine correctness expressed through craftsmanship, expensive detailing, cordovan leather, gray flannel. You knew that anything purchased there would be the unassailable *right thing*. Guyton's work is like that store. It encourages a kind of identification with the well-curated life many aspire to; it even holds your hand, as if to say, "This is not so hard—don't resist so much."

A few miles downtown from the Whitney, the New Museum staged a knockout retrospective of the esteemed German artist Rosemarie Trockel. Her career was launched in the '80s with paintings made on a commercial knitting loom. Motifs like the familiar Delft china sailboat were woven into a grid using two or three colors of wool and stretched on wood supports like paintings. Like Guyton's work, they were unassailable. These knitted paintings, so full of controlled energy, put a smile on the most dour face; they were formally reserved and inwardly layered—visually satisfying objects that delivered a tart feminist rebuke to any overblown, often male, self-regard

that happened to wander into their blast zone. That was the starting point for a career full of trenchant, sometimes uncanny objects. The retrospective showed that Trockel's sensibility has evolved in myriad and increasingly complex ways. The subtitle of the show, "A Cosmos," is well earned. The show is inclusive, expansive—the imagination behind it seems to encompass large chunks of human experience. You can imagine Trockel saying, "Nothing human is foreign to me. And that goes double for animals." Her art takes some of its power from a profound connection to the natural world. Like the pure of heart in gothic literature, every creature speaks to her—and she shares the stage with many of them in this show.

In addition to colored yarn, Trockel works as well with a dozen other materials, and has near-perfect pitch with all of them. Every form, every surface is what it wants to be, neither too little nor too much: fur, yellow-green vinyl, yarn, watercolor, photo-silk-screen, and most magnificently glazed ceramic—materials are used for their intimacies and associative range. She draws like an angel. One of the show's highlights is a long shelf with dozens of handmade books; each is a model of graphic suavity, and taken together they deliver a poignant dismantling of cultural clichés. One cover shows a loose, gestural drawing of two cowboys, one holding a gun to the other's head. Both men are standing with their bowlegs spread wide apart, making a kind of archway. It's titled *Arco de Triumph*. Trockel has an almost aching sensitivity to presentational forms, to forms of attention; it is this awareness that sets her work apart. Her way with materials is like an actor's with a role—you feel her imagination settling into the images and expanding their meaning from the inside out. After the collapse of the formalist constraints, anything is possible now in any material—but one still has to make out of all those possibilities something that sings. Trockel is our Emily Dickinson; she transforms the everyday into bits of visual poetry that can unexpectedly pierce your heart.

PART II

BEING AN ARTIST

Vito Acconci. *The Red Tapes*, 1977.

VITO ACCONCI

The Body Artist

I first met Vito Acconci in 1974 when I was in grad school at CalArts. I had a car, and part of my job as a teaching fellow was to ferry around visiting artists. If someone needed to be picked up at the airport, I would get a little note in my school mailbox. Sometimes the visitors just wanted to go shopping—the curator Germano Celant was on the hunt for Navajo jewelry; filmmaker David Lamelas was obsessed with finding the perfect vintage Hawaiian shirt. I can still hear David's soft Argentine accent after a long day of thrifting: "Now we go to coffee bar?"

Vito, a true New Yorker, did not drive. He had come to LA to make an installation at an alternative gallery, and I was assigned to be his driver and all-around helper for the length of his stay. Borrowing John Baldessari's studio one afternoon, I helped Vito make a videotape component for the installation—one that featured a talking penis. It was simple, really. Vito lay down on a table with a string tied around his dick. With the camera focused in a tight close-up, I would yank the string on cue, giving the impression that the penis was a kind of Beckettian character in an absurdist drama; it would jerk itself upright to deliver a line or two before collapsing back again just out of frame. The penis's first speech: "I'm drowning! I'm drowning!

99

I'm drowning in a sea of tit!" It went on in that vein for some time. The penis really did appear to be talking, and it had a lot of grievances to air. After we finished making the tape, we went for lunch at a little café around the corner from John's studio, and then on to the lumberyard to buy some other things needed for the installation. All in a day's work. Does this experience give me some special insight into Vito's work? Not really—the most prominent feature of Vito's work, its extreme intimacy, is available to all.

Early in his career Vito Acconci was known as a *pioneering body artist*. What does that even mean? Someone who is his own test tube.

Much of Acconci's later work referred, directly or not, to girlfriends. Acconci is hardly the first male artist to feature female partners in his work, but perhaps he is the first to make art that takes as its starting point the question of what a girlfriend *means* in the context of an artwork. Maybe using girlfriends is a way of rooting art in some direct experience. The woman becomes the "vessel" for the male point of view in the end. *Vito, tell the story about your father giving you two prime seats to the opera for your birthday, and then seeing him in the standing-room section when you walked past with your date at intermission.*

Before finding his way as an artist, Acconci had been a poet, and I think he was never far from that identity; language was part of everything he made. The piece I helped him make was originally called *Groping at Body; Groping at Mind; Groping at Culture*—that's the way Vito actually talks—but the title was rejected as being too much in the style of the abstract critical mentality, which, though it came naturally to him, buried more than it uncovered. Despite his formidable intellectualism, Acconci's work also embraced the intuitive. What's more human than *the body*? His installations, with their recorded, incantatory chants, are drenched in a feeling of frustrated desire and futile longing, which in Vito's case is a matter of temperament. His

art is a record of the struggle to externalize that intense interiority, that self-consciousness. That's what a body artist does.

New art sometimes emerges as a caricature of older ideas about the relationship between the artist and the audience. That is to say, an artist may *appear* to take up older forms, going backward to move forward. How is existence defined in an organism? It takes in nourishment, rids itself of waste, and is capable of locomotion. After his body-art period, the residue of which exists mainly as documentary photographs, Acconci moved on to display-like installations that combined spoken texts with faintly Rube Goldberg–ish constructions. A hanging rack of twenty identical red flannel shirts, a gangplank that leads out the gallery window, a little "privacy booth" for some erotic reverie, a swinging door to nowhere, etc.—elements of a sort of three-dimensional rebus used as a staging ground for Acconci's texts, a set for a theater of one. Vito reads beautifully, hypnotically; he recorded his texts in the incantatory, staccato rhythm of the Beats. The recordings are often ribald and wildly funny, but the comedy is bitter and offers little relief. Sometimes they aren't funny, but become so through repetition and sheer outrageousness.

One of Claude Chabrol's later films tells the story of a middle-aged man, proud of his classical education, who begins to lose his young wife to the counterculture. In an effort to save his marriage, he suggests they both take on as many lovers as they want, if only to prove to the world that they are above petty jealousy. The young wife is initially appalled by the idea but eventually finds pleasure with a series of men much younger than her husband—men who are cool, less educated, and much more casual about sex. Predictably, the husband goes mad with jealousy at the idea of his wife, whom he considers to be his intellectual inferior, finding pleasure with his these unsophisticates; he's infuriated that she's fallen for the blandishments of a cultural new wave that will be a great leveling-out. In a rage, he bursts

in on his wife in bed with her lover. He's wounded, not because she has a lover, but because the younger man represents a consciousness that he deems facile, simplistic, and ill bred. He berates the fellow for criticizing what he does not know. "You make fun of Descartes, but you haven't even read him. I have. You don't know anything about any of the things you leave behind." "Maybe not," the young man replies with an indifference tinged with pity, "but we don't need to know anymore."

Vito Acconci's artistic evolution mirrors a generational passage. He is part of a cohort of artists who scrutinized the very foundation of their responses to everything in life—a kind of inner phenomenology, as a way to interrogate the broader culture. In time, Acconci became a bridge to a generation of artists who no longer wish to know anything. From an intense need to *know* to nonchalance in less than a generation. Chalk it up to the abstraction of contemporary life. With knowledge devalued or suspect, there is not much tradition to build on, and young artists will work from the deluded belief that they are making it up from scratch. Or won't much care if they're not. It will be interesting to see how Acconci might influence the next generations of performance artists—those who no longer need to know the reasons for everything they do but are content to simply present an already ratified self, theatrically, as an already formed persona.

John Baldessari. *Four Events and Reactions* (detail showing *Touching a Cactus*), 1975.

THE *PETITE CINEMA* OF
JOHN BALDESSARI

I have an image of John Baldessari at work toward the end of the '60s, his studio an abandoned movie theater a few blocks from the beach in a suburb of San Diego, a terribly long distance from lower Manhattan, where it is all happening. Outside, coastal bleakness up and down the street, the relentless SoCal glare reflecting off of plate-glass windows, bike chrome, even parking meters. The studio shares a mostly empty parking lot with a coin-operated laundry and a few palm trees.

Inside, the theater's raked floor left only the stage as a level surface on which to work. I see John at this end-of-the-earth place, standing at the easel, the blank movie screen filling his field of vision behind the canvas. One can imagine that the light might have been arranged so that John's shadow was cast onto the white screen. Did he not see himself as the protagonist in a movie about the struggles of a painter?

This is a story about how an artist starts with a set of *moves*—and how those moves grow into a successful style that can be exported to (or in this case from) the provinces so that other artists groping around for a container, something that will hold their sensibility, suddenly have a template and a way to proceed. Form—that all-important thing. Once a form is found, ideas that have lain beneath layers of

consciousness, inchoately biding their time, bubble up to the surface. From 1971 to 1975 I was a close-up observer of and occasional participant in the development of John's work when he was literally *making it new*. I was able to see firsthand how the work acquired a shape, which became a look, and then a style. So much has been written about John as an intellectual—a thinker and reactor. If I can, I want to restore to the work a sense of its mystery and psychological complexity; to connect the themes and the content of John's work to what I remember of him as a maker and doer in those formative years.

When CalArts first opened its doors in 1970, John Baldessari initiated a class called Post Studio Art, which for practical purposes simply meant anything other than painting. In the context of the early '70s, when the term "conceptual art" was new, literally *everything* seemed possible, and that very everything-ness was so wide open—coming as it did amidst the Southern California zeitgeist of alternatives in diet, spiritual practice, radio programming, architecture, sexuality—that the cool art-student response to this greatly expanded range of possibilities was, ironically, a blanket acceptance of whatever anyone came up with. Our primary mission as students was to impress each other, but we were not easy to impress. It was as though we had understood the moment as one in which, against so many possibilities, no one thing could stand out. When a music-composition student claimed that flying overhead in a plane was a *concert*, our reaction as a class was a collective shrug. Is that all there is? The only other imperative was to impress John, or at least make him laugh, which was easier.

The students in John's Post Studio class were an elite cadre, almost a revolutionary cell, and John was unusually accessible; it seemed as though he never went home. There was some reciprocity. John found at CalArts a ready, adoring audience, a willing workforce, an entourage, and an atmosphere of young people who (at least in their minds) got up in the morning and moved in a new way. A certain attitudinal

threshold had been crossed. A phrase that was in the air at the time caught it best: anything can be art/art can be anything. Accepting that precept meant that you had to be alert—you never knew where an idea was going to come from. As the name of the class had it, everything good happened *outside* the studio. In practice, this often meant finding ways to keep John amused on field trips to the endless bounty of kitsch that was Los Angeles. I'm sure John thought he was humoring us; we thought we were supplying him with *material*. One class found us at the LA farmers' market, where someone had the idea to buy a freshly plucked chicken and kick it around the stalls so that we could *document the process* before the grit-encrusted bird was deposited in a Dumpster next to a Kentucky Fried Chicken. You get the idea: irreverence veering off into smartass-ness with occasional glimmers of high surrealist poetry.

Leaving Painting Behind

What is *style* in art, and how do you get one? After the 1960s juggernaut of "painting tycoons," as critic Manny Farber memorably put it—by which he meant artists like Frank Stella, Ken Noland, Andy Warhol, and Roy Lichtenstein—younger artists weren't so keen on having a style in that instantly recognizable way; they just wanted to *do* things, to stay loose and close to their experience. Especially in Southern California, having a big-time signature style was the art-world equivalent of going corporate at a time when the counterculture was making its last stand. As Farber elaborated in his classic essay "White Elephant Art vs. Termite Art," style, for that kind of public artist, was like a little pillow to prop up the artist's signature, by which he meant ego. Even if it had been possible in 1970, nobody much wanted to emulate the big guys. The starting point for much of John's work in the early '70s was an attempt to sidestep questions of style—and taste—altogether. Too much macho swagger down that road,

too much older art weighing on every decision. However, art being art, one's sensibility can never really be *cast out*, and though John did manage to make images that seemed taste-neutral, he also arrived at a way to *touch* the image in a surprisingly delicate embrace, so that pictures of noses and palm trees, fingertips pointing at vegetables, crummy office chairs, and ordinary cars parked on meaningless streets started to take on a specific expressive cast. Had John continued to paint, he would have had to confront questions of taste—why paint in that particular manner, why paint that image, why choose anything at all? Ironically, by removing his own hand in the work, John managed to back his way into an aesthetic just as startling, poignant, and, seen from this remove, as glamorous as the look and feel of the New Wave of French cinema at the end of the '60s.

The End of Painting—Tragedy or Opportunity?

For all its occasionally willful obscurity, I think John's work speaks rather clearly to certain personal themes, and the central drama of his early work was the destruction of his paintings and his renunciation of the life of a painter. What John could accomplish in painting was simply not scratching the itch he must have felt—the desire to more completely inhabit his own work, which is the dream of every artist; the longing for completion that comes from uniting form and content, something accomplished by making one's own life and real preoccupations the material of one's art.

From the few paintings of the early and mid-'60s that survive, it seems that John could have had a perfectly viable career as a painter, Southern California, Ironic-Pop-Image Division. Some paintings, like *Bird #1* and *Truck*, both from 1962, and particularly *God Nose* from 1965, are still funny and offbeat and show a sensibility willing to sacrifice a lot of painting's pieties to deliver the joke. John's early paintings present the image pun in a clean, unfussy way; there is

nothing arty about the paint, nor do they feel rigid or didactic. They are impressive in their ability to get out of their own way—something that can still be said about John's work today. Then, all at once, the painting well ran dry. Completely. Decisively. In 1970, John took a large share of his paintings (a few were rescued by his sister) to a crematorium, where he had years' worth of work incinerated, and primly documented the process with photographs (the oven door, open and closed) along with an announcement in the local newspaper. Everyone who has ever painted knows the impulse to slash a canvas to bits, but cremation requires premeditation. It is possible to feel that this theatrical renunciation was the wry, prankish impulse of someone not completely serious. If there had been a fraternity of young artists, the Cremation Project might have been a stunt pulled on a drunken weekend at Zuma Beach. *"Hey, let's burn all the paintings!"* However, I don't think we can underestimate the trauma at the heart of that act of renunciation. Confronting the yawning abyss of failure (for what else is it except an admission that these works, which I had thought were *me*, are actually *not me*) must also have been exhilarating. One door closes and another opens. After this act of renunciation, John went about constructing a way of working using studio-produced as well as found photographs that would be as malleable and complex and ultimately as expressive as the phantom he had been unsuccessfully pursuing in his painting. The early photographic and video pieces, from the early to mid-'70s, are singularly expressive and high-level achievements, all the more so because their starting point, both in terms of subject matter and materiality, is so modest. It's worth noting that in 1971, the idea of assembling groups of photographs in linear compositions, with or without words, was hardly a sure bet as the stuff of big-time art. I think the uncharted territory that opened up when John burned his paintings (*OK, I'm not a painter. Now what?*) was redirected by an epiphany about what kinds of images could hold or create meaning. John often told his students that the singular most

important *visual artist* of the 1960s was neither Warhol nor Johns but rather Jean-Luc Godard. Not just the most important filmmaker—the most important visual artist. Having rejected painting, in a sense having been rejected by painting, John looked around for a guiding spirit and saw that the *syntactical visual poetry* of Godard's great '60s films, with their emphasis of montage over story and their existential way of presenting character, could have direct implications for his art. He hadn't spent all those years painting in an abandoned movie theater for nothing.

Why Was It So Important to Take the Artist Out of the Equation?

The rejection of everything that smacked of personal choice was very much in the air in the art of the late '60s, and can be seen in part as an extended reaction against the slack self-indulgences of the second and even a third generation of abstract expressionist painters. The triumph of ab-ex painting in the late '40s turned out to be short-lived; less than ten years later, it started to implode from a lack of intellectual rigor and by the ease with which it could be superficially imitated. It had become a style, and a crowded one at that. The change came rapidly. From 1958 (the year of Jasper Johns's first show at Castelli) to the late '60s, many roads artistic were headed in the direction of removing or at least minimizing the subjective as an organizing principal. This was happening not only in art but also in music and literature—the *nouvelle roman*, for example. To someone from Mars this might have seemed like a strange development; isn't the "personal" what artists *do*? Yes, but one can arrive there in a variety of ways. A lot of serious-minded people wanted to avoid the trap of self-expression, and the trivializing narcissism it implied. Any other decision-making process might qualify: chance operations, like throwing the I Ching; verifiable propositions, as in game theory, linguistics, irreducible geometries; or

in John's case, simply following a preexisting rule book and/or using someone else's hand to make the work. The first principle of John's art, starting with the photographic paintings of the mid- to late '60s, and on through the photographic and video works of the '70s, was to remove, as much as possible, his personal taste from the outcome.

The results, however, were slightly different. Even though John's work of the early '70s takes as its starting point a rigorous artlessness, John still could not, as indeed any real artist cannot, help but let the *personal in*; he could not help but infuse his overall photographic construct with a kind of reflected glamour, a kind of insouciance, even—which I think is in part the legacy of many hours spent in the dark watching movies, especially French movies of the mid-'60s, and especially the movies of Jean-Luc Godard. Whatever congruent intellectual concerns John found in Godard's work, such as the use of discontinuity and the misalignment of picture and word, as well as the elevation of montage as the driving force behind his narrative, the fact is Godard's camera spends a lot of time gazing at the faces of young people. And I think the source of the glamour in John's early photographic work resides, as it does in Godard's, in the fact that so many of the ostensible subjects are young people, people a little bit unformed, who are posing. We could say that the real subject of much of John's work from the period of the early to mid-'70s, before he began to make extensive use of found images, is youth itself. These works were made in a period in John's life when he was intensely involved in teaching, when CalArts was new and exciting, and when young people, students, still had the change-the-world optimism of the '60s counterculture. In those first years, John spent an inordinate amount of time with his students, some of whom were drafted into the work, on both sides of the camera. In many of John's early works, what we see is youth's embrace of the world in all its tentativeness and receptivity. Consciously or not, young people, not being fully formed, tend to impersonate certain recognizable types. It is perhaps the earli-

est, most long-standing form of appropriation; with a camera focused on them, young people tend to take on an aspect of *people in movies.* There is a doubleness to this impersonation; the actors in Godard's films, many of them untrained, were themselves often impersonating American movie stars of an earlier period. Some of Godard's actors weren't really playing characters so much as just being themselves-in-movies. I think it's possible that John, perhaps without even realizing it, on some level internalized Godard's use of nonactors and other regular people to create a semidocumentary urgency and naturalness in his work.

In those early years at CalArts, there emerged certain personalities in John's work that can be identified; we can even name names. Among the principal actors in John's *petite cinema* were a dark-haired beauty named Shelley (she was our undergrad Anna Karina); the sandy-haired, freckle-faced midwesterner Susan, whose countenance seems to harbor an ironic, wisecracking worldview; Ed, who is pure unbridled anarchy, another Marx brother; and Matt, who looks like a slacker Jacques Tati. All of these young people and more, myself included, appeared in John's many photographs, videotapes, and films. None were actors, but some of us started to take on a recognizable presence in John's work. It's only a small leap to say that John created a miniaturized, SoCal version of the Nouvelle Vague, his own repertory company of faces and attitudes. Only one year younger than Godard, John was always a New Wave baby.

Chapter 3, *In Which a Non-Style Becomes a Style and Vanquishes Loftier Styles*

I remember a party sometime around 1973, when John and Michael Asher were approached by a guy who was a pillar of the old-fashioned art world of Venice Beach, a maker of large, welded metal sculptures

who had a burgeoning career (important New York gallery) but by that time could feel, even in his drunken state, that he was on the wrong side of the stylistic slope. The guy's pretty wasted, and he comes sloshing up to John and Michael, drink in hand, a little belligerent, and says, reaching for menace, "Hey! Aren't you the guys that did away with the *object?*" It was like watching a dinosaur lumber to its final resting place.

A style can be judged successful if it influences the work of other artists; John's work in the '70s was almost immediately influential and has remained resonant several generations later. It provided a template for a way to put things together (images, ideas), with an eye toward discrete objects on the wall. The other kind of success, the one measured by the Internet art indexes and the public veneer of attention and general grooviness, has been much slower to arrive, but it, too, has found its way to John's studio door. What is it about the Baldessari style that has made it so successful, both as influence and commodity? For the first part, ask, "What is it that John's style has allowed other artists to do?" The answer is twofold. First, aesthetics (how it looks), followed by mechanics (how something is put together—composed), which in turn becomes integrated into the aesthetic but in a slightly different way. The hallmarks of John's style in the early and mid-'70s are (1) a cool, uninflected surface, (2) the use of irony as a distancing device that frames images and keeps appropriated sources at arm's length, and (3) malleability, the assumption that the parts of the whole can be recombined into different, equally interesting wholes (that is, the strategy for combining things is more important than the things combined), which leads to (4) the creation of a legible syntax, a readable *language* of images, or the feeling that a language exists even if it can't be precisely described. The first two qualities are about how the art looks, and the other two are about how it functions. The functional, or procedural, part has entered the collective consciousness of several

generations of artists, but the look of John's early photographic and video work has also made its way into the collective, public sensitivity to images generally.

At least three generations of artists have had themselves photographed doing dumb stuff in banal settings. This is largely John's fault.

What the aesthetic embedded in John's work accomplished was to give the everyday-Joe artist a way to embrace and lavish a little love on the everyday-Joe visual culture that is all around us, especially if one is stuck in the provinces and doesn't really have access to the ethos or the rationale of a more highbrow style. Part of John's legacy is the elevation of the generic and unheroic, the vernacular of everywhere and nowhere that began in the late '50s (well, actually with Dada) and continues to this day. John's work made a snapshot of a *thing*, of a *nothing*, really—a ball in the air, a guy in a T-shirt standing in a nowhere street, a Volvo, *whatever*—cool. Anything could be cool as long as you didn't try to exert too much influence over it. Cool is the art of not appearing to try too hard—or to care too much. That neutrality, feigned or otherwise, would come to embody a generation's wishful relationship to the trashy world that is our visual culture, like one long episode of the old *Route 66* TV show, which was about life as seen from a passing car. John's sophistication and knowingness conferred on the *right* mundane object or situation a powerful aura of *cool*. His reluctance to state the obvious, or in some cases the opposite, to state only the obvious, serves to maintain a polite respect for the viewer's intelligence—another facet of cool.

Drama Is the Enemy of Cool

In the 1970s the uninflected, unaltered thing-in-itself would always trump expressionism—i.e., something designed to have symbolic value. Do less. Stay cool. Being cool matters more to young people than just about anything else, up to a point. But it's common for

artists to want it both ways. Cool, but not so cool. Then cool again. A quantity of the work produced over the last thirty-five or so years, especially the work coming out of California but also, increasingly, out of Berlin, or London, or Istanbul, can be seen as a move to locate a sense of personal drama while working within the aesthetics of cool. In other words, having worked so hard to eliminate personal taste and subjectivity, the artist is then struck by the thought: How will they know it's me? Every successful style must have at least a touch of the heroic, at least a nod in that direction, and underneath the deliberately artless surface of John's work there lies the beating heart of a poet. Cool is also the quality of grace under pressure, and acceptance, and knowing oneself. Apart from its satirical, piety-skewering, mocking quality, John's work is often quite poignant—it speaks to the amazingly resilient *desire to make art*, which is to say, to forge unlikely connections between things, to access unexpected emotional currents, to make poetry, to make a new meaning or at least shake off the old one.

The development of John's work in the '70s is a powerful example of an artist turning *left* in order to go forward. If John resolved certain questions of aesthetics by sidestepping them entirely, the unlikely, strange, and often moving result required the creation in his work of a *persona*, a stand-in for the kind of artist John's work seems on the surface to deny. Implicit in John's work are these questions: Can this be enough? Will they know how sensitive I really am? Will they see the *real me* behind the blue skies and palm trees?

Karole Armitage in *The Elizabethan Phrasing of the Late Albert Ayler*, 1986.

KAROLE ARMITAGE AND THE
ART OF COLLABORATION

S taging a new ballet in a major opera house is not for the faint of heart. Much can go wrong. As Dennis Hopper once said about directing a film, "The clock is your enemy." The available rehearsal time is never even close to enough. There are schedules, the orchestra, the unions. Often there are injuries; the dancers are working at the outer edge of physical endurance; they are emotionally vulnerable as well—artists, in a word. Being a choreographer requires, in addition to talent, nerves of steel combined with extraordinary sensitivity; basic showmanship also helps, and what we call stage manners. Making a ballet in collaboration with other artists adds another layer of risk and difficulty, but also reward. Karole Armitage has spent the last thirty-five years making ballets—daring, luminous, and emotionally complex works in themselves—often in collaboration with other artists who are given responsibility for the décor or costumes, or both. The results: ballets that combine dancing with imagery in a way that had not been seen before. The stage picture was largely unprecedented; a new kind of beauty.

Karole's list of collaborators from the worlds of art, fashion, and architecture is impressive: designers Christian Lacroix, Peter Speliopoulos, Jean-Paul Gaultier; artists Brice Marden, Philip Taaffe, Donald

Baechler, Karen Kilimnik, and Jeff Koons; photographer Vera Lutter; Memphis architect Andrea Branzi; biologist Paul Ehrlich; film director James Ivory; lighting designer Clifton Taylor; costumer Alba Clemente. And that's not to mention the legion of composers with whom Karole has worked, commissioning original scores whenever possible. That distinguished chorus includes Thomas Adès, John Luther Adams, Rhys Chatham, and Lukas Ligeti, among many others.

There are two divergent precedents for this sort of thing: the *spectacle* approach embodied by Sergei Diaghilev, for whom the visual element may even have superseded the dancing in importance, and the cooler, more aleatory method practiced by Merce Cunningham, who famously gave his collaborators no direction at all, accepting the chance encounters that ensued with equanimity, even if that state of mind wasn't always shared by the audience. Karole's ballets fall somewhere in between these two goalposts, just as she herself is a product of both the classical tradition, having begun her career in the Balanchine-centric Geneva Ballet, and continued it as a dancer with the Cunningham Company in the late 1970s and early '80s. Karole's unique qualities were recognized early, and Merce created a number of roles for her, often as his partner. Her dancing with the company was distinguished by musicality, gravitas—a sense of inner life onstage, and her improbably long extensions.

I spoke with Karole, for whom I've designed something like a dozen ballets over the years, about her process of collaboration, and this is some of what she had to say.

"Each person has their craft, and a supreme knowledge of that craft which makes the work legible. That kind of *deep* craft—that specificity opens up the world to a bigger experience."

"Some artists work by juxtaposition, some by metaphor. They tend to all work in different ways, but each one enriches what the audience feels."

"You have to put all these things together with a light touch—they can't feel overdetermined."

Karole, like a lot of artists, happens to be an accomplished and imaginative cook, which helps to put this last comment in perspective:

"All these tastes, these spices, have to be blended in a very delicate way, so that all the flavors remain distinct, and you don't want to end up with something overly rich. It takes enormous generosity of spirit—it's not about one's own ego. It's about giving something wonderful to the audience."

My own collaboration with Karole was instinctive and associative. We trusted each other's aesthetic more or less completely. While listening to a ballet's score, we each called up images for the other to respond to, which in turn led to other images, and so on. "When I hear *this* part in the music, I see. . . ." There was a certain appetite for risk. We were guided by a desire for freshness and wit—it was part of what we wanted to see onstage. Our combined sensibility was one of juxtaposition, images in counterpoint to a given passage in the music and dance. The goal, the art part, the real work of it, was to make these intersections of dance and image *mean* something, but in a way that didn't necessarily yield to logical analysis. We wanted to complicate and deepen the emotional tone of the ballet without resorting to illustration.

Lighting is critical to dance—it tells the audience what to expect. For most of the ballets, I wanted the stage space to be theatrical—that is to say, volumetrically lit, the dancers occupying their own charged world, but still accessible. A certain feeling of anticipation in the lighting. Not arch, as Bob Wilson's stage pictures can sometimes be, but *specific*. It never bothered me that fashion was running in the other direction. Some of the juxtapositions we made onstage seemed to me to be unprecedented, and still do.

Once, years ago at the Opéra-Comique in Paris, at a performance of Karole's ballet, *Contempt*, I happened to be seated next to the distinguished film director Alain Resnais. It was a ballet I had designed, together with Jeff Koons, and the stage was strewn with images of great tenderness as well as pure absurdist humor: giant trash cans, an inflatable pig costume, a film of Jeff's Buster Keaton sculpture magically moving through a living room. Poetical, imagistic non sequiturs with virtuosic dancing; Bach, Mingus, and John Zorn. When it was over, Resnais turned to me and said, with his lovely accent on the second syllable, "Ka*role*—she gives the audience *a lot*. Oui?" Yes. Yes she does.

Julian Schnabel. *The Diving Bell and the Butterfly*, 2007.

THE CAMERA BLINKS

L ong before 1941, and the genius of *Citizen Kane*, Orson Welles
was experimenting with film techniques designed to heighten
audience awareness of the relationship between the teller of the tale
and the tale being told. It's a relationship that's fundamental to mov-
ies, and you can see Welles toying with it in 1938, in a little-known
precursor to *Citizen Kane* titled *Too Much Johnson*. In that unreleased
film, Welles made inventive use of a handheld camera in an attempt to
expose the phenomenological conundrum at the heart of moviemak-
ing: How do you make an audience aware of the artificiality of cine-
matic reality while keeping them emotionally connected to the story?

In the great leap that was *Kane*, Welles further explored using the
camera's intrinsically unstable point of view to heighten awareness
of a character's psychological state, creating an inner life onscreen
as fluid and complex as in literature. Along with cinematographer
Gregg Toland, Welles liberated the camera from a fixed point of view
and conveyed a sense of the world of thought and feeling. This was
done not just by photographing a scene from a character's point of
view but by making the camera a subjective player in its own right, at
times motivated by inchoate feeling or pure sensation. Surprisingly,
Welles's innovations were not taken up by Hollywood filmmakers
of the '40s. In a *New Yorker* article, Claudia Roth Pierpont noted

that even directors who worked with Toland, such as William Wyler, Howard Hawks, and George Cukor, had no interest in expanding on the terrain Welles opened up. Finally, beginning in the late '50s, auteur filmmakers like John Cassavetes and Martin Scorsese—and later, Paul Thomas Anderson—began making use of the full palette of visual possibilities Welles intuited. On a parallel track, a rich tradition of avant-garde filmmakers have treated movies as personal poetry more or less detached from conventional narrative. Underground film, as it was known, was arty by definition and seemed to have little relationship to its commercial counterpart, though a few vanguard Hollywood directors have borrowed its techniques. (John Schlesinger's film of 1969, *Midnight Cowboy*, comes to mind.)

It has taken many decades, and an American painter working in France, to fully deliver on the promise of Welles's experiments in subjective cinema. In his film of 2007, *The Diving Bell and the Butterfly*, Julian Schnabel successfully fuses an aesthetic descended from avant-garde filmmakers like Maya Deren, Stan Brakhage, Mikhail Kalatozov, and Andrei Tarkovsky with a satisfying emotional narrative. Structured as a series of encounters between a mute protagonist and his sympathetic (and beautiful) female interpreters, the film charts a man's progress through the last stage of his life, and, along the way, hurls itself fully into a liberated and subjective kind of moviemaking.

Strange as it may seem now, words like "subjectivity" and "sensibility" were deemed uncool in the art world of the mid- to late '70s; the artist was seen as a kind of philosophical worker, visual arts division, who took pains to leave few fingerprints. During that period, it was considered heresy for an artist to insist on the primacy of his or her subjectivity. One risked being called arbitrary, and who wants to be that? This began to change when Julian, along with other artists of a similar age, emerged at the end of the decade and sounded a big Bronx cheer for the pieties and anemia of a generation drifting out to sea on a leaky raft of conceptual precepts. Julian helped lead the charge by taking a hammer to a box of china in 1978, smashing plates

to create a ground for his paintings. Believe me, the blow of that hammer resounded loudly all along West Broadway. Those early plate paintings operated outside the permissions of the day, and they represented nerve and a willingness to stake everything on a spontaneous decision. These works, and the kabuki backdrop paintings that followed, were anchored in nothing other than Julian's sensibility, and that constituted an act of rebellion. The paintings were also about something; they celebrated holy fools and, in their subject matter and execution, presented images of suffering and redemption; they were as much about human frailty as they were about artistic reach. They contained a vein of raw vulnerability and tenderness that was sometimes obscured by their bravado and scale.

Adapting the memoir of Jean-Dominique Bauby, the editor of *French Elle* who suffered a massive stroke at the age of forty-three and became the paralyzed victim of "locked-in" syndrome, *The Diving Bell and the Butterfly* required Julian to bring his talents as an in-the-moment artist to bear on the creation of a cinematic equivalent for a myriad of sense impressions. Essentially, Julian made a visual representation of Bauby's consciousness as it observes itself being reconstituted. Early in the film Bauby's right eye is sewn shut, a turn of events that makes the one-to-one correspondence between the monocular vision of the camera, and that of the lead character, logically and dramatically appropriate. But the consciousness within the film expands to include all of us, and eventually achieves that rare thing: a cinematic metaphor for all human relationships, and for the delicacy, poignancy, and immediacy of consciousness itself.

Films about damaged people invariably include a scene in which the protagonist struggles to regain a lost capability—to walk, or speak, or write a sentence. These scenes, and these movies, seldom work. Apart from Arthur Penn's masterful 1962 film, *The Miracle Worker*, *The Diving Bell and the Butterfly* is the only film of this sort that made me feel that I was a participant in the hero's struggle. Henriette, the vibrantly alive speech therapist played with great humility by Marie-

Josée Croze, devises a way for Bauby to "speak"; the therapist recites the alphabet and Bauby blinks his one functioning eyelid when she utters the correct letter. Julian's patient camera allows us to participate in real time as Bauby and Henriette construct the words and phrases, one letter at a time, that reconnect him to the world and eventually allow him to compose his book. As his caregivers, along with Céline (the mother of his children, but not the love of his life), master this system of communication, we instinctively race ahead to link up the letters to spell his next word. It's a strange dialogue; Bauby's "voice" emerges from his interlocutors, and this transference is so absorbing, so suspenseful to watch, that I forgot I don't speak French.

As these language sessions progress, our experience of a person reconstructing his world using the most evanescent but resilient tools is exhilarating. The film matches this exhilaration with its extravagantly buoyant camerawork and freely associative editing. So readily does the viewer accept the idea that what we're seeing is what Bauby sees that, twenty minutes into the film, when we have our first view of Bauby from the "outside," we still remain somehow within his perceptual chain of command. Everything is his inside—even his outside. A sense that meaning has been snatched from the enveloping void—symbolized by the diving bell itself—pervades the film. But there's more. Making the moment-by-moment, fleeting nature of life coexist with the stubborn force of an erotic love at odds with the familial bond is the film's real achievement. Bauby is a kind of style arbiter, and the film charts the heartbreaking nature of a true aesthete's relationship to beauty with piercing specificity; Bauby's entire world becomes suffused with a poetic, perceptual sweetness expressed through the dispersal of light on film. (This bittersweet juxtaposition of poignant beauty with a narrative of tragic inevitability is also a theme in Julian's paintings.)

When I replay the film in my head, the image that keeps floating to the surface is that of Céline (Emmanuelle Seigner) gazing straight into the lens, the camera eye that is also Bauby's monocular point

of view. Blond bangs partially obscuring her immensely sad eyes, Seigner is side-lit in such a way that the highlights in her hair are blown out; she's crowned with a halo of light. The way the image is constructed—by slathering light on Seigner's blond head as if she were being painted—is characteristic of Julian's style as a filmmaker. Photography, moving or still, is a record of light; the great cinematographers are said to paint with light.

In Julian's plate paintings, broken shards of china are the carriers of the marks that reconstitute the sitters' likenesses. At their best, these works are neither decorative nor purely scenic; rather, they have the freshness of something coming into being as we observe it. It's a quality that speaks to the phenomenology of the seeing eye and the search for form. Julian reconstitutes Bauby's visual field not just through the correspondence between the camera and the character's monocular gaze but by using the materials of cinema as freely as he did his smashed plates. Commercial cinema is a recalcitrant medium. While a camera is capable of recording the immediacy of minute shifts of light on a wafting curtain, a movie set is a difficult environment in which to locate these sensations, and this makes Julian's achievement all the more remarkable.

As with other painters of his generation, Julian's aesthetic is rooted in a surprising juxtaposition of images, and the ability to see images and pure form as part of the same continuum. What set his work apart was his use of a fragmented, physically demanding surface that imbued his style of free association with a flickering, tentative quality, one that insisted on the materiality of painting. We can feel the same impulses at work in his film; *The Diving Bell* flickers, too, and the gorgeous light that makes Bauby's curtain glow is the artist's material. Subjective experience and narrative come together in the film's astringent and luscious gaze.

Malcolm Morley. *B25 Liberator Over Independence*, 2013.

OLD GUYS PAINTING

Painting is one of the few things in life for which youth holds no advantage. The diminutions wrought by aging—of muscle mass, stamina, hearing, mental agility (the list goes on)—are offset among painters by fearlessness, finely honed technique, and heightened resolve. A ticking clock focuses the mind. There's a recurring narrative about late style in painting: from Rembrandt to de Kooning to, in our own era, Agnes Martin and Cy Twombly, the trajectory of the long-lived painter in the final decade or two reaches toward a greater openness and a simplifying of form, along with efficiency of execution. Muscle memory is the last thing to go. In this reading, a painter's late work is characterized by letting go—the older painter needs to do less. This effortlessness is also embraced by young painters, but for a different reason: they're placing a bet on one idea and hoping it's enough. Anyway, young people are in a hurry—there's no time for psychological complexity. Conflict is left for the middle years.

Two shows in New York in the spring of 2015 illustrate the effect I'm talking about: Alex Katz (age eighty-eight) at Gavin Brown's Enterprise, and Malcolm Morley (eighty-four) at Sperone Westwater. Both artists had strong and invigorating exhibitions that refocused our sense of how their painting, and painting generally, can be extended.

To these shows I would add a third that happened to coincide: Georg Baselitz's *Orange Eaters* and *Drinkers* series, from the early 1980s, at Skarstedt. Can we do that? When he made these paintings Baselitz was barely into his forties—a *youth*. True, but some people are never really young. Baselitz strikes me as someone for whom the sunniness of youth held no savor. Maybe it was the war—gravitas settled heavy on him from an early age. The beginning of the '80s was an especially fruitful time for Baselitz, and the "Drinkers" and "Orange Eaters" are among the very best pictures of his robust career. There is a certitude and a clarity about them, the end point of a hard-won evolution, as well as a wiliness; it's remarkable they were made by anyone semi-young. I'm told that Baselitz thinks of himself as a young artist, his chronological age a mere technicality, and that he's surprised not to be included in shows of young painters. But to paraphrase Bob Dylan, he may be younger now, but he was so much older then.

All three shows had in common a concern with the way painting takes an image and makes out of it something iconic. How is an image built out of paint? What holds it together, and to what end? For Baselitz, the starting point is a gesture—someone raising a glass to his lips—and through repetition and intensely focused observation he makes of that gesture a piece of existence; the painting *holds* our seeing it. At first look, the image seems to exist merely to give the paint something to do; the space is flat, the figures barely volumetric. Baselitz paints the world upside down, like a human retina in reverse; his visual field is upended and projected, one mark at a time, onto the canvas. It's a demanding perceptual conversion, like walking backward through a crowd. The purpose of this self-imposed awkwardness has been to ensure that the visual translation natural to painting is made with maximum attention. Try it. You'll see how exhausting it is—exhausting to do, exciting to see.

For Katz, on the other hand, the iconic image begins with scanning a scene for interlocking patterns of light and shadow, as well

as overlapping objects that create scale and distance—an observed bite of reality, like a house glimpsed in some woods, say, its chimney and front door glowing pink in the sun, that forms the image in embryo. These are the ingredients from which a unity is sought and onto which it is imposed, like pieces of a puzzle that snap together. These pieces, the shapes, are given contours of such specificity as to create a sense of authenticity, of life. Sometimes the very improbability of his shapes guarantees their veracity; *it could only have been thus*. Painting at this level has a moral dimension: Katz's work is permeated with an awareness of *things as they are*. It's a matter of core identity. One doesn't just paint—one merges with painting. His six-decade career reminds me of James Boswell's view of Samuel Johnson (quoted by Andrew O'Hagan in a recent issue of the *New York Review of Books*), that Johnson was a "moral unity, a man who was never not knowingly himself."

Malcolm Morley begins with something semi-iconic—a model airplane, a toy boat, or a postcard—and finds in it, through a complex and stubborn act of mimesis at the end of a brush, the image that is the painting. He doesn't paint life per se. Rather, he crafts scenes assembled from models, mostly of his own making, and the paintings that result from this convoluted process are like a loopy costume party: everyone is masked; true identities are withheld. What we see is only the shmushy, malleable surface behind which the actual, sharp-focus world resides. And what with painting's central paradox—that there is no world behind the painting, any painting, only the painting itself—looking at a Morley can give you the sensation of being trapped in a painterly hall of mirrors. At times, it can feel a little airless.

These three painters also have diverse approaches to the question of how to treat an edge within a nominally realist enterprise. Edges in painting are like accents—you can place where someone's from by his or her diction. Baselitz, hewing close to the Northern European

graphic tradition that runs from Dürer to Max Beckmann, uses line, or more properly marks, to corral and lay out his subject. With a slashing brush loaded with black paint, he constructs a contour for the figure, not so much to define the form but as a way to fix it in space—*to get it down*, as closely as possible, to the generating moment of perception. In this regard, Baselitz inhabits the same stylistic and moral universe as Giacometti, whose incessant erasure and redrawing of the model is an obvious precursor. "Image capture" indeed—it's not only on your laptop. Painting the image upside down makes it impossible to work in any traditional figurative manner—that is, from the inside out, from bones to flesh. Baselitz applies color in the general vicinity of the form and then holds in the expanding area of color with an accumulation of black marks; the lines give the color a kind of exoskeleton.

Katz, on the other hand, eschews outlines altogether. The edge, the place where two shapes meet, is everything. The edge for Katz is like phrasing in ballet—it's the essence of his Astaire-like painterly grace. Color is thinly brushed out to the perimeter of a shape and left to stay there. In the same way that Baselitz started out with a style rooted in the past and bent it to his own historical position and temperament, Katz began with what is essentially the classical French tradition (forms described by areas of color; where the plane changes, so does the color) and brought to it the flatness, immediacy, and graphic enlargement of pop art. It's a good example of how a style or technique, once common but now attenuated, can be redirected—nearly a hundred years later, by a radically different historical imperative—into a completely new look. It's what used to be called tradition—a thing one understood and, if one was ambitious and lucky, built on. Probably no one in 1860 could have predicted that Manet's style, the simplifying of form into light and shadow, would be reborn as Katz's, but that's one way to think of it.

As for the edge in Morley's melty universe, it's all negotiable. In

1982 the artist painted *Cradle of Civilization with American Woman*, which remains a kind of ur-postmodern picture. I remember being struck by the painting when it was first shown at the old Xavier Fourcade Gallery uptown. A sienna-hued nude woman sunbathing on a crowded beach lies huge at the bottom of the picture plane—she looks to have been painted with the kind of wire brush used to clean barbecue grills—while crowds of people, swimmers red as tomatoes, cavort and collide in the surf. Superimposed onto this scene are a figure of vaguely Hellenistic appearance, encased in a cerulean-blue outline, and a black horse, minus rider, with a Trojan battle helmet floating over its back. The picture should come with a warning: don't try this at home.

Morley had been working for years to find a way to translate his fracturing, shattering, and disjunctive impulses into paint. In *Cradle* the transgressive id runs riot; the picture is a gas. It has neither outlines nor, strictly speaking, edges. It has instead Morley's exploding, dissolving, at times deliquescing sense of form; you feel that his forms are made from the inside out, that each figure or tuft of hair or ocean wave is the result of a micro-explosion of paint, a kind of paintball in reverse.

The probem with Katz's work, if it can be called a problem, is that so much flawless painting over so many decades has lulled his audience into thinking that they know everything there is to know about the old boy. People can relax into the knowledge that Katz isn't likely to break new ground at this point in his career. The steady stream of perfectly realized paintings calls to mind one of those graphs showing a dauntingly expanding series of prime numbers, each one uniquely itself but all related, stretching to infinity, or Charlie Parker at the Five Spot—so many perfectly struck notes played in rapid succession that it's hard to pick out the gems. But that's the audience's problem, not the artist's. And for Katz (unlike Parker), the story is far from over.

Most, if not all, of the paintings in Katz's show at Gavin Brown bring a jujitsu-like ingenuity to the familiar Katzian playing field. To see him work is like watching a seasoned master of the soccer field—the

green expanse is familiar, but in tonight's game he will introduce some new moves, some new inflection of the knee that will subtly change the game's dynamic. Maybe a goal will be scored from an improbably long distance—the accuracy, seemingly effortless and happening in an instant, bringing the crowd to its feet. True to the late-work notion, these paintings are exceedingly open, both in their conception of what is sufficient to make a painted image and in the way they're painted. The brushwork is loose and precise at the same time; some fairly complex shapes whose edges are cut out and into like so much cookie dough are laid down with an enormous brush using very few actual strokes. You wouldn't think such a tight corner could be taken in such a wide vehicle, but it seems to offer no resistance; the paint appears to know exactly where it needs to go, and goes there without argument. The color intervals as well as the value pattern of these new pictures have a level of sophistication not seen in New York for a long time, if ever. Some of the color has the elegance and unexpectedness of Italian fashion design: teal blue with brown and cream, emerald green with pale yellow and brown, black with blue and cream. You want to look at, wear, and eat them all at the same time. For all their looseness (and in one or two the paint is so thin it looks like it might slide off the canvas), the paintings are held together by a firm undergirding; a rigorously delineated map keeps the painting from flying off into formlessness. Katz's world is not all cream puffs and daisies; this understructure is made of hardened steel.

Slab City 2 (2013), titled after the unlikely name of the town in Maine where Katz has summered for nearly sixty years, revisits a familiar theme: a lone house by a road glimpsed through some woods. How is Katz able to make this image look so immediate? We have the sensation truly of coming upon it unexpectedly; it's a hushed little surprise, painting's secrets revealed. The picture is very tall; it puts our sight line somewhere improbably high up, so that we seem to be swooping in and down through the trees, floating over

the road to arrive just short of the cabin door, which glows pink in the late-afternoon light. The huge trees are interlocking fingers of green, a quartet of greens, creating three overlapping, directional weaves, each one pulsing energy out to the edges. And the crisp sliver of pink door—one brushstroke with an angled top—is the grace note amidst so much green. The painting, along with many others in the show, is so right, and executed with such controlled abandon, that I had the sensation of someone gaining traction on air.

This individuality, this uniqueness of shape or mark, is primarily *a form of attention*, and it carries with it an implicit worldview. Coming in contact with it makes you realize yet again that all the arguments against painting, which are determinist, economic, and political, have little to do with the practice of painting, and have in fact had little impact on it. Questions of dominance or irrelevancy, or of the market, are of a different nature from what is most vital about painting, which is found in the realm of specific attention paid to specific visual schema.

Morley, too, has been perfecting a very specific, highly personal, idiosyncratic way of putting paint on canvas for a very long time. Besides octogenarianism, Katz and Morley don't have much in common. Morley is mercurial and restless, experimental, literary, theoretical, and perverse. His work is squarely in the tradition of his countryman J. M. W. Turner, with its mists, tunneling light, images of combat, and outward spiraling squalls of paint, but it also has something in common with Arcimboldo and other mannerist eccentrics. He's a windmill tilter.

While Katz uses the largest possible brush for each form, only switching to smaller, pointed brushes (called "brights," a name I love) for details like eyelashes or buttonholes, Morley uses small-bore brushes for the whole goddamn painting. And whereas Katz uses the least number of brushstrokes to set the scene, once confiding that a lovely painting of a seagull in flight was made with "exactly 45 brushstrokes," Morley seems intent on seeing just how many densely

packed licks of the brush he can bundle into every square inch of canvas surface. It cannot be said of him, as Fairfield Porter once wrote about Roy Lichtenstein, that he "does not torture the paint." Morley tortures it good and plenty.

Morley's work is almost punishingly dense, demanding, uningratiating; he dares us to imagine the act of sustained concentration that goes into its making. Ship masts, airplane insignia, ocean waves, tiny flags, portraiture, battle, motion, and weather: Morley loads difficulty on top of still more difficulty; if there's a harder, more roundabout way to make a painting, Morley has yet to discover it.

At its best, all this *travail*, all this surface agitation achieved at such effort, combined with the warping, sheared-off, roller-coaster-on-the-descent kind of spatial feeling, results in pictures that win our admiration. A good example is *Dakota* (2015), in which a WWII-era bomber, a few freight-train cars on a track to nowhere, a modern-day tanker, a Viking ship, and a turreted brick castle tower all share a Permanent Green Light sky and a similarly hued sea, the waves of which are rendered as little chicken scratches of white or darker green. And in the bravura *The Island of the Day before Regained* (2013)—a depiction of two Messerschmitts going after an improbably candy-striped US Army bomber that looks about to crash into a man-o'-war ship of vaguely eighteenth-century appearance—the whole kind of I don't-give-a-fuck surface roils and boils with manufactured abandon.

One thing has changed. True to the cliché about older artists stripping away all unnecessary scaffolding, Morley has more or less deserted the grid that informed his work for decades in favor of a direct attack with the brush. The absence of the grid—the device by which the painting was broken down into small, manageable bits—has resulted in paintings even more fluid and disembodied than before. Unconventional to the core, Morley has the autodidact's surety of self, along with a frenetic, anxious, gleeful will to please. At eighty-four, he's like the boy who wants to be praised for blowing up his toys.

More than any other painter, Baselitz works like a boxer: he makes you lean in, but in the next instant keeps you at arm's length; get too close and you could take one on the chin. (Compare him to Anselm Kiefer, whose work yields no advantage when viewed up close. The effect of Kiefer's work is theatrical, akin to how images work on a proscenium stage; the best seat in the house is about row K.) Baselitz's surfaces are a balance between raw agitation and calculation, between perceptual rigor and design. The paint is applied with insistent, overlapping brushstrokes that might get around to defining an image but are mostly just themselves. There is in his work an internal sense of when to start and when to stop; when to introduce a new color, a bigger scale of mark; when to insist and when to leave off insisting; when to feint and when to jab. Whereas Katz's work is like being roughed up by a cloud, Baselitz aims to bruise. As a colorist, he has something in common with Brice Marden. His '80s work is an essay into the possibilities of yellow (yellow-orange, yellow-green, yellow-black), as well as green-black, turquoise, mint, mud, and, surprisingly, white. His color is visceral, sophisticated, and mostly free of referents. It's all art.

The show at Skarstedt, handpicked and deliberately assembled, was in large part composed of masterpieces. I was struck by what a sophisticated designer Baselitz is—something I hadn't noticed before. And there was something else in these paintings that Baselitz is not known for: wit. In *Drinker with Glass* (1981), a man seen in profile, one hand up to his cheek, is gingerly sipping from a cobalt blue martini glass that is about two feet tall. His red nose and the slightly alarmed look in his eye tell the whole story. It's a deeply poignant and funny and gorgeous picture. In *Orange Eater III* (1982), we see Baselitz the quirky designer. The orange eater of the title is wearing some kind of harlequin or argyle shirt. Aquamarine, turquoise, brickred, and white diamonds jostle together, floating free of their wearer, while alongside the picture's right edge a cascade of loosely crosshatched teal blue marks declares its autonomy: sometimes paint is just paint.

Marsden Hartley. *Granite by the Sea*, 1937.

Philip Guston. *Cabal*, 1977.

THE GRAPPLERS

Marsden Hartley, Philip Guston, and Clyfford Still

A ll were big men. Guston and Hartley were fully fleshed, meaty. Men of the earth, the sea. One looks at their wide faces and feels the heft of the man. Clyfford Still was a lean tree-trunk of a man, tall and upright with rectitude. All three painters carried forward the lineage of American painting, the one concerned with the physical, materiality of it—paint as creational clay, or fire. Painting joined to nature. They took painting head-on, a little brutally. There's a truculence in their attitude—why try to hide it? Wrestlers of paint. A painting is something grappled with, brought to ground. It's a Promethean effort. The artist prevails, but at a cost.

The effortfulness of their painting is meant to show; it has a purpose, which is originality. They paint with the loneliness that must be borne if one is to achieve uniqueness. Their story is one of independence achieved; the American character redeemed. They are part of the creation of a new aesthetic identity, from the trauma of its birthing to the triumph of its independence, and later, with Guston, its painful self-examination. They are different versions of an American type: the self-created individual of tamped-down grandiosity, artists before art was popular. As Sanford Schwartz once

wrote about Guston, "His painting says, 'Am I a genius, am I a fraud, I'm dying.'"

Their origins were various: the West; New England; small villages and also the cities. The built-up verticality of the metropolis in contrast with the open air, the horizon line and the sea—that was a part of their common story. They lived like frontiersmen—someone who expects little from society. Craggy-faced, cranky, man-mountains, stoical in their separateness even from others like them—each one a kind of lonely peak.

A jagged clot of paint made by a slashing palette knife; a heavy, worried black outline that lassoes its subject; an impacted thicket of wide, assertive brushstrokes, wet into wet, black paint defiantly dragged into red—these are the terms of engagement, alternately lyrical and militant, with which each artist defines himself. Guston and Hartley also wrestle with their own lofty self-images. Each one's style is a snapshot of the American character: rough-hewn, scratched from hard soil, or cut from stones. A glacial lake discovered after a long climb; a fire of mesquite wood, its fragrant trail of smoke rising through the night air.

Hartley's clouds, mountains, wharfs, roses, sailors—painted as if hacked from dirty marble or granite; Still's craggy cliff faces and promontories; Guston's blunt caricatures, the scrum and mush of outlines lost and found again—all externalizing an inner gloom. As in nature, disaster is always close to grandeur. Their painting is sturdy, durable—it rests on thick beams of wood, or of steel, a bulwark against the taste of the committee. In this way, it is romantic, adolescent. The story of the individual against the many. This is what is meant by existential painting.

Urs Fischer. *Dried*. 2012.

URS FISCHER

Waste Management

History bestows on every generation of artists a set of cultural imperatives that will be used to take its measure. How an individual artist reacts to these broad paradigm shifts—and whether or not someone chooses to even acknowledge them—gives evidence of "character." If the problem facing artists thirty years ago was how to stand in relation to popular culture while retaining some sense of art's autonomy, artists coming to maturity in the age of social media—some of whom seem uncomfortable with even the most basic notion of the artist as an individual "actor"—must express a point of view about the Internet and its ubiquity. Artists have always adapted to new technologies, from the introduction of oil paint in the fourteenth century to the availability of lightweight video cameras in the 1970s; they have embraced the possibilities of new mediums, as well as changes in art's distribution that followed in their wake. For those still making their bones, no one wants to be the guy standing on the corner in 1910, shouting "Get a horse!" at a passing motorcar.

Although nothing ever really goes away (somewhere people are still making cloisonné miniatures), and while the art world reserves some fondness for artists who, curmudgeonlike, turn their backs on the latest advances, conditions for making art do change. Young art-

ists today must confront, and figure out their relationship to, the endless flood and immateriality of digital imagery. For the first time in history, images have no fungible sense of authorship; pictures of every imaginable thing, person, event, are just so much visual weather. They don't call it the "cloud" for nothing. The age of global connectivity and Google search may have taken us to a place where art won't only look superficially different because it's made of different materials (as was intermittently the case over the last five hundred years) but will function differently as well. The meaning and significance of artists' individual identities—the cornerstone of how we think about art since the Renaissance—may submit to a broader notion of art's social utility. *Who's it for?* may surpass *What is it?* as a way of grasping the meaning of visual experience. What does this preamble have to do with Urs Fischer? He's an interesting example of *transition fluency*: in this case, the way an artist can use digital technology, which is both for and about the many, and still retain a working relationship to the idea of the solitary artist alone in his studio dreaming his solitary dreams.

Like much else in contemporary art, Fischer's work relies on the inversion principle: up is down, light is dark, and irony is sincerity. But he is no mere ironist. His expansive personality combines aspects of the engineer, camp counselor, social director, homespun philosopher, outsider artist, social critic, and activist provocateur. He is clearly ambitious vis-à-vis art history and carries himself with the swagger of someone swinging for the fences. He's simultaneously irreverent and deeply serious; that is to say, he thinks his own ideas are real, and here to stay. Fischer's self-confidence seems to never have suffered a dent; whatever else he is or is not, he's all in. And if a bet doesn't pay off, he has scads more ideas just waiting to be developed. All good artists are self-appointed, of course—no one asks them to change the world. Most people don't even know the world needed changing.

Initially I had doubts about Fischer. There's something of the gad-

fly about him, and his work can seem superficial at first glance; certain works come across as mere commentary, a gloss on a cultural condition, as opposed to a primary experience. Nothing wrong with this in particular, but work whose commentary-to-originality ratio is over a certain percentage is unlikely to last.

Fischer trained as a commercial photographer, and his work has an offhand exactitude that's easy to miss. Those who dismiss his silkscreen paintings as pure appropriation should look more closely; they are a successful synthesis of the presentational (*Look at this!*) and the pictorial, the formal aspects that bind together all of a picture's moving parts. A work like *Problem Painting*, from 2012, might appear to be nothing more than a bouquet of found images—lemon slices, bananas—but the commercial glaze of Fischer's imagery is painstakingly created in the studio. You might ask why that's a distinction that needs to be made, and it's a fair question. Fischer photographs prosaic objects—nails, cigarette butts, and the like—so as to maximize their ordinariness; these pictures leave you feeling oversaturated by the familiar. Jeff Koons hovers over these paintings (as does Warhol), but Fischer doesn't achieve anything like Koons's sophisticated space or poetical image-syntax, nor is he trying to. His juxtapositions have the blunt force of political cartoons, and it's possible to imagine him in another life as an effective propagandist. You might wonder why or how this could become a good thing, but there's something compelling about Fischer's stance. His work says, "Don't just take my word for it! Look at all this dreck! Isn't it beautiful?" He can toy with the polished, hyperfinished surface that is characteristic of Koons's work, but he can also recruit hundreds of volunteers to make something rough-hewn and provisional; his work is democratic and technocratic at the same time.

Fischer's work is rooted in two visual strategies in wide usage: collage and the gigantic enlargement. Much of his work is built on the rudest possible yoking together of the digital detritus media culture

throws off every day—and he uses the insubstantiality of images that live primarily on screens as the raw material for his art. With Fischer the mash-up is literally *mashed-up*, and his work vibrates with the relentless churn of popular culture. As a grown-up child of the digital age, he uses the computer as a primary drawing tool, and, like today's youth, what he sees of the world is what's pictured on the Web; what he knows, everyone else also knows. But to the Web's undifferentiated sea of images, Fischer brings a kind of attention that is dense and purposeful; what he selects feels thought-out. What he's seeking is the hidden codes of similarity and difference that lie underneath the semipublic modes of depiction in contemporary Internet culture, and when you approach his image-strewn work with that idea in mind, the very act of culling images from the Web's cornucopia starts to feel like a heroic act of waste supply management. Fischer's gleeful way of using of images, so many copies of the copy, starts to expand in the mind like a paper flower when it hits the water. It's what makes Fischer's work feel of this time; comfortably at home in the digital age, he somehow stands apart from it.

An idea prevalent in the Renaissance, as well as the early twentieth century, before American formalism effected its various purges, was that an artist should be able to solve any design problem that affected human life, to elevate our everyday experience in the world. Fischer takes that brief seriously. Good artists are often the offspring of two seemingly irreconcilable forces; he is that rare thing—an iconoclast with good taste. I've never been to the product design lab at Stanford, the famous *D-Lab*, but I like to imagine it as something akin to Fischer's studio—a kind of specialized ad agency crossed with a machine shop, tattoo parlor, computer imaging lab, and resistance cell. (Unlike Stanford, Fischer's studio, should you be lucky enough to drop in at the right time, produces daily a delicious organic lunch served family-style.)

Something about Fischer's persona fuses the modern and the very

old, even the prehistoric; he's like someone who hasn't yet learned what other people think is good. He works in a variety of materials and processes, some highly refined, others deliberately crude. Not everything is high tech. Collapsing the precultural into a Dadaist gesture, his clay sculptures have a Venus-of-Willendorf charm, while the silk-screen paintings are post–Pictures Generation appropriations at their most aggressive and corrosive. This is visual culture at its most bland, meaningless, and seductive, presented with precision and control. Good art, even if you don't especially like it, works like an eclipse; it blots out everything around it, so that you see only what it wants you to.

Earlier in his career Fischer created a spectacle by excavating the floor of Gavin Brown's West Village Gallery. It was meant to be "negative sculpture," but it looked to me an awful lot like a big hole in the floor. The literal deconstruction struck me as too tautological to achieve any kind of metaphoric lift. A few years later, Fischer staged the same piece at the Brant Foundation, in Greenwich, Connecticut; there, adjacent to the emerald expanse of a polo field, the floor of an elegant stone barn was removed down to bare earth, revealing gas pipes to nowhere and crippled rebar. What made the second iteration convincing was its deep-down integration with the building's structure. In addition to the excavated floor, Fischer created in another room of the Foundation a kind of Second Life representation of his patron's artifacts, like the tomb of a Chinese nobleman sent to the afterlife accompanied by all the accouterments of his worldly status. In this case, paintings substituted for a terra-cotta army.

For this architectural doppelganger, Fischer photographed the library in Brant's home (which sits just across the road from the foundation in almost unimaginable splendor) and, using digitally produced wallpaper, re-created the room in every minute detail, down to the spines of art books shelved in alphabetical order. Positioned in the center of the room was a life-sized wax effigy of Brant, a modern-day

Medici, a burning wick nestled in his hair. The simulacrum library, the silk-screened dust paintings on the floor above, and the excavated dirt on the main floor combined to make an unexpected reconceptualization of three-dimensional space. One floor poured through another "like sands through the hourglass," as the introduction to my grandmother's favorite soap opera would have it. The wax effigy of Brant slowly melted and sculptural energy seemed to pour through the building from the ceiling through the floor below, all the way down to the exposed earth. It was a stunning effect, and perhaps an unrepeatable one.

In a literal as well as metaphoric sense, Fischer is the embodiment of Manny Farber's "termite artist"; he keeps his gaze focused on the middle distance while making sculpture that tears through space like a buzz saw or tornado. Because of their scale, Fischer's excavated foundations are evocative of sites of antiquity from Canyon de Chelly to the Roman Forum to the ancient Lebanese port of Byblos; they remind us of what's come before, of civilization's continuity, and the ways that built structures have been sculpted out of the earth. Take a moment to immerse yourself in them, and you may get the soaring feeling that comes from gazing at a cathedral arch or a rosette window. What does a relational artist do? He exposes foundations—structures by which cultural artifacts take on meaning. Fischer goes about the exposing with a Swiss thoroughness and literal-mindedness. He operates in a zone somewhere between camp irony and earnest science.

Fischer's 2013 exhibition at the Museum of Contemporary Art in Los Angeles included a recent work, *Horse/Bed*, a striking example of modern technology at the service of pure, anarchic image. A more or less life-size, finely detailed horse carved from solid stainless steel stood, complete with bridle and blinkers, in an otherwise empty room, reassuringly oblivious to the scene around him. More than eight feet tall to the tips of his ears, the horse wore an expression of equine

forbearance, an air of ennobling grandeur. This workhorse, stoically doing its job, was obviously a stand-in for the artist himself and made me want to cheer him on. Perhaps this is what art has been missing in recent years—a recognizable protagonist, someone to root for who's not from the world of cartoons. But in art, as in dreams, a horse is never just a horse, and this one is horizontally bisected at roughly a 30-degree angle by an enormous hospital bed, also rendered in exacting stainless steel. That's right—you could never have guessed it. The bed is seen coming apart as if reentering the atmosphere après-orbit, and its various parts—the cranked up, V-shaped mattress and side rails, the headboard, the tray table—all float free and slice into the uncomplaining horse with varying degrees of penetration. The sheer chutzpah of the juxtaposition is startling, hilarious, and ultimately melancholic. It's a breathtaking example of equipoise where by rights none should exist. On the surface of it, the piece is accessible and immediate without leaning on popular culture, and that is an accomplishment in itself. Taking off from the spatial conundrum of the removal works, *Horse/Bed* is a deeper mediation on the continuum of space and time. It asks, "Why are these things here and not somewhere else? Why are we whole, and not broken into pieces?" The horse doesn't know the answer.

With all this visual pizzazz, all these charming ideas, why then did Fischer's MoCA retrospective leave me feeling a little less boosterish than I had wished? The show left me to think about the difference between intention and realization—a difference that has more or less collapsed in today's art world. Since the dissolution of the formalist hegemony at the end of the '60s, there has been little or no agreement about which forms and expressions have significance. What is the difference between a *form-giver* and an appropriationist? Can one take the place of the other? Instead of "significant form," the term used to judge sculpture fifty or sixty years ago, we have the "sign." The trouble with trying to judge art today is just that: too many reputations are

based on a fluency in the reading of cultural signs, something that gives people the feeling of being in on the game. In a world where clicking off the signifiers trumps any other response, one person's hokum is another's profundity. "Bad" or kitschy taste can have a positive value in art, helping to propel an artist's work past the moment's available permissions, but it can also be boring. After spending time with Fischer's sprawling exhibition at MoCA, I started to notice some chinks in his armor. Without the force of his personal charisma to boost its often mundane visual affect, the work can look like just so much cultural detritus, uninflected, and impersonal. And without the strict curatorial control exerted by a Peter Brant, the work's sprawl takes up a lot of real estate. Fischer is vulnerable to the bloating—to which some of our most ambitious artists have been prone. He is not a "form-giver" in any traditional sense, but then neither is Koons. Both work with the "form" of culture itself, a slippery enterprise if there ever was one. But this is a larger problem, for which no one artist can be held accountable. The rub with relational aesthetics is its starting premise: that all things, all *values*, are relational; ergo, something only means what you can get someone else to agree to. What happens when that agreement is withdrawn?

Jack Goldstein. *A Glass of Milk*, 1972.

JACK GOLDSTEIN

Clinging to the Life Raft

Jack Goldstein is the kind of artist who thinks he has to be the prickliest cactus in the desert. He's like the guy who doesn't want to be a member of any club that would have him. His work is fueled by a sense of alienation that, when he gets the form right, breaks through to a lonely beauty. It's like walking through dried leaves on a chilly fall day—you keep your hands in your pockets, kicking leaves into the gutter, all the while hoping someone will see and feel sorry for you. The self-consciousness of the act doesn't necessarily diminish its poetry.

In 1970, Jack was among the hundred or so aspirants (myself included) who arrived in Los Angeles for the opening of the California Institute of the Arts, an incubator for much of the experimental art that would proliferate in the coming decades. Jack was older; he came as a graduate student already fluent in the restrained, tautological vocabulary of postminimal sculpture: one early work consisted of a tall stack of large sheets of white paper, with one corner of the top sheet turned back. A work's form was determined by an "operation." He emerged from the forge that was John Baldessari's Post Studio class with a chip on his shoulder as well as the idea that an artist had to be book smart. His work is tense, anxious, and often

formally striking. It strives to turn rigor into glamour—it wants to overpower, but his best things achieve their effects with deliberately modest means. An artist is often the last to know what his or her real strengths are; doing and knowing what one has done are two different things. Which of us really knows what we've made? Where is the point from which one can achieve that objective viewpoint? Although authentic in its own way, Goldstein's work is in part a cautionary tale about the monomania that's part of being an artist. In Jack's case that meant adopting the stringencies and restrictions of conceptualism, which may or may not have been a good fit, and without doubt accentuated his tragic self-image. Of course, conceptual art can't be blamed for Jack going off the rails. It's something you see in all walks of life: a series of choices brings out something in a person. It's what art is supposed to do, after all—sometimes the cost is high.

At school, Jack was a teaching assistant for a class on performance art that I took when that form was still considered avant-garde. A very cool cat, good-looking in a '70s way—I never saw Jack without a leather jacket or a cigarette. He was capable of a withering disregard; certain things mattered, others didn't. We became good friends, especially after I came to New York, where he had already planted his flag. The late '70s were very lean years in the art world—the audience for new art was small, mostly other artists and few of those. I brought Jack up to teach at the University of Hartford, where I'd landed the year before. We commuted to Hartford in Jack's car, AM radio, no spare in the trunk. To save money he bunked with a couple of our prize students, sleeping on their couch two nights a week. He clung to teaching like a life raft, and the students adored him.

As *Jack Goldstein X 10,000*, an exhibition at the Jewish Museum in 2013, made clear, his radical achievements came in the form of records pressed from a sound effects library, and a dozen or so 16 mm short films, each one recording a single action or idea. Some of these still have the power to stun—they're like facts that can't be argued

with. Seen today, the films are powerfully redolent of their time and ethos. There's an edgy, almost abrasive quality; they're declarative rather than ruminative. My favorite is a black-and-white film, shot from a single camera angle, of a glass of milk positioned in the middle of a card table. A man's arm, hand clenched into a fist, reaches in from the right edge of the frame and repeatedly bangs on the table, each time making the glass jump a little closer to the edge and leaving a spill of white on the black tabletop. The film ends when the glass falls over from the blow's impact, the remaining liquid puddling on the table before it slops over the edge. The work tightly compresses means and ends, image and abstraction, into a taut absurdity. Its bleakness and casual violence are typical of much of Jack's work; the emotional content feels squeezed out of an eyedropper.

Eventually the films ran aground as Jack drifted away from his roots as a sculptor. He became enamored with the idea of pure image; we were all wrestling with this idea in one way or another. For Jack's films, this meant special effects, animation, large lab bills. Some of the later color films would be perfect as something glimpsed on a cell phone—a tiny hit of artful animation—but they don't go much deeper. In the early '80s, feeling left out of the burgeoning art market, Jack turned to painting to expand his audience, though he never had any real feel for the medium. The paintings, which were all made by assistants, are illustrational in the worst way, without any inner life. But in the rush to get them to market, no one seemed to notice; the paintings featured charged images like bombing runs, extreme weather, and the like, and were celebrated by a certain critical faction for their lifelessness. Their *distance*, as Jack would have it. Though just as inert as when they were made, in recent years they seem to have been rediscovered as chic décor.

Before his decline, Jack could be wonderful company, with an ironic sense of humor. He lived in the edges, the extremes. The cliché would have it that he gave all he had to his work, when it might be

more accurate to say that apart from the work, there wasn't much in this life that he could claim as his own. It is true that he sacrificed a great deal—eventually even his health, as he feared the ideas would not come without drugs, and amphetamine isn't good for the skin. He was a man who had somehow failed to be "made" by his experiences—he was only "un-made" by them, the residue of disappointments and half-digested philosophical crushes. After a while he could no longer sustain his studio.

In the '90s, he returned to California, living in a trailer near his mother's house in San Bernardino. The story that had started with a leather jacket and a Porsche ran out like a trickle of water in the desert. The sense of failure, and the torment of trying to stay clean, must have been unendurable. In 2003, Jack's mother found him hanging from a tree. He was fifty-seven. He called me a few months before it happened—we hadn't talked in years. He sounded groggy and far away; he wanted me to know he thought I wasn't a phony. I didn't realize it was a good-bye call. The next part of the story is also a familiar one: since his death, Jack has been lionized by a new generation of young artists who see in his rigid and strained sensibility a yearning for something clean and pure, which today's sluice of money makes all the more urgent.

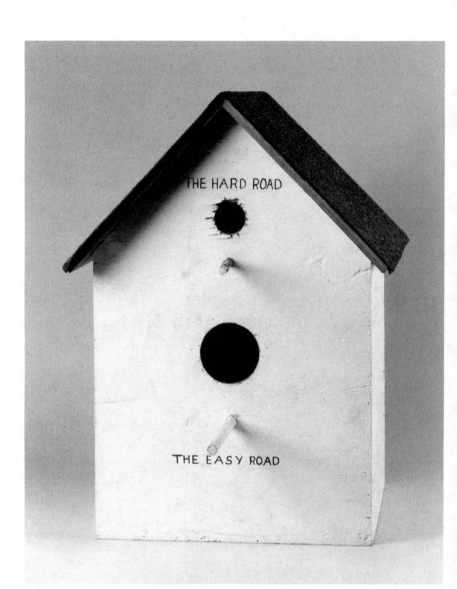

Mike Kelley. *Catholic Birdhouse*, 1978.

SAD CLOWN

The Art of Mike Kelley

It's hard to love an artist whose primary emotional register is shame. Despite this, or perhaps because of it, Mike Kelley managed during his lifetime to attract a big-top full of cultish, fervent partisans that included disaffected intellectuals and Park Avenue matrons; the lecturers joined hands with the lectured to. He was loved protectively, the way one loves a brilliant but unsocialized child, which is fitting, considering that the central theme of his art is the emotional brutality and false cheer of American adolescence; childhood as merely the introduction to a larger con. It seemed odd at times that people could be so drawn to art with such a bottomless reservoir of schadenfreude and humiliation in all its guises—of bad feeling in general. Such is the power of a strong, charismatic artist who taps into a desire for change; he bends the audience to the contours of his own rants. Whatever reservations I might have had about Kelley's relentless insistence on humiliation as subject matter were silenced when he took his own life in 2012. Suicide is the real arbiter—its finality can't be trumped; it makes the survivors seem small, which was, perhaps, the point. Seeing his expansive retrospective, organized by the Stedelijk Museum the year after his death, deepened and enlarged my estimation of his work. I had followed Kelley's New York gallery shows over the years,

and had always valued his acidity, but hadn't really grasped the enormous range and formal inventiveness, as well as the visual specificity, of his work. Kelley is a difficult artist to get hold of piecemeal, but when confronted by his thirty-plus-year achievement, in all its facets and manifestations, he comes through unmistakably as a major artist, and his work is perhaps the saddest I know.

Like a bomb programmed to detonate, Kelley's personality intersected the forces that were radically transforming art culture at the end of the '70s. He grew up in Detroit, that tutorial of harsh feeling, and his early life was like a checklist for "artist most likely to make a rumpus": lower-middle-class upbringing; Catholic altar boy, with all that entails; played in a punk rock band; went to art school, where he acquired just enough traditional skill to be dangerous; kicked around for a while as a have-not in the Detroit backwaters; then, in the late '70s, went off to that incubator of rabid, ferocious criticality, California Institute of the Arts. His timing was perfect. Kelley came of age as an artist just as the idea of "performance" became a standard-issue part of the artist's toolbox, alongside the paintbrushes and the camera. Its usefulness, and ubiquity, had to do with the objectification of style achieved through parody, pretending, ventriloquism, and acting out. It's not an accident that this movement toward cultural parody expressed through narrative coincided with the rise of rough-hewn sketch comedy of the *Saturday Night Live* kind, and its many antecedents and offshoots. Requiring more nerve than skill, performance took hold as a formal idea, an organizing principle reminiscent of the way action painting captured the imagination of anyone going to art school in the late '50s. Performance answered a lot of questions young artists were asking themselves in the '70s, principally: How do you externalize emotion without descending into sentimentality?

One "did" a performance using any kind of found or constructed prop, along with one's own body, voice, and image. One "directed" others, created "roles," made costumes, etc.—very much like poor

theater. But the fact that it *wasn't* theater lent the work a protective cloak; the point was not to create realistic illusion, as on a stage, but to forge a relationship between personal histories, weird rituals, a love of dopey props, and myth. By the end of the '90s thousands of young artists were doing performances in art schools, alternative spaces, and museums, and for the most part, the performances rose or fell on the ability to organize space and time with coherence and charisma, the very thing that makes you want to watch someone. Most young artists were unable to muster the skills required, but Kelley was one of the very few who could. He had a gift for creating a character that externalized a wide range of feeling, from remorse to rage—essentially the work of a very dark comic. A lot of the *rightness* of the early performance pieces that were preserved on videotape stems from the brilliant use of handmade, as well as found, props. The specifically tailored hats and megaphones, tables, charts, and banners, the fool costumes, all brilliantly deployed in a charged space, show that from early in his career Kelley was a master of postminimal sculpture. If he had stopped there, he could have been the legitimate heir to a lineage that included early Keith Sonnier, Bruce Nauman, Kurt Schwitters, Eva Hesse, and Joan Jonas. Kelley had much bigger ambitions, though—I think he wanted to take on the whole modern world. But the intimacy of the early performances, their direct access to haunting feelings, their improvised, amateurish quality, and their fragility remained touchstones in his work even as it began to bloat with the huge influx of money and influence that came his way at the end of the '90s.

The found plush toys and handmade afghans from the early '90s are Kelley's best-known works, and they are a collector's dream. They give you a way to love kitsch and to hate it at the same time. The series culminates in the silly, upsetting, and beautiful *Half a Man*, an orgy of stuffed animals, sock monkeys, toys, blankets, Styrofoam balls, yarn, Raggedy Ann dolls, tassels, knitted hats, and tea cozies that Kelley

worked on from 1987 through 1993. You can imagine all this junk in his grandmother's house in Detroit; grow up with stuff like this and, if you're sensitive, the shame gets baked in. Later on, when you go out into the big world and acquire some visual sophistication, you learn to reject these talismans of middle-class bathos. For Kelley, becoming an artist had the reverse effect; it allowed him to give all these kitschy treasures pride of place. Kitsch, of course, can mean lots of different things depending on who's doing the collecting, on what the artist's relationship is to in the first place. Some artists use kitsch to allow the audience to laugh at themselves—or laugh at someone. In Kelley's work, any laughter is bound to be short-lived. Many artists of his generation have made childhood a central tenet of their work, enshrining its artifacts for our bemused and indulgent backward look. In Kelley's career-long dissection of the corrosive American adolescence, there is no love, no redemption, and you can never take back anything you said.

Frank Stella. *Jill*, 1959.

FRANK STELLA
AT THE WHITNEY

The dance critic Arlene Croce once referred to the composer John Cage as a crack-pot American inventor, and that mostly affectionate phrase came to mind walking through the leviathan 2015 Frank Stella retrospective at the Whitney Museum. No other artist more completely embodied the expansive optimism, as well as the complexities and contradictions, of our American pragmatism in the second half of the twentieth century. Seeing the breadth and diversity of Stella's relentless pictorial invention, an inventiveness that often risks nonsense, or kitsch, even silliness, is exhilarating but also unsettling; it's the story of someone marching to his own beat come hell or high water.

Nearly sixty years ago, while still a Princeton undergraduate, Stella fused an inclination for intellectual rigor with a hunger for paint—paint as material and efficient, manual process. Not long on technique, Stella instinctively understood something fundamental about painting: that it is made by covering a flat surface with paint, and anything else is not in the job description. If a painting could be executed with a kind of internal integrity, the *image*—i.e., the meaning—would take care of itself. Between the painter and the painting there is only a brush. In Stella's case, that meant a four-inch housepainter's tool used

to lay down brush-width bands of pigment, the paint signifying only itself. He went at it with a great deal of will. The paint was enamel, the color black.

The point was to get the paint onto the canvas, directly and without fuss. The painted bands were aligned with the rectilinear edge, or were given a simple course to follow: a V shape, or a T, or a diamond. Nothing else intruded on the painting's singular purpose, which was simply to hold the wall. Out of those slender, stubborn means emerged one of the great inventions of twentieth-century painting. In reproduction, the pinstripe paintings resemble men's suiting, but being in the same room with them tends to nullify any wish for *more*. The metaphysical is now. The paintings' literalness is the source of their freedom. As the artist himself memorably put it, "What you see is what you see." When first shown, as part of MoMA's seminal 1959 exhibition "16 Americans," they were considered by the second-generation abstract expressionist painters to signal the end of art. If Stella's black paintings were right, everything they were doing—all the drips and splatters and nervous brushwork—was wrong. He was twenty-three, at the start of one of the longest runs in history. The next thirty years were more or less dominated by Stella's restless formal imagination and aggressive styling. He had his first MoMA retrospective in 1970, at age thirty-three; a second one followed in 1989. Together they formed the story of Genesis told in paint: after first stripping down painting to its essentials, the creator then populated the world with every manner of flora and fauna. When the work finally reached a cul-de-sac of its own making, sometime before the beginning of the new century, it was like seeing a great champion of the ring, a little wobbly of knee, finally hit the canvas. But for decades, Stella consistently rode the style curve's outer edge; he led, the audience followed.

In the glory years, the early to late 1960s, Stella's work is surpassingly brilliant of mind and visually so expansive, confident, and

new as to be almost overwhelming. The irregular shaped paintings of 1966–67, and the gigantic protractor paintings that followed, with their bands of Day-Glo color tracing twenty-foot arcs, have not dated at all; their clearheadedness and sense of vitality connect us to what was best and most optimistic about the time of their making. Refusing all cant, they are extroverted yet eccentric; they still look improbable and wholly original. Simply put, Stella made abstraction that could compete with pop art.

In the 1970s and '80s, Stella developed an increasingly complex project of pushing painting into literal three-dimensional space, building pictorial reliefs from all manner of rigid materials: aluminum, honeycomb steel, fiberglass, anything that could be cut, bolted, etched. His paintings became high-tech versions of that nineteenth-century staple, the artist's letter rack—a genre perfected by the Americans Harnett and Peto (which was later parodied by Roy Lichtenstein in his pictures of that name). The letter-rack trope is a device that allows the painter to bring things from the outside world and "hang" them on the painting. With an armature of steel that could support the most eccentric, computer-generated shapes, Stella introduced the French curve and all its arabesquelike derivatives into his vocabulary. Color was applied either as hard-edged, form-describing computer graphics or as their opposite: loopy gestural marks. Stella was essentially *exploding* painting, then reconstituting it as an industrial, Space Age product. Although of opposite temperament in most ways, it would be interesting to see Stella's late reliefs next to some of Jeff Koons's industrial fabrications; both are products of a high-tech imaging capacity unique to our time.

The series titles are a roll call of Stella's interests and sources of inspiration: *Exotic Birds, Polish Village, Race Track, The Whiteness of the Whale.* In the face of such far-ranging diversity, how to isolate the artist's principal achievements? There are two main qualities that set the work apart from that of his contemporaries. What Stella actually

did was to free painting from drawing once and for all. While not the first to do so—Malevich, along with the whole constructivist movement and, most importantly, Mondrian are clear precedents—Stella was the first presumed heir to the New York school whose work did not evolve from drawing. Even Mark Rothko, a painter of iconic, reductive abstraction, began as a surrealist doodler. De Kooning, of course, offered the next generation a lesson in drawing with the brush, a practice *he* inherited from Picasso, and Toulouse-Lautrec before him. It was how paintings were made: draw to find the form, then translate that idea to paint. Stella went straight to painting, aligning his intention with the physical object itself, and in so doing cleared the way for minimalism and its restraints. But Stella didn't linger in minimal-town for long. He was too restless, not enough of a Calvinist. Never the enforcer type, Stella would instead address himself to the more expansive, as well as quixotic, project of fusing constructivism with the multilayered tradition of the baroque.

His other main contribution to the history of modern painting was to look to the East. Beginning with the *Protractor Series* in the late 1960s, this quintessentially Western, rational, stubbornly unmystical painter injected a kind of neo-orientalist rhythm into abstraction's music. In art history, "orientalism" connotes not Asian art but rather that of the Middle East, of Persia and Syria, of Babylonia. If minimalism was in pursuit of the rectilinear, Stella's art made an avatar of the arabesque.

Stella has always been one of the most intelligent and articulate artists. He is a trenchant and free-thinking essayist; I wish he would devote more time to it. I attended two of the Norton Lectures he delivered at Harvard in the '80s, and I found him to be an impassioned lecturer. The topic was space in painting, what it is, why it matters—Stella's great all-encompassing theme, and also his white whale. His trajectory as a form-giver has the dramatic arc of a morality play. Starting at the end of the 1950s with paintings that

insisted on their flatness, refusing any interpretive reading-in on the part of the viewer, Stella was, by the end of the 1970s, producing three-dimensional wall reliefs, often of a breathtaking spatial complexity, the component parts of which were stamped, cast, cut, and extruded from aluminum, magnesium, fiberglass—anything to project the painting into the viewer's space. In the '80s and '90s these experiments in projection grew until some of the jagged, bristling, just-landed-meteor-looking cast aluminum works ate whole rooms. Stella cantilevered his constructions so that the paintings levitate into space itself, a dramatic achievement to be sure, but one that can never be completely satisfactory. *Things* have boundaries—discrete works can never eat quite *enough* space, and so must keep getting bigger and bigger to express their theme to *become* space.

Writing in 1959, the year of Stella's first public exposure, the great critic and painter Fairfield Porter had this to say about the emergent sensibility: "The new American painting stands by itself, and one remembers it on its own terms. Art is measured by an interior intensity. Somewhere along the line . . . attention has been paid to something whose importance to the artist is a measure of its reality to him. The painting compels the imagination of the spectator as it compelled the painter's."

That's the transformational grammar of art at work: though born of an inner necessity, art is not a private language. The paintings have to convince us of the importance of their trajectory. At a certain point, it became hard to identify with whatever it was that Stella found compelling; the paintings failed to convince on their own terms. The paintings from the late '80s and the '90s, festooned with glitter and gestural, candy-colored paint applied to aggressively three-dimensional constructions, today have an aspect of strained good cheer. Without the cover of institutional rigor, that is to say, once the paintings move from the museum to the developer's lobby, their extreme extroversion slides into a kind of solipsistic baroque. The paintings of the last ten

or fifteen years can still occasionally command our attention, even awe, but more often than not they leave us with a feeling of a lot of energy being expended to no particular end, of being more trouble than they're worth. I'm sure they mean something compelling to Stella himself, but they no longer make me care about what it might be. I can manufacture a reason and a logic for their appearance, but I don't feel it as a necessity just from looking at them. As I walked through the exhibition a second and then a third time, after what felt like miles of pure retinal engagement, the overwhelming realization could no longer be held at bay: this is decorative painting. Even when the work is outwardly structurally complicated (and some are doozies of complication), there doesn't seem to be a deeper sense of structure—a structure of meaning—that generates the eccentric forms. Eccentricity for its own sake always ends up being decorative. It might seem a strange pairing, but Stella's closest philosophical kin is not so much Malevich as art nouveau, his closest stylistic relative the Grand Kabuki.

Yet all this emphasis on the literal, on painting's physicality, the denial of illusionism and theatricality as sources of painting's allure— in a way it's merely the official version. Stella's titles tell a different story. *The Whiteness of the Whale, Raft of the Medusa, Eskimo Curlew, Gran Cairo*: for all the rigorous pictorial logic, Stella is also a windmill tilter and whale hunter.

PROVINCIALISM WITHOUT A CAPITAL

The Art of Thomas Houseago

Style reflects character. It's the aggregate of choices one has made, consciously or not, regarding art that came before.

I remember an episode of *The Sopranos* that goes something like this. Mobster John's life sentence just got a lot shorter: we see him in the prison hospital as he learns he has late-stage cancer. Tough break. The hospital orderly, also a lifer (played with touching eagerness by director Sydney Pollack), was an oncologist on the outside. The unlikeliness of the two men occupying the same room is heavy in the air. Patient and orderly start talking. Holding a mop in one hand, the doc looks at Mobster John's chart and offers a second, more hopeful opinion. The conversation turns to what the doctor is in for. "I shot my wife's lover," he says matter-of-factly. "Shot her, too, and then a couple of other people." Mobster John's incredulous: "That was stupid—why did you shoot the others? If you'd just shot the boyfriend, you might have got off with aggravated manslaughter—maybe do eight years, get out on parole. Now you're fucked." "Well," says the former doctor, "once I shot him, I couldn't leave a witness, so I shot her, too. And then these two guys rush into the room—this was at the Plaza—and I figured I was *already so far in*, my only chance was

to just keep on going. So I took out the two security guys. Now I'm in here." Thomas Houseago's work reminds me of that scene.

When the stylistic hegemony of midcentury formalism, with its idea of progress and Hegelian inevitability, started to deflate and finally collapsed sometime in the mid-1970s, the art world was like Palmyra after the collateral damage. Modernism's long reign was also a kind of de facto repression; its core mechanism was exclusion. This but not that; get rid of all unnecessary frou-frou. But unnecessary to whom? Formalism was a more successful Maginot Line against the chaos of subjectivity. When it crumbled, no one wanted to be left behind to defend it. And art, like nature, does indeed abhor a vacuum; all sorts of things rushed in to fill the gap left by high modernism's receding tide. Art that would have looked comfortably at home in one of the lesser national pavilions at Venice in, say, 1954 or 1964 or even 1970, places that foster art with humanistic, sick-soul-of-man-type imagery; painting and sculpture meant to reflect man's existential condition; or art styled into a shamanistic, avatar brutalism—all this and more was let in through the front gate. Provincialism—art that looks to the metropole, adding its own local dialect to the available permissions—has always been part of the ecology. (Sometimes it turns out to be great.) Provincialism is the mechanism by which a dominant style is disseminated; it's also how an economic influence is maintained, almost like a form of taxation, a tax on the mind. Amidst today's postformalist, Internet leveling, there is no meaningful distinction between client state and capital. And though the imagery and stylistic vocabulary of the provinces, cut off from their models, now feel arbitrary, they can go, in fact are welcomed, everywhere.

Houseago is a British sculptor who makes skullish, masklike forms from the palest cream-colored plaster. Their surfaces are seductive, semismooth or roughed up, and pleasingly matte; they resemble Jean-Michel Frank's lamp bases of the 1930s. Houseago's forms—thickly delineated skulls and lumpy, 3-D renderings of heads—

reach for an archaeological, even mythological realm. Borrowing from Greek sculpture—heavy ropes of modeling clay as hair, eyes as hollowed-out sockets—these mask-heads have a severe, glum aspect. Their glowering countenance might scare a small child.

Houseago has a few tools to convince us of his seriousness; the principal one is size. If something is dull or camp at three or five feet, one can try blowing it up to sixteen feet, or repeating it in a sequence stretching over an even larger area, or both. Scaling up a form comes with problems of its own. Sculptors since the Renaissance have had to deal with the greatly enlarged model: Venetian horses, Roman emperors, etc. It's not as easy as it looks.

Masks (Pentagon), installed at Rockefeller Center, is made up of five enormous, outlined skull shapes that touch at their edges to form an empty space in the center. The skulls become increasingly "abstracted" as they move around the perimeter; the last one is an intersection of jagged linear shapes. Like a modern-day plaster Stonehenge, the grove of heads asks to be decoded—ask your local Druid—but to what end would be hard to say. The ensemble, modeled as it was out of clay and cardboard, might have had a certain artisanal charm at tabletop scale: the stepped-back wafer construction used to build up a certain thickness of the skull; the lumpy ropes of clay heaped upon the heavy brow; the tweaked bit of clay that forms a mobile nose, flattened to one side; the little raised clay line laid underneath the nose to create a tight-lipped mouth—one of the heads is a regular Rocky Marciano of clay. But the appeal evaporates in the lumbering enlargement, and the scale still can't compete with the cavernous architecture. With Houseago's art, we get to the punch line before he finishes telling the joke; the audience is way out in front.

Houseago's other idea is to show us how an image can be deconstructed along cubist principles: reduce the thing to a few jagged lines, make them intersect, and boom—you've got a jazzy abstract head to add to the fun. It's an idea that was already ripe for parody

in 1982 when Roy Lichtenstein made sport of Theo van Doesburg's abstracted cows.

The problem is that the *image-base,* the imaginative foundation on which Houseago's images are built, feels borrowed, generic. Most things in art are derived from a chain of influence; the question is what's behind the borrowing. Image-wise, the heads have an aura of the archaeological kitsch found in video games and cartoons; you feel that Houseago wants to say something about the way such images reach back across time to connect us with their original meaning. Fragments of armor, helmets, bared teeth and torsos—the forms are meant to look heroic, like something excavated at Knossos, but their ponderous theatricality is not that of the ancients; it feels trumped up. Houseago's sculptures lack a persuasive personality; it's like someone yelling too loudly because they're afraid of not being heard. Houseago's art wants to look like something that made itself, but it doesn't have that kind of abandon; the work is uncomfortably lashed to the artist's self-regard. The heroic authenticity of antiquity, the mute awe and dust of ages long past, is just what I don't find myself thinking about with his grove of heads.

In *The Medusa and Other Heads*, a concurrent show at Gagosian Gallery, *Algol Head, 2015*, sits on its rough-hewn yet too elaborate base in such a way as to expose another problem. Instead of engineering the form to stand upright from a single anchor point, Houseago places triangular wooden shims under the plaster mask at three points along its curved edge to get it to stand upright. The little wooden shims are just distracting. The wooden pedestal itself is made up of a sequence of triangular forms for no apparent reason other than that its bulging waistline sort of echoes Brancusi, or Native American totem poles. Houseago's work, with its heroic scale and existential themes, its repetition and insistence on its own humanistic exceptionalism, mostly just wears me out.

Frederic Tuten

The Art of Appropriation

—an introduction to a marathon reading of
The Adventures of Mao on the Long March
at the Jane Hotel, December 4, 2011

When I was very small, perhaps five or six years old, I saw on the black and white television in the living room of our house an episode of Ted Mack's *Original Amateur Hour*. On this particular evening, a young woman came on stage and sang a wonderful song called "I'm Gonna Wash That Man Right Outta My Hair." Everything about her performance was a powerful lesson in charm.

The stage was bare except for a plain wooden stool. The dark-haired young woman came out from behind the curtain carrying a towel and a washbasin full of water. Smiling radiantly at the audience, already winning my affection, she placed the basin on the stool in a casual manner, draped the towel over a rung, and then gazed meaningfully at the audience, her eyebrows drawn together for a tiny moment before the orchestra cued her song. She was dressed in a pair of dark slacks and what looked like a white bra. Her shirt was somewhere else. Perhaps one reason I remember her performance was the incongruous costume; a woman appearing on national television on a Sunday evening as if she were alone in her own house. I sensed something special about this woman who was, in a very nonchalant

way, practically in her underwear—something that allowed me to watch her without feeling like I was spying on her, and yet still have a little of that feeling. Of course, a woman removes her blouse before washing her hair.

I remember being impressed by what was, to me, the striking originality of the song and the way it was staged. Throughout the song, the young woman was washing her hair—not just miming but, actually washing it in the basin of water. I just couldn't believe how witty we had become! To my child's mind, this congruence of singing and hair-washing was a stroke of theatrical brilliance—it was "representation" of an order I had not imagined before. The washing finished, the woman took the towel from the stool and dried her hair with it, just as she would do in her own home, finally wrapping the towel around her head to make a turban the way women did in ads I had seen in magazines. And through it all she sang, her lovely dark-edged mouth enunciating every syllable. Reaching the last chorus, she gave the audience a warm look, arms outstretched, the way young women do when their hair is wrapped in a towel and they are singing and smiling, because they know they are at that moment adorable.

It was all so wonderful, ingenious really; the song's lyrics were clever and wise and the song's melody was so bright and stirring. It was a rueful song about her trouble with a man, and her desire to be rid of his troubling influence. I couldn't believe that someone as talented and original, someone who had conceived this theatrical scene that had pierced my young heart had not yet been "discovered," that this person was still performing on amateur variety shows waiting for her big break.

The thing was, I had no idea that her song came from the popular Broadway show, *South Pacific*. I was, after all, just a small child in the Midwest; I didn't know there were things called "shows" and had never heard or seen one. Certainly I had never heard the words, "South Pacific," or the names, Rodgers and Hammerstein, or the names of any

other Broadway composers or lyricists. I thought the young woman had written the song herself, that it reflected her own problems in the love department; and that she had, by herself, devised the very winning bit of stage business used to convey the world of the song. I was certain she would win that week's prize from the Ted Mack people. I'm not sure, but I think this has something to do with appropriation.

More than fifty years later, this theme has come into sharper focus. There is a certain history. David Markson, in one of his late anti-novels—erudite, deeply sad works (comprised largely of notes from his voluminous reading)—relates that even James Joyce was "quite content to go down to posterity as a scissors and paste man." Without really meaning to, I seem to have made a career out of it myself, and if nothing else, have succeeded in irritating a lot of people. The late Veronica Geng, another writer who practiced the art of literary ventriloquism at a sublime level, related what a critic once told her about me: "His work is like a car with the engine taken out, but it runs anyway."

But where would art be without contradiction? It might seem odd coming from me, but I still believe the things that really matter are invention and originality—originality of spirit. Not all appropriationists are created equal, and as is the case with any technique or medium, the spirit of the maker comes through in the work, sometimes in mysterious ways. Taste—thought to be too trivial a word but perhaps the right one anyway—is like a filament of genetic imprint. It binds with other bits of coded matter to find a way to express itself. An artist is always making art; the art will out. The act of choosing in and of itself, in the right hands, can be art enough.

Through art's alchemical power to transform, the appropriated models in Frederic Tuten's classic 1971 scissors-and-paste novel are shaped by his sense of personal exuberance and historical tragedy. This is no small achievement. One needn't look far to find appropriationist art that is dour, withholding, one-note. Frederic's work, by

contrast, is buoyant, and on the side of life; it revels in life's unruliness and contradictions.

Tuten's writing is a *re-reading* that combines repositioned and repurposed elements with images and scenes fashioned from whole cloth. Complex and multifaceted, finely attuned to the rhythms of speech, Tuten's book is a fractured travelogue, a dispatch from the front, and a love story. *Mao* has the high modernist brio of Tuten's literary heroes, combined with a linguistic style that's distinctly of his time: direct, unsentimental, but also parodistic, absurdist, and, at times, romantic.

The Adventures of Mao . . . celebrates neither the death of the novel nor the irrelevance of the author; it's a high-spirited invigoration of both. Like pop art, Frederic's work starts out from a state of *liking things*, and writing is a way to share that enthusiasm with others. *Mao* is the most generous of books, and among other things, it's Frederic's way of presenting us with some of the authors who have mesmerized him, as well as a meditation on some of the historic events that have appalled him.

The aesthetic rationale for using appropriation, as distinct from a political one (though it may come to the same thing), is to insert a tiny wedge between the name and the named, to search out a crack in the wall built of habit and certainty, and work into that small fissure a measure of existential rebellion. Who has not, at times, felt constrained by the habits of mind that surface in the act of representation? We could all use some more space to move around in. Change the context, and meaning is made anew. Even if you repaint, or reprint, something as close as possible to its model, you will end up making a new thing.

The appropriationist must define art's new context with a high level of specificity. And intent. In one of the book's key scenes, a Western journalist arrives at the rebel camp to interview Mao, and the two men discuss everything from Marxist/Leninist theory to the films

of Jean-Luc Godard. The interview, entirely made up, is convincing enough to have fooled Diana Vreeland, then the editor of *Vogue*, where Frederic was moonlighting as a movie critic. Well, OK—maybe *Vogue* in those years was not known for its investigated stories filed from across the globe, but no matter. Vreeland was so taken with the veracity of Fred's account that she telegraphed—that's what people did back then—her congratulations to Fred on being the first American journalist to secure an interview with the Chinese leader.

Some readers have asked the question of just how much of this book is sourced and how much of it is new—as if an optimal ratio could be found. I think this is beside the point. The appropriate question is: "Have you ever read a book like *Mao* before?" Its bracing originality is apparent from the first page to the last. The wonderful conceit central to the novel—that we are observing firsthand the progress of Mao's Red Army, is delicious, as is the language with which this feint is conjured. Frederic's ear for diction is sly and acute; the specific language used to build his sentences is pungent and vivid. To which a skeptic might say, "But those words are Fenimore Cooper's or Walter Pater's," to which I would reply, "Yes, but they're Frederic's, too. The car runs anyway."

In one of the book's memorable mash-ups, we find Greta Garbo arriving at Mao's camp in a tank. Then, after a fireside chat, Garbo offers herself to the great man in his tent. Frederic gives Mao the implausible but fascinating conflict of not being particularly attracted to Garbo—he prefers Jean Harlow! The following thought flickers through Mao's mind: "The woman is clearly mad. Yet she is beautiful and the tank seems to work."

PART III

ART IN THE WORLD

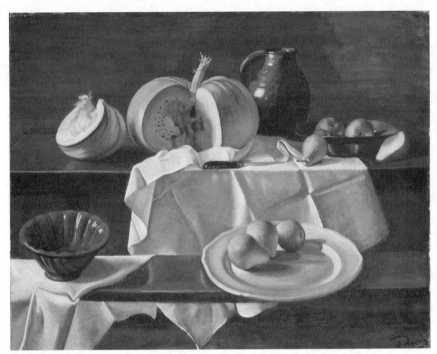

André Derain. *Still Life with Pumpkin (La Citrouille)*, 1939.

ANDRÉ DERAIN AND
COURBET'S PALETTE

Art history—what does it mean for a painter? Most painting is a conversation between continuity and novelty. The latter will get you attention, which can be habit forming. Some people seem to think that continuity, or tradition, is a narrowing down—what's left over after the innovators have moved on. But in practice, it's an enlargement of the painter's sphere; a reweaving of the web of connections. It's what most painters feel as their work evolves. Continuity is the dialogue a painter carries on with himself in the guise of his precursors. You push off from your forebears only to find yourself merged with them in the end. An example of what I mean is André Derain, an artist who was present at the birthing, so to speak, of the modernist movement—but who found it uncongenial to his nature.

As a former enfant terrible myself, I find Derain's story especially interesting. I've been taken with his painting for a long time now, both for how it looks and what it stands for in the convoluted story of twentieth century art. I've never seen an entire show of his; it's rare to see even a single picture in an American museum painted after his fauve period. In European museums, in France, you can occasionally see one or two of his neoclassical still-life paintings from the '20s, but it's hard to get a sense of his achievement as a whole. There are books, of course. The photographs one sees present a French type: the

overfed provincial—he could be the *patron* of a restaurant, or a rare-book dealer, or maybe a prosperous farmer. Wearing a beret, a cigarette between his plump fingers, he regards the camera coolly. Other photos give a different side. One from 1925 shows Derain dressed for a ball as Louis XIV; with his wig and garters he looks corpulent, decadent. And there is the famous Balthus painting of Derain standing in his studio—a large man in a dressing gown, a slightly dyspeptic expression on his face, his young daughter seated at his side. It's hard to square these images of him with the young man who, in 1906, painted the urgent and lyrical view of the Thames, *Blackfriars*, one of the defining images of painting's liberation made in that time.

He came from a good family, was well educated—an aesthete. Fernande Olivier, Picasso's mistress at the time, records in her memoir that Derain was the most cultivated, witty, and urbane of the painters and poets in Picasso's circle. Tall and thin in his youth, he had a formal manner and was always elegantly turned out, a *boulevardier*. By the late '20s, he ballooned into the lumbering, old-before-his-time-looking guy with small eyes and an unsmiling mouth that we know from pictures. But what a rich and complex inner life! Derain consistently and rigorously interrogated painting, in all its complexity, as a form of recovered cultural memory.

In the first decade of the new century, Derain divorced color from the conventional idea of naturalism, relying instead on a combination of emotional intuition and the almost scientific recording of chroma as sensation, as wave phenomenon—*color* as *light*. The browns, grays, and amber-whites of the previous century were washed clean, to be replaced by pinks, yellows, emerald greens—colors that still feel fresh today. His paintings of that time have a lot of air in them—he opened up the space between colors, between brushstrokes, giving the eye room to reset; the paintings *breathe*. Along with Matisse, Derain defined what it meant to be a modern colorist; the art press of the day thanked them with the sobriquet "fauve"—wild beast. It must have felt glorious to be so *opposed*, and so untethered to what

had come before. How many get to have that feeling? In those early years, 1904–8, Derain's work enjoyed pride of place alongside that of his pals Matisse and Picasso, and the rest of the troublemakers, Vlaminck, Maurice Denis, et al. Something, however, did not rest easily in his psyche. The headlong rush toward the new sensation in painting, standing, as it were, in the bow of the boat, feeling the intoxicating, stinging salt spray on his face—the freedom of it, the weightlessness—must in some way have gone against his nature. We can imagine a feeling of inauthenticity souring Derain's appetite for controversy. At heart, Derain was a classicist in form as well as content—it was a matter of temperament. By today's lights, his later work looks conservative, romantic, and not part of the main story. But whose story is this so-called main one? By whose lights is the winner in that race called? Derain is an example of an artist with the courage to go his own way. Though a sociable man, he was not a joiner. As early as 1910, poet and critic Andre Salmon worried that Derain "was on the margin of modern art." Even then, there was an anxiety—on the part of others—over inclusion. Maybe it was in part the legacy of cubism, with its dour palette and analytic turn of mind, but by the early teens, the feeling of fresh air goes out of Derain's painting, and it is in this moment that his work becomes interesting.

Derain's pictures from the early teens, when he was in his thirties, are made with such restraint and controlled pressure, with so many conscious allusions to art of the past, they're like a rebuke to the free-spirited, spontaneous-looking pictures of his youth. He became a painter of *heaviness*: his bowls of pears have *weight*; even his table-cloths have a stubborn solidity. In the paintings of kitchen utensils and fruit nestled on farmhouse tables, the forms feel *wrought*; every object seems carved from stone or plaster, or made at the blacksmith's forge, and the backgrounds look scraped, excavated; the light comes from one side, full of drama, the way it does in Italian painting, and the background tones are often amber or dark brown—it's as if he's painting inside of a cave. The work is so *unmodern* looking; he could

be in a huddle with the Old Masters. In fact, Derain was in a conscious dialogue with a great many influences, from Byzantine, medieval, and Gothic art on through centuries of European painting, to the art of India, Java, and Cambodia. Throughout this rotating wheel of often religious references, the artist Derain most closely resembles, especially in his still-life paintings, is early Cézanne, who also sought to imbed a religious impulse within paintings of striking awkwardness and anxiety. Having followed, along with his fellow modernists, Cézanne's example forward into cubism and other forms of deconstruction, Derain circled back to the early Cézanne en route to something even more remote. Derain's paintings don't exactly look like Piero's, or El Greco's or Gauguin's, to name three diverse points on his aesthetic map, but you can feel those artists nodding approval at the atmosphere in them: his pictures give a palpable sense of the way forms in painting, much like a secret handshake, can be transmitted across time.

Why do I like him so much? In Zurich, on a little side street off the main avenue that runs along the lake, you will find a good art-book store. I used to go there whenever I was in the city; it's a pleasure to wander for a time, looking at the new titles. On one visit I happened on the catalog of a large Derain show that had been staged at the Pompidou. My Swiss dealer, Bruno Bischofberger, a man of great erudition and original taste, was almost offended, challenging me as we left the store to name *one thing* that Derain did after 1912 that could be considered of the first rank. It's a commonly held opinion. Derain's postfauvist paintings, not only the still lifes but also his portraits and classically posed nudes, resonate for me in a way that's hard to account for. I doubt very many painters share my enthusiasm. In fact, I would be surprised if younger artists have anything more than a shadowy image of who he was and what he did.

Derain's story is part of a debate about aesthetic revolution and counterrevolution that's still going on. He's the kind of independent spirit that the official avant-garde has little use for. His work after

1910 is barely mentioned, and, at least in America, his work after the 1920s has been more or less written out of the official story, having no contribution to make in the relentless and seemingly inevitable march toward abstraction and the triumph of the New York school. That version obviously leaves a lot out, but even in his own time, Derain was something of a spoiler. After the blaze of radical innovation in the first years of the twentieth century, Derain turned his back on modernism forever. He went so far as to burn all the fauvist pictures still in his possession. That's commitment—the rebel turned reactionary, the refusenik.

What Derain turned to is that body of shared intents, the great laying on of hands, that is the history of painting. A braid woven from many strands, a river with many tributaries, an ancient tree with branches too numerous to count: use whatever metaphor you like, the history of painting is large and complex and fashioned from interconnected stories, all of which, for a painter, are contemporaneous. Derain's work responds to various pictorial traditions as a *rhythm of echoes*, a great lyrical song of the inner life brought to the surface; his paintings have a lot to say about the way older styles can be made to rhyme with present-day concerns. Derain's story interests me, in part, because he exposes the "narrow and cracked determinism," to borrow a phrase from Joan Didion, of contemporary art history, the more or less complete failure of that history to take into account what it actually feels like to make something, the *why* of it—why someone would want to go to the trouble—as well the special feeling of looking at it. Like determinism in any walk of life, aesthetic as well as political, the wish to have it a certain way is at odds with what people are really like. Derain's painting still hasn't been recognized as the new synthesis that it represents.

Artists routinely go backward and forward into art history; its supposed linearity is of little consequence in the studio. Often an artist looks back in order to move forward, tunneling termitelike, to use Manny Farber's unforgettable formulation, toward something the

existence of which can only be intuited. You know it when you see it, if you're lucky and paying attention. The famous story of Picasso spotted by another artist on the steps of the Louvre: "What are you doing here?" To which the Master replied, "Going shopping."

The steady stream of still-life paintings that Derain began around 1910 and continued to the end of his life shows him reaching for the kind of heavy, obdurate physicality found in quattrocento paintings and frescoes. You can feel the long chain of influence: Gothic and Romanesque painting; El Greco and the Spanish baroque; Piero and the early Renaissance, as well as the later varieties, Perugino especially—all serve as models of sobriety, dignity, even spirituality. Over Derain's long career, the echoes of still other painters can be felt in turn: Poussin, Corot, Van Gogh. His color stayed changed. The brilliantly hued fauvist color and the efficient, choppy, open brushwork with which it was applied gave way to a palette of darker earth tones, grays, burgundies, grayed blues, ochers, and dirty whites taking the place of pink and yellow. He took the palette of Courbet's portraits from seventy years earlier (an alliance Picasso would also effect in the 1930s and '40s). And his brushwork became subdued, even circumspect; tones were blended, contrasts muted—painting with a high degree of *finish*, in the manner of the nineteenth century and earlier. What Derain seems to have been doing by casting his subjects in a neoclassical style was to remove painting from the hurlyburly of current events; he wanted to project a more timeless image of the artist.

Although his conversion started well before he was called up—for a second time, at the age of thirty-five—it's tempting to blame the war. When he returned to Paris in 1919 after four years in the trenches, it must have been easy to reject modernity in general—look at what it had wrought. In fact, a major realignment of cultural life was under way in every sphere, and by the early '20s Derain was celebrated as the standard-bearer for neoclassicism's dream of stability, exactly what later generations of art historians would dismiss him for.

We're taught to think of modernism, of art history in general, as a story of progress and up-to-date-ness, a developmental stream that seems logical, even inevitable. But some of the most interesting painting exists in the margins, apart from the official story. In addition to Derain and Picasso, Francis Picabia, Giorgio de Chirico, and René Magritte, and also Kasmir Malevich, to name just a few, reached back not just to art history but also to mythology, dramaturgy, and antiquity in order to find a form that more deeply expressed the complexity of ideas and their lives. It's a question of temperament and talent, and also of context, rather than linear progress. This period in art history—the time between the First World War and the rise of surrealism—is often seen as a retreat from modernism's precepts, a regression brought about by the trauma of war and a failure of nerve in the political sphere.

Aesthetically, this is a very unproductive, not to mention tone-deaf, reading. Whatever its origins, I think what Derain achieved in his neoclassicist painting was to foreground the constructed, theatrical nature of pictorial representation, and to claim for himself a link on the great chain of painterly being. It's what all painters want, one way or another. Derain sought to combine the classical with the anecdotal, to squeeze the one into the other, almost with his bare hands. He painted everyday life, the view out the window, the people around him, but with one eye on his forebears; with a sense of compression and narrativity one gets from bringing an updated version of the past into the present.

His paintings, from the teens onward, have a *wrought* quality; the white tablecloths are like plaster-soaked rags twisted between his hands. He *wrestled* with form, and he lets the wrestling show. His forms seem hacked from larger solids as if with a machete; shapes are contorted, and their edges left ragged. His subject matter—all the classical genres: still life, portraits, landscape, nudes—can produce a surprising narrative tone. He somehow makes a painting of a tree feel wistful, nostalgic. There are some paintings from the late '30s and

'40s—like the startling self-portrait of the artist at his easel, brushes in hand, contemplating a still life of pears, while his anxious-looking family hovers in the background—that are so romantically cockeyed you don't know whether to feel sad for the sallow-faced people or laugh at Derain's overblown self-image.

In addition to the roll call of European artists already commingling in the firmament, the artist who strikes me as Derain's closest stylistic relative is the American Marsden Hartley. Comparing a Derain landscape like *L'eglise a vers* with any number of Hartley paintings of Maine or New Mexico, you can feel a shared DNA. Hartley was another large, bulky man in a dialogue with older art, poetry, and nature; another outsider who left his early modernist experiments behind. Both artists sought to locate a quasi-spiritual sensibility in genre paintings that deployed a directness of attack on top of a solid compositional structure. It's odd: Hartley is so little known in Europe, while here Derain is just a name. I think Derain made great paintings that feel especially relevant today. They are full of contradiction and a raging desire to be taken, loved even, on their own terms. I particularly love his dirty whites—the white with gray or brown dragged in, which makes the shape of a napkin or scarf seem as if cut from plaster, a scraped-down fragment.

A pendulum, a slowly rotating wheel, a river into which one cannot step in the same water twice—the metaphor changes, but the meaning is the same. The narrative of art history is not fixed; it evolves. Periodically, the constellations are realigned and given new names. In 2012, the Museum of Modern Art in Paris unveiled the collection of German art dealer Michael Werner, whose gallery in Cologne, starting in the late '60s, has been the showcase for much of the best postwar German painting. Polke, Baselitz, Immendorff, Penk, Lupertz—Michael's gallery offered a powerful counterargument to the Anglo-American pantheon of pop, minimalism, conceptualism, etc. The American tradition is largely external, while the European aesthetic tends toward existential reflection. Stylisti-

cally, Michael's artists also went backward in order to go forward, combining and recasting the Northern European graphic tradition with expressionism and enlarged scale to arrive at a type of figurative painting that has great vitality and urgency. It was a sensibility that spoke to contemporary reality while acknowledging, directly or allusively, Germany's complex legacy. Michael has described himself as a conservative anarchist, and you can feel both impulses percolating through the history of his gallery. Some of the most persuasive painting of the last forty years came out of that nucleus, and what began in 1963 as a marginal alternative to mainstream taste ended up dominating German art.

An artist is both himself and a distillation of everything relevant that preceded him. When we look at Roy Lichtenstein, to take one example more or less at random, we see not only Leger—that's obvious—but also Jackson Pollock, Frederic Remington, and Raphaelle Peale. Michael's own collecting provided the roots for his gallery; he bought work by the artists who had formed his sensibility, the ones his artists were also looking at and taking confidence from. As a collector, Michael began with the great exemplar Wilhelm Lehmbruck, eventually acquiring work by Arp, Picabia, Henri Michaux, and Jean Fautrier, each one balancing a substrate of mythology with pictorial immediacy. Like a path through an unfamiliar wood, Michael's collection is an alternative, a rebuke even, to the American stylistic hegemony. There is no history, only histories. Except for the oddball expat James Lee Byars and the painter Don Van Vliet (better known as the musician Captain Beefheart), there were no Americans in the Paris show. In an exhibition of over seven hundred works by forty artists spanning a period of nearly eighty years, the first things one sees are a series of terra-cotta masks made by Derain in the late '30s. He's right there at the beginning of the journey.

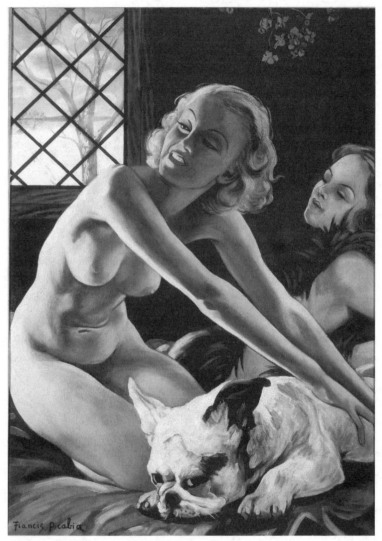

Francis Picabia. *Femmes au bull-dog*, 1941–1942.

Picabia, C'est Moi

"Westkunst," Kasper Koenig's sprawling, contrarian, and magisterial show of paintings from the 1930s to the '80s, was our introduction to late Picabia. That was in 1981, in Cologne, the capital of the European art world, home to most of the German artists worth knowing and the important galleries, too. Directly across the Rhine was its artier twin, Dusseldorf, where Joseph Beuys taught at the Kunstakademie, but it was in Cologne, a rough-and-tumble city that had been flattened in the war and hastily rebuilt in the '50s, that the real scene was happening. In the giant exhibition hall where the show took place, Picabia's slightly unhinged-feeling paintings of the '30s and '40s—nudes, bullfighters, weird abstractions that were close to outsider art—came as a shock to those who knew only his early cubist paintings, which is to say, nearly everyone. At the time I didn't even know his "transparency" paintings from the '20s, the model from which my paintings at the end of the '70s were mistakenly thought to derive. Picabia, if he was taught in the schools at all, was a footnote in the social history of the avant-garde; a *sportif* playboy and Dadaist provocateur who helped give the teens and early '20s their savor, but hardly someone to be taken seriously as *a painter*. As I remember it, Kasper had installed a single large room with works from the late '30s

193

to early '50s, mostly realistic scenes painted from photographs: female nudes, nudes with dogs, nudes with eroticized flowers, mixed-gender nudes (Adam and Eve), bullfighters and flamenco dancers—all rendered in a lurid, heavily outlined and varnished style that was, even at the time of their making, a good forty years out of date. The look of those late paintings leans heavily on a use of line—alternately elegant or crude—that Picabia had cribbed from Lautrec and Picasso. A cursive brush mark becomes an eyebrow, or a plump mouth, or any other part of a face. He had something of the sign painter's way with a brush, attentive to the way an image could be simplified into a sign. Along with his fellow Dadists, Picabia recognized the enduring appeal of diagrams, alphabets, logos, and other insignia. He also wrote concrete poetry and loved to play around with arranging type on a page. His was a graphic style, influenced by advertising and poster art, and some of his best paintings of the '20s, like *Spanish Night* and *Fig Leaf*, both from 1923, are sophisticated, top-flight décor; they would look great in a room with Jean-Michel Frank furniture. Dadaism and deco turn out to be quite companionable. When Picabia turned his hand to realism—basically a system in which volumetric form is defined by contrasts of light and shadow—he kept his penchant for outlining as a kind of graphic stimulation, and the mash-up of volume plus outline gives the paintings of the '30s and '40s a brazen, provocative feeling. At the time, no one had seen anything like them.

Picabia's sensibility, though newly seen, already felt familiar in a way that was hard to account for. Melodramatic and full of unlikely juxtapositions, the somewhat ham-handed illustrational way of painting, with its chiseled brushstrokes alternating with little curlicues, and the unabashedly erotic secondhand imagery presented with sincere interest and theatricality—all that made sense to me in a way that was hard to account for. His pictures struck a strange, dissonant chord that coincided with the general collapse of formalist pieties. I had never before seen painting as untethered to notions of taste or

intention; there was no way of knowing how to take it, or whether even to take it seriously at all. The work was so *undefended*—it was exhilarating. What was going on? For one thing, this was painting made during a collapse of authority. The war had scattered the avant-garde to the winds, or at least to America. Picabia decamped to the South of France in 1941 and sat out the Occupation in relative isolation. Funds were running low, an inheritance from his mother having largely been spent on the high life, racing Bugattis and collecting African sculpture. He needed to sell some paintings. Picabia turned to girlie magazines as source material and, in one of the strangest intertwinings of art and commerce, sold a quantity of the resultant paintings to an Algerian businessman, who used them to decorate brothels in North Africa. One can only imagine. Whatever the reasons or motivations, what Picabia produced over the last fifteen years of his life really had no precedent—and not much follow-up until the 1980s.

After "Westkunst," Picabias from the late '30s and '40s started to turn up here and there, mostly in German galleries—Hans Neuendorf and Michael Werner mainly, but also at Rudolph Zwirner and a few others. As soon as I could afford it (they were not expensive), I bought one from a private dealer in Paris who had a connection to one of the heirs. There was a story about paintings sitting for decades in a bank vault due to competing interests of mistresses and wives—that was why so few pictures had been seen. Probably it was true. Mine was a portrait of the French actress Viviane Romance, dated 1939. It was clearly painted from a photograph: a trashy-looking redhead in a slip glancing over her shoulder at the viewer, with wavy hair and bright red lipstick, a heavy vamp look in her eyes. It was painted on a cheap board, and thickly varnished to boot—a real mess.

I had no clue as to the sitter's identity until one day the critic Robert Pincus-Witten saw the painting hanging in my loft. He had seen her films when he had lived in Paris as a young man. Sadly, the painting disappeared in a divorce, and I have no idea where it is now. It

hung for years in my living room as both a compass point and a dare: I bet you can't make something as discordant and unsettling as this!

In 1983, I took part in a small two-person show in a Munich gallery with a few Picabia paintings, our pictures had a shared subject matter. It was perhaps a slender connection. We had both used images of bullfighting, in my case as part of larger compositions, almost like a decorative frieze, while Picabia really went for it: pretty straightforward touristic scenes of the corrida and the matador, painted with just the right unconvincing gusto. The heavy black outline. The show was modest, and little seen, but the juxtaposition did look surprising, and also right, and it made both painters (one being myself) exist in the immediate present, or even a little ahead of it, as if the audience were following right behind. That turned out to be an illusion; it took another thirty years for it to catch up.

In 2014, another posthumous collaboration was staged at Galerie Thaddaeus Ropac in Paris. This time out, we tried to find specific Picabia paintings that would rhyme with certain aspects of mine. Not with subject matter necessarily; the point was not to encourage a one-to-one correspondence. We tried to dig deep into what I call the *shared DNA* of art—a connection on an almost cellular level. The paintings were carefully paired, and in their proximity, some *current or charge* jumped from one to another and back again. It was almost as though we were making diptychs using one of his pictures and one of mine. It was a little uncanny, but it was palpable. A shared sensibility has to do with how an artist makes choices: what he's willing to sacrifice, what he's trying to foreground, and the extent to which he deliberately lets himself be guided, no, taken over, by certain pictorial conventions that he then, using a thousand tiny signals, partially nullifies. The resultant style might be called "heroic nihilism."

A number of the painters I started out with were interested in Picabia's transgressive taste. It was reassuring to know another rebel in the field. He seemed to foreshadow Sigmar Polke's early work, and

PICABIA, C'EST MOI

you can see his influence on Julian Schnabel, Francesco Clemente, Martin Kippenberger, Albert Oehlen, and myself, among others. Liking Picabia's work in 1981 or '82 was almost an affront to the people who had championed, say, Robert Ryman's all-white paintings. Every generation must feel some version of wanting to correct the story, and to extricate painting from the narrows and constrictions of theory, and letting the air out of the story of linear progress had been our mission in a way. We wanted to create our own precursors.

The work of Picabia's that feels most alive to me now is the figurative paintings, which were made from photographs first seen in nudist magazines of the time, publications like *Paris Sex-Appeal*. Sometimes the paintings are a direct translation of the photographs; others are collaged together from different poses. He painted himself into several of them, a satyr with flowing white hair and white teeth. It's hard to say if their main attraction is aesthetic, satirical, or camp—or a comingling of all three. Some pictures are so detached and schematic, painted with such indifferent technique, as to feel a bit hollow, as if his attention were elsewhere. But in pictures like *Adam and Eve*, *Two Women with Bulldog*, and *Woman with Idol*, and many others from that period, Picabia found the right container for his instincts. Those paintings make me deliriously happy; they sing. It's amazing they exist.

BABY'S GIANT BEAN

It is, in the first place, big—very, very big; sometimes, bigger than you ever thought a thing could be. And it's shiny—metallic and very, very shiny; or it is brightly colored, red, or more exactly, magenta, or cerise. Very, very shiny—it's metal (you can touch it—don't hit your head—*bong*! Ouch!) and highly colored, reflective, and very, very big. Even though it's metallic and hard, you to want to cuddle it, or more exactly, to be cuddled by it, scooped up in its enormous arms—or ears, or tail, or whatever features it has—and be held, finally safe.

This is art that says, "Now there will be ice cream." This is art that says, "Forget all that stuff you thought you knew, that stuff about the phenomenology of perception, about institutional critique, and feminism, and postcolonialism, and queer theory, and the theory of desire—forget about all of that; *this* is what you really want. Cartoons."

This is, undeniably, the age of childhood. Of course, it's also the age of many other things: class war; government dysfunction; religious fundamentalism; the baking of the planet—take your pick, the list goes on. Maybe the childhood thing is a kind of recompense for all the other things that it is the age of. A child, not well cared for, one

who has forgotten his latchkey, so to speak, looking for another home, can't be too picky about it.

The specter of a truly rotten childhood marked by trauma will not go away anytime soon. There it is, the emotions so raw and unrelenting. The fucked-up childhood and the stunted life that follows. It just goes on and on.

So too in the arts of this moment. As Daniel Mendelsohn has written, even a seemingly grown-up TV show like *Mad Men* is really about childhood; it shows how the adult world looks through the eyes of a child. The child tries to parse the mysteries of adult behavior, to understand what's going on. It's tantalizing—he knows it means something but can't be sure what. The grown-ups are also not really grown up at all. They're fake grown-ups who live with a crippling fear of discovery. Because then what?

In the world of contemporary art, the quantity of work that depicts, appeals to, references, critiques, or mimics childhood has reached critical mass. For the first time, the international style is not a matter of form or invention but one of content. And that content is all wrapped up with regression. The art public becomes excited by the same things that babies like: bright, shiny things; simple, rounded forms; cartoons; and, always, animals. Brightly colored or shiny and highly reflective; or soft, squishy, furry, pliable—*huggable*. What's going on?

A work by the British artist Anish Kapoor: an enormous stainless steel bean in Chicago's Millennium Park. I stood in front of it for a time before I realized what I was looking at. It's a giant baby toy, something suspended over a crib, a giant silver teething ring (from Tiffany's!) or baby's rattle. People have compared it to a UFO, but that doesn't strike me as right—it's from *before* there were UFOs. Baby doesn't know about UFOs yet—baby just wants to grab shiny bean. Oh, look how it dangles there, making your reflection go upside down! Fun!

The art world today has its own approximation of adolescence: the art fair—what is it really? The school field trip. *The kids are all excited to be going; this year is really going to be something—we're going on the bus! Everybody wait your turn. It's going to be so much fun. I have to go to the bathroom. . . .*

Another thing. Today, we know a work of art has established itself as a *sign*, when people, that is to say, tourists, want to be photographed in front of it. In addition to Kapoor's bean, Hirst's *Visible Woman*, Urs Fischer's giant thumbprint sculptures, just about anything by Jeff Koons, Murakami's manga figures, Cattelan's fallen pope, Paul McCarthy's *Santa with Butt Plug*—especially the butt plug!—the list goes on and on. I suppose that has always been the definition of a monument, something that one needs to be photographed in front of to cement the deal: "I was there." In the past, however, one might not have wanted to align one's identity as an *art person* with that of the tourist. How many people have had themselves photographed in front of Duchamp's *The Large Glass*? Apart from the fact that photography is not permitted in the Philadelphia Museum of Art, probably not very many. And, before it was largely underwater, having oneself photographed in front of Robert Smithson's *Spiral Jetty*, saying cheese and waving to the camera, would almost certainly indicate a lapse of taste or judgment, whichever applies, or at the very least suggest that the subject of such a photograph, as well as the person who snapped the shutter, was high at the time. What this means, of course, is that neither *The Large Glass* nor the *Spiral Jetty*, strictly speaking, needs you. Its art status is largely confirmed precisely by that fact—it is *autonomous*, at least as far as its originating impulse is concerned. That is not to say that it is not meant to be seen. One has either seen *The Large Glass* or not. But if one were to use a selfie-stick to make an image of oneself waving and smiling in front of it, or in front of the *Spiral Jetty*, it would simply make that person look like an idiot, or someone deliberately poking

fun at Duchamp or Smithson. Not so Kapoor's giant bean, which is designed, like a funhouse mirror, precisely to make one look like an idiot, or a giant, or a small person, or a blob, depending on the angle of reflection.

Checking on the current status of *alienation*, we find that there isn't any. It has, apparently, all been used up. Giant bean makes of its audience, whether resident or not, honorary citizens of Chicago, full of fellow feeling, civic pride, and curiosity about how the damn thing was made, and paid for. *The Large Glass*, on the other hand, fills one with a different kind of wonder; it leaves one with an awareness, not altogether comforting but just as awe-inspiring, of how far down the road you can go on marching to the beat of your own drummer.

Barbara Bloom. *Spice Container*, First Half Nineteenth Century.

LOVELY MUSIC

The Art of Barbara Bloom

Barbara Bloom brought a woman's touch to conceptual art. Against the linguistic/mathematical/theoretical impulses—and macho posturing (my theory is more radical than your theory)—that coursed through early conceptualism, Bloom championed the evanescent and ephemeral. She is, first of all, a noticer. Her subject is a sense of enchantment, her installations are object lessons in how to attain it. To that end, Bloom studies the way coincidence intrudes on everyday life, and she gives form to the hard-to-name feelings that bubble up in the wake of that intrusion. Coincidence—or maybe better, confluence—is the engine that sets Bloom's narratives in motion; it's threaded through all of her constructions, and the rippling out of unlikely connections continues long after one's initial encounter. Like perfume, its impression lingers.

Barbara and I were both part of the spirited inaugural class at CalArts, where, as an undergraduate, her sensibility was already established. I remember a long-duration performance piece that required the audience to spend the night in the windowless student gallery. We were requested to bring sleeping bags and present ourselves at 9:00 PM. The atmosphere was festive while people got settled, and then the lights were turned off and we all went to sleep. The room was completely dark. At some point during the night, we were jolted

awake by a short, intense blast of high-pitched sound—*what's going on? where am I?*—followed seconds later by a wall-sized projection of a black-and-white photograph of the Great Pyramids. Then pitch blackness again. The whole intrusion into sleep's interiority lasted just a few seconds. As we lay again in complete darkness, an afterimage of the Pyramids flickered in our retinas before, eventually, sleep returned. One dreamed of ancient Egypt. The process—first sound, then picture—was repeated three times during the night. Each time, I awoke into nothingness and, before I had time to orient myself was overwhelmed by a vision of ancient Egypt. In the morning, when the lights were turned on, everyone had slept marvelously. The mood was high. No one was really sure what had taken place. I'm still savoring the memory some forty years later.

Bloom works somewhat like an art director, combining various presentational tropes—the science fair, the museum exhibit, the department store display case, the vitrine—together with beautifully honed texts to lodge images and ideas in the mind of the viewer. Her work is conceptually expansive and formally pristine; it treads lightly around weighty themes and carries an idiosyncratic erudition, casually worn. She shows a great concern for craft, both in the sense of things well made and also in the craft of mind, conceptual craft—she makes thought objects. Her primary tools are simile and synecdoche, and she uses metonymy as an aesthetic principle: the detail or fragment standing in for the whole. Bloom strives for a sense of timelessness—things taken out of life's ordinary rhythm.

In 2012, Bloom was asked by the Jewish Museum to install selections of its vast holdings of fine, decorative, and liturgical art in the historic second-floor rooms of its home in the former Warburg mansion on upper Fifth Avenue. The choice of material was left to the artist. The resulting exhibition, "As it were . . . So to speak," was an exercise in the art of display, rather than the other way round. The overall design was sophisticated, with the hushed feeling of a posh jewelry store from midcentury, but also a little bit pretendy, in

a knowing sort of way. Through an enfilade of rooms, all painted the same shade of blue-green gray (Benjamin Moore palladian blue), Bloom created visual and narrative contexts for the display of objects from everyday as well as religious life: Torah pointers, antique hats, amulets, bookmarks, timepieces, spice containers, ceremonial cups, old portraits—an archaeology of an haute bourgeoisie. The results were lovely to look at and pedagogical in the best sense. From her introduction to the show's catalog:

> The emptied rooms were filled with "ghosts" of furnishing—abstracted furniture-like structures with traces of specific detailing, designed in a style . . . somewhere between Donald Judd and Biedermeier. The furnishings doubled as display cases. Each "furniture-case" housed a grouping of objects that were selected for their historical resonance, their implicit narratives, or marked with traces of past lives.
>
> Each display was accompanied by what appeared to be book pages floating off the walls. On these pages were illustrated texts—invoking imagined pairings of historical figures from diverse times. The texts were from a variety of voices.

Bloom's method is to link an image or object to a story, and then to coax that story into some fragile, evanescent visual form. The narrative information that provides the keys to the various objects' meaning is printed on elegant book-shaped sculptures that accompany each installation. Black type on the bow-wing shape of a turned page; the wall text turned into an actual book.

Normally, the idea of a room full of the sort of Yiddisha-kite knickknacks that my grandparents might have *kvelled* over would have me looking for the exit. Yet, in a piece simply called *Window* (each piece is named for the part of the mansion it occupies), I found myself raptly admiring a row of thirteen silver spice containers presented *en silhouette,* each one framed by a small window of translucent glass set into a wall painted the same delicious shade of gray. These

highly worked, whimsically imagistic examples of the silversmith's art, all from nineteenth-century Poland or Vienna, took on the aspect of figures in a Balinese shadow-puppet show: intricate and mysterious. The containers have a special function: "During the ceremony that marks the end of the Sabbath, participants inhale the scent of the sweet spices to revive the soul saddened by the end of the Sabbath," to paraphrase Maimonides. In Bloom's installation, the spice containers also allude to synesthesia—"the neurological condition in which stimulation of one sensory pathway leads to an automatic . . . secondary . . . pathway." She elaborates the theme by naming various luminaries who have experienced different forms of synesthesia, from Franz Liszt and Kandinsky to Mozart and Marilyn Monroe. That's classic Bloom: the quirky object, the jewellike presentation, the odd bit of history combined with neurology, and an eclectic cast of characters who make this one-time appearance on the same stage. Somehow it's neither pedantic nor maudlin. Like I said: perfume.

In *Piano*, Bloom made a vitrine in the shape of a baby grand piano minus the lid, also painted gray. We look down into the body of the piano and see, in the place of strings, silver Torah pointers—the tool one uses instead of a finger to keep one's place while reading the Torah—laid end to end. The pointers shimmer. The work refers to the unlikely friendship of Arnold Schoenberg and George Gershwin in the late 1930s, when both composers were living in Los Angeles. A wall text and a black-and-white home movie projected on a miniature screen (an iPhone) tell the story of the friendly rivalry that regularly took place across the tennis net of Gershwin's Beverly Hills mansion. The little movie of Arnold Schoenberg in white flannels on the court with Gershwin delivers an unexpected view into a past so lost we didn't know we had it in the first place. It's strangely reassuring and deeply poignant.

Bloom also likes to play detective—objects are clues, and the installation form is her magnifying glass. Her biggest influences are Duchamp and Nabokov; *The Large Glass* and *Ada* in equal measure.

Her work makes objects speak with an eloquence we often wish to feel but seldom do. In another piece, *Hidden Cupboards*, six hats worn by "Jewish Peoples" at various times in history are seen floating in a tidy vertical stack, each hat identified and described in a text off to one side. In the middle of this magically levitated column of headgear, each one a handsomely made shape of velvet or wool, there floats a seventh hat, the striped cap of a concentration camp inmate—that instantly grasped symbol of incomprehensible tragedy, literally a remnant of evil. But one searches in vain for its description; this hat is left unidentified. In the wall text, we find an account of the making of Claude Lanzmann's epic Holocaust film, *Shoah*. Lanzmann's radical gamble in that film was to use no archival footage—no images of the camps at all. His film is essentially nine hours of people talking, his idea was that the Holocaust really *cannot* be shown. To show that which is beyond imagination lessens the cumulative power of the survivors' testimony. Similarly, the striped cap is present but not identified—it's a ghost, occupying space but missing at the same time.

Bloom starts with a *curiosity*—about history, say, or literature, or psychoanalysis, or music, really about people's inner lives—and at a closer look this curiosity is enlarged by a feeling for the way that history repeats itself, and even *leapfrogs* across time to do so. Hers is an art in which the "background" is always turning out to be the "foreground." The overlooked detail becomes a tiny window with a view of the uncanny. Complex feelings remain just out of reach. Bloom's work speaks to the interconnectedness and strangeness of human affairs, and her Jewish Museum installations are about the overall design, often hidden or elusive, of human life as it is impacted by history. Sometimes Bloom's work makes me feel that this connectedness—the ability to bind narrative and image into a hovering sense of form—is actually a type of human happiness. She sifts through culture's detritus with a delicate touch—she grasps the strange pattern of the butterfly's wings without tearing them off.

Richard Aldrich. *Two Dancers with Haze in Their Heart Waves Atop a Remake of "One Page, Two Pages, Two Paintings,"* 2010.

STRUCTURE RISING

A group show is like any party—there are the people you want to spend time with and the bores you can't wait to get away from. There are artists and pictures that repay our attention with interest and others that simply use it up. The qualities we admire in people—resourcefulness, intelligence, decisiveness, wit, the ability to bring others into the emotional, substantive self—are often the same ones we feel in art that holds our attention. Less than admirable qualities—waffling, self-aggrandizement, stridency, self-absorption—are also present in work that, for one reason or another, remains unconvincing.

"The Forever Now: Painting in an Atemporal World" was MoMA's 2014 survey of recent painting, its first in well over thirty years. Senior Curator Laura Hoptman invited to her party seventeen artists who have come to notice in the last decade or so, and collectively they give off a synaptic charge. There are a fair number of clunkers, but the majority of the painters here display an honestly arrived-at complexity, expressed through a rigorous series of choices made at what feels like a granularly visual level. Their work rewards hard looking.

The good artists in the show are very good indeed. Charline Von Heyl, Josh Smith, Richard Aldrich, Amy Sillman, Mark Grotjahn, Nicole Eisenman, Joe Bradley, and Mary Weatherford have all devel-

oped tenacious and highly individual styles. Each makes work that engages the viewer on the paintings' own terms and shakes free whatever journalistic shorthand might, in passing, get stuck on them. What drives these artists is resolved in painting that is self-reliant and unassailable while remaining open and undogmatic; it's the ebullience of secular art freed of any ideological task.

Two words one should probably avoid using in exhibition titles are "forever" and "now," and Hoptman uses both. "Atemporal" comes from a William Gibson story, and Hoptman worked it into a hip-sounding phrase, but it's just distracting, like someone talking too loudly while you're trying to think. She wants to make a point about painting in the Internet age, but the conceit is a red herring—the Web's frenetic sprawl is opposite to the type of focus required to make a painting, or, for that matter, to look at one.

What does "atemporal" mean, in the context of painting? Judging from Hoptman's catalog essay, it's the confidence, or panache, to take what one likes from the vast storehouse of style, without being overly concerned with the idea of progress or with what something means as a *sign*. Linear art history is so twentieth century. Today, "all eras co-exist at once," Hoptman writes. She goes on to say that this atemporality is a "wholly unique phenomenon in Western culture." *Big news*. The free-agent status accorded the artists in her show is something I take as a good thing—maybe "minding one's own business" would be a better way of putting it—but her claim for its uniqueness is harder to swallow; it's more or less what I've been advocating for the last thirty-five years. Not that I take any credit for the idea; within a certain milieu it's just common knowledge.

In her desire to connect everything to a narrative of the digital future, Hoptman misses the salient difference between the best work here and its immediate antecedents: a sense of structure. By structure I don't mean only relational composition—though that plays a part—but more generally the sense of a painting's internal rationale,

its "inside energy," as Alex Katz would say, that alignment of inten-
tion, talent, and form. Hoptman wants to make a clean break for
her crew from the mores of appropriation, but again, the emphasis is
misplaced. Appropriation—as a style—had a tendency to stop short,
visually speaking. The real concern was with "presentation" itself,
and the work that resulted was often an analog for the screen, or
field, something upon which images composed themselves into some
public/private drama. Appropriation pointed to something—some
psychological or cultural condition outside of the work itself—that
was the basis of its claim to criticality and, at its best, excavated some-
thing deep in the psyche. But there are other things in life. At present,
painting is focused on structure—on discovering and molding picto-
rial form for its own sake.

Atemporality, then, is nothing new. Most if not all art reaches
back to earlier models in some way; every rupture is also continuity.
The "reaching back" might be to unexpected sources, but imprints
of earlier achievements are what give art its gristle and sinew. What's
different is how to see what's there. As an example, Mary Weather-
ford places tubes of colored neon in front of fields of paint-stained
canvas. In the old, appropriationist mindset, one might get hung up
on a list of signifiers along the lines of, say, Mario Merz or Gilberto
Zorio meets Helen Frankenthaler; this reductionism was, from the
beginning, an unsatisfying way to see. Pleasantly, reassuringly, more
like an old friend showing up after a long absence, Arte Povera echoes
through Weatherford's work, but it doesn't feel like a self-conscious
reference. Her work clears a space where it can be taken on its own
terms. They do, as Ben Jonson said in a somewhat different context,
"win to themselves a kind of grace-like newness."

In a related, refreshing development, Warhol's gloomy, vam-
piric fatalism is no longer dragging down the party. Duchamp, too,
is absent. What a relief. Nothing against the two masters as far as
their own work is concerned, but they have exerted such an outsized

gravitational pull on generations of artists that finally being out from under them feels like waking from a lurid dream. There is camp in "The Forever Now," to be sure (Eisenman), and imagery, and irony (Williams), and "presentation," but they are not the main event.

Painting also seems to have shed its preoccupation with photography; here you will find only the faintest nod to the age of mechanical reproduction. Even for Laura Owens, who blithely tries on the visual conundrums of the digital world, photography isn't really part of her DNA. It turns out that much of the art-historical handwringing of the last forty years over Walter Benjamin's famous prophecy was either misplaced or just plain wrong. Painting is not competing with the Internet, even when making use of its proliferative effects. Owens, though a favorite of many, has always eluded me as an artist. She uses an image field the way an earlier LA artist might have used fiberglass: casually, for its surface properties. Her work gives off a feeling of cleverness; it's conceptual without being especially intelligent, not that the two are necessarily linked. She's like an eager-to-please kid in class—she finishes the assignment but seems to lack any deeper motivation.

Imagery is present to varying degrees in many of these artists' works. It's front and center in Nicole Eisenman's paintings, exuberantly evident in Josh Smith, lambent in Joe Bradley. Drawn forms, some with a goofy, cartoony quality, are often the basis of Amy Sillman's muscular lyricism. Sillman is a great picture-builder; her evocative and *gemutlich* paintings give the show some real gravitas. Representation even shows up in the trenchant cerebral complexities of Von Heyl, but none of these artists are involved with the tradition of realism. They are not translating what can be seen into what can be painted. While everything, even abstraction, is an image in the ontological sense, and there are snatches of imagery in most of these paintings, these artists are simply not imagists; their images are more like the folk melodies in Bartók—present as understructure, there but not there.

The overall tone of "The Forever Now" has a West Coast casual feel about it. Five of the artists in the exhibition—Grotjahn, Weatherford, Owens, Dianna Molzan, and Matt Connors—are based in Southern California, and their work has some of LA's take-it-or-leave-it attitude toward materiality. It's a feeling I remember from living in Los Angeles in the '70s: a slightly secondhand relationship to the New York school pieties. The alternative to sober, grown-up painting was an emphasis on materials, often industrial or nonart materials, and on the idea of process itself. The work embodies a youthful vigor and an absence of polemic—in a word, *cool*. When combined with an internal structural core, the result has a kind of multiplier effect; it wins you over.

(The situation in literature today is not so different; while still avoiding straight realism, the parodists, inventors, miniaturists, and tinkerers are now coming into prominence, taking over from the arid metafictionists. Writers like George Saunders, Ben Marcus, Sam Lipsyte, Sheila Heti, Ben Lerner, and Chris Kraus have clear parallels with painters Charline Von Heyl, Mary Weatherford, Joe Bradley, Chris Martin, Richard Aldrich, et al. Painting and advanced writing are now closer in spirit than at any other time in living memory.)

But I want to return to that quality that sets apart certain painters in this exhibition—that sense of structure—and show how I think it works. Like diamonds, Mark Grotjahn's paintings are the result of great pressure brought to bear over a protracted period of time on a malleable material. His work is a good example of how many artists today are using imagery and history—which is to say, the way that artists have mainly always done. Grotjahn manages to simultaneously invoke cubism, futurism, surrealism, and abstract expressionism—everyone from Malevich to Victor Brauner—and translate those impulses into an intensely focused, schematic composition that leaves just enough room for his hand to do its stuff.

Much has been made of Grotjahn's Picassoid heads, but the over-

all looping structure of his paintings produces an effect closer to Joseph Stella's paintings of the Brooklyn Bridge. Grotjahn reimagines Stella's swooping catenaries into arched ribbons of constructivist, impasto paint. Because the chunks of color are small and contiguous, they tend to blend together in the viewer's eye, giving the paintings an alternating current of macro and micro focus. Those colors are dark red and burgundy, forest green, warm white, cobalt blue—the colors of striped silk neckties. They are preppy in a nice way, with a whiff of the 1940s. More importantly, Grotjahn's color intervals are exacting. They put the painting in a major key. Their simple, clear visual forms—arcs, circles, lozenge and ovoid shapes, like segments of an orange—sometimes overlap and cut into each other, creating a space of increasing, sobering complexity. Grotjahn's paintings do a funny thing: they achieve great scale through the linear arrangement of small areas of paint, and their structural and imagistic concatenations are in good alignment with the color and paint application. The what and the how are in productive sync. These paintings are tight, shipshape, and very satisfying to look at. At forty-six, Grotjahn is close on to being a modernist master.

Richard Aldrich has been making interesting and surprising paintings for a while, and one of his works here shows great panache. *Two Dancers with Haze in Their Heart Waves Atop a Remake of "One Page, Two Pages, Two Paintings,"* from 2010, is Aldrich at his least gimmicky and most in tune with the spirit of abstract painting as deconstruction. The painting's success lies in its loose-limbed sense of structure: a grid or ladderlike armature along which an array of painted shapes and brush-drawn lines alternate with the interstitial white spaces to form a syncopated rhythm. Its painterly touch calls to mind Joan Mitchell and Philip Guston, and also Rauschenberg's *Winter Pool* from 1959—two canvases joined in the middle by a ladder—as well as Rauschenberg's later Combines. Aldrich's palette here is sophisticated, just shy of decoratorish; he takes eight or nine

hues and nudges them into perfectly tuned intervals of cream, white, Pompeii red, burnt umber, and a grayed cobalt green—colors that feel at once Mediterranean and Nordic. This particular painting touches on a number of visual cues without leaning too heavily on any of them; the four irregular black rectangles framed by cream-colored bands suggest darkened windows in a cracked plaster wall.

That Aldrich's painting is reminiscent of earlier paintings while maintaining a clear sense of contemporaneity is perhaps what Hoptman means by "atemporal." But this is what painting is always about, in one way or another. Rauschenberg's work of the late '50s and early '60s was itself a deconstruction and reconstruction of abstract expressionism, freed from its self-importance. Aldrich has taken a lot from that period in Rauschenberg's work, but his tone is lighter; it has Rauschenberg's insouciance, without the urgent nervousness. The stakes are different. This is now. Though informal, at times almost flippant, Aldrich's work is sturdier and more tough-minded than it first appears. His painting says, "Lean on me."

Susan Sontag, writing nearly fifty years ago, observed that no self-respecting critic would want to be seen separating form from content, and yet most of them seem drawn to do just that, after first offering a disclaimer to the contrary. Make that double for curators. The real problem with "The Forever Now" is that it's two shows: there are the painters who make stand-alone paintings—*we don't need no backstory*—and those who use a rectangularish surface to do something else. The artists in the former group are the raison d'être for the show: their work has formal inventiveness and pictorial intelligence; it lives in the moment. As for the latter, they are artists who make tip-of-the-iceberg art. What's on the canvas is the evidence, or residue, of what happens offstage. Nothing at all wrong with this in principle, of course, but it can result in an arid busyness that masks a core indecisiveness or, worse, emptiness. There's a problem when the gap between what a work purports to be—its presumed intention—and

what it actually looks like is too big to be papered over, and such is the case with several of the most celebrated artists included in "The Forever Now."

George Balanchine once complained that the praise had been laid on a little thick. "Everyone's overrated," said the greatest choreographer in history. "Even Jack Benny is overrated." He meant that once it's decided that someone is great, a misty halo of reverence surrounds everything the person does. The reality is more prosaic: some things, or some parts of things, will be great and others not. The problem of grade inflation has been with us since at least the 1920s, when H. L. Mencken, in his *American Mercury* magazine, coined the term "American Boob" to mean our national variant of philistinism. The flip side of "Boob-ism," in Mencken's formulation, was the wholesale enthusiasm for everything cultural, lest one be thought a philistine. It's created a hell of confusion ever since.

It's annoying to be overpraised; it's like showing your work to your parents. The lack of criticality is one of the things that gives our current art milieu the feeling of the political sphere (I don't mean *political art*). Politics, as a job, is the place where the truth can never be told; it would bring the merry-go-round to a halt.

I decided a long time ago not to write about things I don't care for. So much work is deeply and movingly realized, and so many artists of real talent are working today, that it's just not worth the time to take an individual clunker to task. There's an audience for everything—*who cares?* Besides, one can always be wrong. However I'm compelled to make an exception in the case of twenty-seven-year-old Oscar Murillo. It's not his fault for being shot out of the cannon too early, but I feel one has to say something lest perception be allowed to irretrievably swamp reality. There have always been artists who were taken up by collectors, curators, or journalists, artists who fit a certain narrative but are of little interest to other artists, so why get worked up over it now? Of course, it's not just him. The problem

is really one of what constitutes interpretation; it's the fault line of a deepening divide between how artists and curators see the world. Though it may be unfair to single Murillo out, the best way to explain why the distinction matters is to describe his work.

Murillo seems to want to say something with his work about palimpsest and memory and being an outsider, but he lacks, to my eye, most of what is needed to make a convincing picture of that type. His grasp of the elements that engage people who paint—like scale, color, surface, image, and line—is journeymanlike at best. His sense of composition is strictly rectilinear; he doesn't seem to have discovered the diagonal or the arabesque. Worse, he can't seem to generate any sense of internal pictorial rhythm.

Murillo's paintings lack personality. He uses plenty of dark colors, scraping, rubbing, dripping, graffiti marks, and dirty tarpaulins—run-of-the-mill stuff, signifiers all. The work looks like something made by an art director; it's meant to look gritty and "real" but comes across as fainthearted. This is painting for people who don't have much interest in looking, who prefer the backstory to what is in front of their eyes. Murillo is in so far over his head that even a cabal of powerful dealers won't be able to save him. He must on some level know this, and so he tries to make up for what's missing by adding on other effects. One piece in "The Forever Now" is a pile of canvases crumpled up on the floor that viewers can move about as they choose. It's *interactive*—get it? MoMA visitors with a long memory will recognize this as a variation on early work by Allan Kaprow, the inventor of Happenings, who wished to mimic the expressionist impulses in '50s paintings and channel them into little games that invited viewer participation, with the result that what had once been pictorially alive became pure tedium. To quote Fairfield Porter, writing at the time, "Kaprow uses art, and he makes clichés. . . . If he wants to prove that certain things can't be done again because they have already been done, he couldn't be more convincing." You can kick Murillo's can-

vases around from here to Tuesday—there is no way to bring them to life, because they never lived in the first place.

The real news from "The Forever Now," the good news, is that painting didn't die. The argument that tried to make painting obsolete was always a category mistake. That historically determinist line has itself expired; painting is doing just fine. Painting may no longer be dominant, but that has had, if anything, a salutary effect: not everyone can paint, or needs to. While art audiences have gone their distracted way, painting, like a truffle growing under cover of leaves, has developed flavors both rich and deep, though perhaps not for everyone. Not having to spend so much energy defending one's decision to paint has given painters the freedom to think about what painting can be. For those who make paintings, or who find in them a compass point, this is a time of enormous vitality.

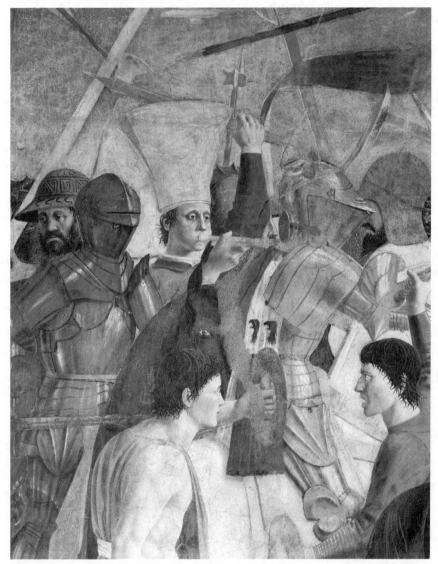

Piero della Francesca. *Legend of the True Cross: Battle of Heraclius and Khosrow*, ca. 1450–1465.

Piero della Francesca

Piero della Francesca, who died in 1492, is an artist whose vitality lives on in the New World. Less famous but perhaps more subtly influential than Michelangelo, he took painting a quantum leap forward in the use of pictorial space. The static linearity of early Renaissance painting, in which a roll call of biblical personae occupy a shallow plane notably lacking in gravity, is transformed into a dynamic, ordered set of relationships; the dramatic groupings of figures are like illustrations from a textbook of theatrical staging.

New York's Frick Museum assembled a group of his pictures in 2013, simply called "Piero della Francesca in America," with a focus on two other notable aspects of his art: color and drawing. Of the seven paintings in this show, four from a single altarpiece depicting the life of Saint Augustine, most were single figures, monumental in attitude, and all extremely beautiful; holding-your-breath beautiful. But getting a sense of Piero's compositional brilliance, the greater part of his legacy, is more of a challenge, since all of his large-scale paintings, the groups of figures arrayed in procession, are in Italian museums and are too fragile to travel. His masterwork, the fresco cycle *Legends of the True Cross*, was painted in situ and therefore can never leave home. A condensed history of Christendom in picture form,

Legends was painted for the church of San Francesco, in Arezzo; the work was completed in 1466. As in a Hollywood epic crowded with familiar actors, everyone from Adam, King Solomon, and Constantine to the Queen of Sheba makes an appearance. Four large rectangular panels comprise an object lesson in narrative time expressed through pictorial clarity. The result is dazzling. To continue the cinematic analogy, the lyrical sweep of these frescos is like CinemaScope five hundred years before the event; two large battle scenes are really just *it*—their depiction of space is uncannily contemporary.

Although not the first artist to use it (who's counting?), Piero perfected the secret weapon that would define Western painting for centuries: perspective. Nothing telegraphs humankind's place in the physical world—nor locates the viewer's—more effectively than the vanishing point. (If you don't believe me, just watch Monte Hellman's cult film *Two-Lane Blacktop*. Or look at any painting by Anselm Kiefer.) It makes sense that Piero would have a genius for composition, which, after all, is about the relationship of the parts to the whole, since he was also a geometrician whose treatise on perspective is featured in Vasari's *Lives of the Most Excellent Painters, Sculptors, and Architects*. He dynamically masses groups of figures along what feels like mathematically determined coordinates, yet his drawing doesn't feel rote or static. Like an Elia Kazan of staging, Piero choreographs the relationships between his protagonists to yield moments of realization and insight. Crowded with shouting warriors, charging horses, fluttering flags, rushing clouds, thrusting lances—the degree of simultaneity in these battle paintings, combined with the figures' sense of arrested motion, is both bracing and dizzying, as if an unseen hand has momentarily stilled the gears of the celestial clockworks.

Anointed as a "monarch of painting" in the late fifteenth century, Piero was more or less ignored by later generations, until the twentieth century, when the chaste clarity and equipoise of his paintings spoke to the modernist desire for rigor within an all-over-type compo-

sition. Painters as diverse as Paul Cadmus, Philip Guston, Francesco Clemente, and Brice Marden show his influence, while the eccentric unmodernist Balthus developed his ability to invest pubescent girls with a look of heavenly derangement after an apprenticeship copying Piero. And his influence is not confined to painting; postmodern architects Michael Graves and Aldo Rossi, to name two, were confirmed in their sense of neoclassical gravitas by Piero's pictorial structures (his turreted and crenelated towers with their square windows were a big hit with the po-mo crowd), and the director Robert Bresson modeled the battle scenes of his film *The Trial of Joan of Arc* after Piero's panoramic frescos.

The single-figure paintings showcase jewelescent luminosity created by the proximity of saturated high-keyed colors next to grayed, darker tones. Piero's heads are, first of all, geometric forms; as in an early how-to-draw book, the features are added to a block or a ball. His people have a look of serenity, even sweetness, an inward quality freed from the masklike stiffness of early Sienese painting. But the drawing is only part of the story; Piero was principally concerned with the division of forms into areas of light and dark. It is this modeling that gives his drawing expressive weight. In some paintings his drapery has the look of Greek sculpture, or Bernini's terra-cotta maquettes; the billowing robes of the saints feel almost chiseled—the edges have a satisfying thickness.

What is it that makes an artist whose work was produced before the discovery of the New World so useful to such a wide sampling of contemporary artists, even ones of radically different temperaments and styles? The great Philip Guston wouldn't have gotten far without Piero's sense of mass as a compass point. What is the link? Modernism has been powered by many different and sometimes conflicting beliefs, but one of the most enduring and widely shared is the conviction that stripping art of unnecessary artifice is the path to greater depth of feeling; less is not just more but more *real*, more sin-

cere. In this, Piero got there first, and best. But there's another thing, which might be seen as almost contradictory: that Piero is a monarch because of his style—the insouciance, the sweetness of it, the lilting, floating quality of his figures. Honest solidity of form on one hand and weightless arabesques on the other. Piero's Hellenist-leaning, presentational gravitas, combined as it is with the attention to light and shadow, makes his work feel alive in the moment. Light and air seem to move through it.

PART IV

PEDAGOGY AND POLEMICS

THE '80s—WHAT WERE
THEY GOOD FOR?

*A Lecture Delivered at
the Milwaukee Museum of Art*

When I was a kid of seven or eight, there was a TV show called *Ripley's Believe It or Not!* I remember being particularly impressed by an episode about a guy who claimed to have eaten his car. It took him more than four years, but by chopping the car into *tiny* pieces and swallowing a little bit every day, this guy managed to eat the entire car: steering wheel, chrome, tires, and all. He didn't even know he was making art.

Here's the situation as it stands today. Contemporary art is divided into two main camps. On the one side, there exists the centuries-long continuity of work that I call *pictorial*, and on the other, the growing body of work that is more *presentational* in attitude—that is, art that privileges intentionality and the delivery system, or context for art. Within these two worldviews, the one is identified with art as self-expression, while the other reads art primarily as a set of cultural signs. This may sound like the old Duchampian distinction between the retinal and the cerebral, but the balance has tipped in a way that Duchamp could hardly have imagined sixty years ago. In the final decades of the twentieth century, the emphasis on theory seriously

eroded, if not invalidated, one of the basic precepts of art: that quality which used to be called presence, or *aura*. Baldly put, a work of art was said to emanate this aura as a result of the transference of energy from the artist to the work, an aesthetic variant of the law of thermodynamics. Few people today would defend that idea. The question remains, what do we have to replace it with?

I recently visited the Zurich home of my friend, Bruno Bischofberger, the great collector and dealer who represents the appropriation artist Mike Bidlo. In Bruno's living room, by a window with a view onto Lake Zurich, was a Bidlo bicycle wheel after Duchamp. You know—the wheel mounted upside-down on a simple wooden stool. Although an exact replica of the original, which itself is an assemblage of commercially available objects, the Bidlo bicycle wheel lacked presence; it was, in fact, dead as a doornail. *Strange*—how can that be? It's an *exact replica* of a nonartisanal object. As we stood in Bruno's living room, looking at Bidlo's sculpture, Bruno's wife, Yoyo, made the astute observation that "an artist's work either has presence or it doesn't, and although anything *can* have it, nothing has it necessarily." It might sound like magical thinking, but the original—in this case a funny word to use—bicycle wheel is gratifying to look at. It has an aura. The replica, not so much. Is context alone, and the expectations that come with it, enough to explain the difference?

The differences between the older view and that of Duchamp's many descendants involves more than a distinction between expressionist and detached art, or warm art and cool; cool art can be highly pictorial, and a good deal of art, perhaps most art that we remember, manages to be simultaneously pictorial *and* presentational. Like many things in life, it's a matter of emphasis, which is to say, a question of sensibility. Art is often the product of ideas; space, materiality; cultural history and identity; time and narrative; styles of representation and the very nature of the image to name only a handful. In the art we still talk about today, those ideas are embodied by *form*. Of course,

nothing in art is either/or; even this statement can be contradicted. The most pictorial art also contains an element of the presentational. The presentational is *baked-in* in a way. Sophisticated paintings are self-aware, they present *themselves*. In fact, I would say that what art does is to strike a balance between the two; one quality acting as a brake on the other.

However, with the canonization of Duchamp following his death in 1968, presentational art began proliferating; it began to get the upper hand. As the audience for contemporary art grew, and the ranks of college-educated artists swelled, art that engaged the delivery system itself began to eclipse the thing being delivered. There are a number of reasons that this approach to art-making has flourished, principal among them is simple demographics: the great increase in the number of young people enrolled in art schools and the adjacent curatorial programs. Another reason, also demographically determined, is the rise of the tourist model of international art fairs and biennials—what Peter Schjeldahl has called "festivalism." The context for art does, to some extent, shape what will be created.

We have also seen a proliferation of art whose function is to deliver content of a specific, legible sort. You know the joke about what the painter said when asked what his work meant: "When I want to send a message I call Western Union." In social realist painting of the '30s, a work was judged by what it had to say about the class conflict. The visuals have changed but the criteria for judgment of message-laden art are still with us.

I'll confess straightaway that the proliferation of presentational art makes my heart sink. The inconvenient truth is this: It's easier to present art than to make it. It's easier to select than it is to invent. It gets confusing, because some of the great pictorial inventors of the twentieth century, like Andy obviously, *appeared* to be doing nothing more than choosing—but that was an illusion, something borrowed from the beauty industry, where the amount of time spent in the

makeup chair is supposed to result in an effortlessly natural look. To make something that really holds our attention, especially over repeated viewings, requires levels of integration—intellectual, visual, cultural—expressed with a unique physicality. Art that eschews this integration is unlikely to be durably compelling for the simple reason that less is at stake. Chances are, the tension of vulnerability and the emotional power will be diminished. Over time, the result will have the flavor of commentary.

Sometimes I think we don't know what kind of artists we want, and you could ask, "Why would we?" There have always been the kinds of artists who present themselves as avatars of our perceived cultural moment, as if that's the job description. And no doubt for some it is. Art in the largely presentational mode has now further evolved into the realm of the iconic spectacle, which, far from denying the existence of art's aura, has transferred the idea of auratic vibration to how something can be staged for the camera. This may be a new form in itself, a kind of art whose pictorial values are meant to be understood, maybe can *only* be understood, within the framing device of a magazine page or a screen. I don't mean here the staged photographs of Cindy Sherman, an artist more or less universally admired. I'm referring to a more controlled use of pictures within the systems, both social and editorial, that deliver them. I find among art students today a reluctance to make any meaningful distinction between art and ads. I'm generalizing, but it's a noticeable shift. Today's art students can't easily even recognize the difference, and also don't see any particular need to do so. As I've suggested, maybe this is simply a different kind of aura. An example could be Maurizio Cattelan's re-creation of the Hollywood sign in the hills above Palermo; the photograph in *Artforum* makes us smile; we appreciate its complex layers of cheekiness. But how many really feel compelled to go to Sicily to see it?

Frank Stella, never one to shy away from a fight, mince words, or go with the flow, has this to say:

Owing to its reading of Duchamp, the literalist art of the last twenty-five years has defined itself by the act of presentation. Artists have tried to make a mountain out of a molehill, and celebrate their ability to select objects and activities from daily life and to present them in a different context, the context of the art museum or gallery. Where literalist art challenges painting by asserting that the art of presentation is the equal of the art of creation, we have to recognize its lack of seriousness. I am easily tempted to dismiss this variant of literalism, which has become a current darling of art critics because it is obviously a practice with which they can easily identify. That is, critics can easily see that they would be comfortable practicing this kind of art, which aggressively identifies itself with typing skills.

The New York art market flourished for a time in the '80s, and this attracted the attention of mainstream media. The art world hadn't been considered interesting to talk about for a while—all that arid conceptual art making people feel stupid—and now there was something to dress up for. The gossip was amusing, some of the personalities were colorful. Most talk about the art of the '80s and '90s is really talk about the art world as a social system, and while this may be mildly interesting, it's not the same, nor as interesting, as the art itself. The art market was robust, briefly, after a period of quietude that had gone on so long it was considered the norm, and when it changed, some people, instead of taking the long view, had an attitude about it. They stopped looking at the work. I remember sometime in the early '90s receiving a query from something called the *Nordic Art Review* that posed the stark question; "The 1980s; what was it good for?"

At least as far back as the Renaissance, the arts have been populated by eccentrics with strange and sometimes alarming personal habits—the painter Il Rosso, for instance, reportedly lived with an ape as his domestic companion. Closer to our own time, Calvin Tom-

kins, in his biography of Duchamp, describes a peripheral artist of
Duchamp's circle of the late '20s in New York, a proto–performance
artist who used to walk down Fifth Avenue with live birds pinned to
her skirts, as being "unhampered by sanity." I don't think we'd want
it any other way. As I said earlier, maybe we don't know anymore what
kind of artists we want. One way a work of art takes on meaning is
when its formal, pictorial patterns resonate with systems of attention
in the larger world. Another way is when the larger than life person-
ality of the artist does the same thing. When something is judged to
be passé, what's really meant is that the image of the artist encoded in
those patterns is the wrong one for the moment. Hemline too long,
or too short.

Fashions do change. A disheartening aspect of the art world is its
willingness to indulge in ad hominem attacks disguised as a defense
of certain values. Much of the criticism of '80s art was nakedly elitist.
People didn't like a painting because they didn't like the people who
did. Critic Robert Hughes's venomous attack on '80s art included
contempt for its collectors, and the phrase "newly minted art for
newly minted money" was smugly thrown around, as if the Farnese
or Borghese were fundamentally different in their day. Today we can
see Hughes's rhetoric for the distasteful snobbery that it was.

But let's return for a moment to the problem of representation. It's
been the case for quite a while—at least since Picasso—that how well
a work reproduces plays a significant role in its popularity; the most
acclaimed artists from the '60s, for instance, looks fabulous in repro-
duction. This isn't to suggest that those works didn't also have tremen-
dous physical presence, but the fact remains *most* people are primarily
familiar with a work of art through a reproduction; those who have
the good fortune of experiencing the painting firsthand are fewer in
number, and those who have the luxury of actually living with it are
very few indeed. But that's different from the situation I'm describing:
art that tangibly occupies three-dimensional space, yet seems to exist

in more compelling form when seen in a magazine than it does in real life. What is the difference exactly? Art conceived as spectacle comes from a different impulse, essentially that of an art director, and is the legacy of conceptual art fused with pictorial irony. Art direction is the science of directing attention, often to a con; a place of making you think you're smarter or more attractive than you are. Increasingly, the art world is in thrall to the triumph of art direction, something which places art in the service of irony—of the ironic presentation of *forms*, the distance from which is the art's *message*. As noted earlier, kids in art schools today don't care about the distinction between ads and art. And why, you might ask, should they? Especially if no one else does.

At CalArts in the halcyon early '70s, when the school was still flush with Disney money, students could apply for grants to carry out special projects. I once sat on the panel to pick the winners. One guy asked for $3,000—a lot of money at the time—so that he could take a television and a generator up to a remote mountaintop, where he planned to watch reruns of *The Beverly Hillbillies,* and then blast the TV screen with a twelve-gauge shotgun. We gave him $300 with the suggestion that he check into the worst fleabag hotel in downtown Los Angeles, and shoot out the television screen in his room with a BB gun. Sometimes less is more. Since that innocent time, things have developed dramatically, and museums now routinely pay artists to fly around the world creating pieces that are subsequently pho- tographed and disseminated through the art publications and social media. Nice work if you can get it, as the saying goes, and what we're left with is an image in a magazine.

A Talk for the
First Day of Class

A rt school. We've all been there, one way or another. We're still *going.* The problem remains: the art is mute, but we want to talk. How to talk about art in a useful way, in a way that is relevant to both the viewer and the art. It can be approached from different angles: acting theory, poetry, nature, psychology can all contribute to the conversation. I think the task is to describe how the sensation evoked by a work of art emerges from the intersection of talent, formal decisions, and cultural context. And to do so with a light touch. This text is the result of my on-again, off-again relationship to teaching. Things I might have said, or wished I had said to students over the years. Or things that other people have said to me.

In a number of the pieces in this collection, I have quoted from or made references to the work of my late friend George Trow, a sui generis contrarian writer and polemicist. I have a draft of a letter George sent to Tina Brown, who was then editor of *The New Yorker.* After nearly thirty years as a staff writer, George resigned from the magazine. The letter starts with the memorable line: "Tina, Tina, Tina—Zeitgeist all wrong" and continues as a kind of Trow primer in miniature. George's theme, one of them anyway, was how to continue to cultivate a sense of wonder in the face of the new cultural

anarchy. He had come from a class and a culture that had enjoyed dominance for many decades. In fact, he was at the end point of that culture, and foresaw and celebrated its demise. The problem is, what do you replace it with? George wrote: "Modern art . . . shows the pain of living in a world in which old dominance rituals have died." He goes on to say that what is needed is a new set of dominance rituals, "a new way of being ruled, aesthetically." In the spirit of George, these particular exercises could be taken as a way to get this ball rolling, to do the imaginative work of finding new ways to describe the forces that shape our visual experience.

Take this as a talk given on the first day of school, the ground rules for engagement. Consider the exercises that follow as class projects, or party games for the esthetically curious.

1. The Givens Hold Us Back

Bob Rauschenberg once told me he could fix any painting with two pencil lines. Which in his case was probably true. Of course, it's easier to fix someone else's work than it is your own. Even Bob couldn't always do it for himself. Not easy, but I'm going to ask you to imagine that you *are* that someone else; that is, to confront your own work with that kind of detachment, to imagine how your work looks to someone who may not have your sensitivity. And to ask yourself, very simply: How does this work come across? Also to ask the corollary question: As I look at this thing, do I feel that the artist did all that could be done? If the answer is *no*, or even *perhaps*—can you imagine two pencil lines, whatever that means to you, applied in the right place, in the right way, that would help? Sometimes, a relatively simple thing done in the right spirit brings in a new rhythm—it can focus the viewer's attention in just the way that is needed. It's often the case, especially with art made in schools that something is missing—an absence that the artist tries to make up for with a kind of wishful thinking. The

wish has to do with the power of ambiguity, the wanting a work of art to do something, but not do it too completely, lest it be the wrong thing. Wishful thinking is powerful; it blinds us to what is actually there. Or, we fall in love with our intention, or our lines, shapes, colors, and images, thinking we have something to protect. But there's another way to look at it: What do we have to lose?

2. *Intentionality Does Matter, Sort Of*

Try to imagine how your work looks in its ideal version. This may expose the measure of how much you have fallen short of your ideal. Try not to waste time defending something that is probably not the final draft. You might even come to realize that the thing you wanted to express isn't all that compelling after all. It's a relief sometimes to let go of things that no longer serve. Comparison is teaching's shorthand. If we make a comparison between your work and something in the world that it on some level resembles, see it in the best light. Ask yourself: Is this what I was trying to say? Originality often lies on the other side of familiarity. While ideas can drive the work, what constitutes an art idea may not be as simple as it seems. The thing we call talent is partly having the *right kind* of idea. Actually, ideas are not likely to be a problem—we all have plenty. In fact, it's *finding the appropriate form* that is hard. Aspire to let talent, idea, and form come together in a way—each one activated—that is malleable enough to let the unexpected or even the untoward rise to the surface.

3. *Trust the Process*

I have always found it a relief to let go of stuff that I only partly believe in. It makes me feel lighter, better. To that end, we won't tell you something is great if it is not. Honesty, brutal or otherwise, is also the social contract here, with a certain basic consideration as a given.

This is not a contact sport; we don't believe in kicking people when they're down. Some opinions will be off the mark and may confuse you. Of course, we can all be *wrong*. However, "you don't get it" is not a sufficient rejoinder to criticism. Even in the unlikely case that it's true, your job is to be able to explain exactly *in what way* your point has been missed; it's your only assurance that there is indeed a point to be gotten in the first place. A lot of points have a way of evaporating when you have to explain how they are manifest.

4. We're All Pros Here

The kind of thing I'm talking about—extreme honesty, hard looking—works best if we're in agreement about why we are all here. The assumption is that you are pursuing careers as working artists. Obviously, I don't mean that you will all become artists who show their work in high-profile galleries—I know that many of you likely have no interest in that path, that you have a very different idea of the shape you want your career to take, but the economics of it is not the point. When I say "working artist," I mean simply a person for whom making art, and participating in the larger art conversation, is central to his or her identity, and not something done to become a more well-rounded something else. If you are here as a kind of art tourist, that's OK, too; just take whatever you can use and ignore the rest. But if you're here because you can't *not* make art, or can't imagine your life without that empowering, free-falling, slightly scary, almost illicit thrill of *creating*, of using your ability to give form to your imaginings—if that is how you see yourself, then the kinds of things we will talk about here might ease you over some of the developmental hurdles. Except in very few cases, the hurdles all still have to be gotten over; we're just trying to take them faster, with less bruising. Part of how we will do that is to be scrupulous in acknowledging what is and what is not the case.

When confronted with negative feedback, our instinct is often to reject it out of hand. Try to resist. We tend to think of criticism as all right or all wrong; that someone is simply in sync with your work or not. Rather, I'd argue, it's a matter of degree. Criticism of any sort stings because on *some level* it's true. Even when it's biased, willfully obtuse, or unobservant (and we see these kinds of criticisms all the time), it can still produce a frisson of recognition and end up being constructive. Even when it's wrong, try not to bat it away too quickly, before seeing if there isn't something useful inside the snowball.

5. What Are Aesthetic Values?

We tend to think of aesthetic values as somehow independent of all other values, but I think the opposite is true. What is it that we value in people? Imagination, humanity, wit, charm, joy, suffering transformed, penetrating intellect, warmth, physical assurance, humility, sexual charisma, daring, wisdom? Take your pick—it probably has an aesthetic manifestation. "A work of art is not an oracular outpouring, but an object which has been constructed deliberately with the aim of producing a certain effect." Can we all agree on that, *for the purposes of advancing our work*, this is a useful idea? Would it surprise you to know that the phrase was written in 1931 by Edmund Wilson to describe the work of T. S. Eliot?

6. This Process Doesn't End When You Graduate— Because We Never Graduate

I recently saw an early work of mine from 1977 hanging in the storage racks of the Menil Collection in Houston. It happened to be next to a Warhol painting—nothing special, not Andy on a good day, but a Warhol nonetheless. I think it was one of his glitter shoe paintings. Pretty bland image, but good color. One of his more phoned-in iter-

241

ations. *My* picture, by comparison, the thing I had come to in a state of almost deranged inspiration and complete originality some thirty-five years ago, on *this* day looked like nothing so much as a medium-sized hangover, rendered in tones of grayish green. Anemic, tepid, unresolved—in short, full of wishful thinking. So deficient was my picture compared to the Andy it was hanging next to, it sort of took my breath away. I hadn't seen that particular picture of mine in well over thirty years, but in my mind's eye it had long been established as a kind of impudent, nervy little picture. I hadn't remembered it as *so weak*. I was left feeling pretty low. Then I had the somewhat self-serving, ameliorating thought: I had not, in my early twenties, had the benefit of an Emile de Antonio or a Henry Geldzahler to guide me in my studio. Let me explain. Emile de Antonio, or Dee, as he was known, whom I got to know a little bit late in his life, and Henry, whom I knew very well, and loved, were two of the people who, at crucial moments, told Andy what to paint. This is true. Andy would show them a few different things, some with drips, some clean, and they would say: : "Do this, this is great; that thing over there is nothing. Throw it out." Not that Andy wouldn't have figured it out on his own, but it's possible that Dee and Henry saved him years of floundering. Like most other young artists, I had no one to tell me how provisional my work was—how tentative. I wish someone had said to me: "What are you so afraid of?!" There is an unwritten rule that artists are not supposed to tell other artists what to do, because it might interfere with their singularity. And while it is true that bad editing can be harmful, no editing at all is likely to cost you time, sometimes years. Let's try to be the Dee and Henry for each other.

Exercises

Getting more deeply into what works of art are really like, we can start to see the points at which style, personality, and temporality

intersect. These exercises are really more on the order of party games, something that can be done on a long car trip, or with friends in a bar. Their purpose is simply to encourage you to think in a nonliteral, as well as nonlinear, way. Forget what you think you know about historical movements or generational tendencies or meanings—generalizations of any sort. Ask only: What does this work make me *feel*? And, *What do I find myself thinking about?*

A. LET'S MAKE A SHOW
Imagine that you are the curator of an infinite museum collection and can make an exhibition without any logistical constraints. Hang anything next to anything. As the cliché goes, the only limit is your imagination.

Make a list of ten or more combinations of three or four artists that together illuminate some less-than-obvious quality in one or all of the group. The quartet—or trio—might emphasize congruencies of tone, vocabulary, concision, interiority, scale, gregariousness, refinement, materiality—or their opposites. Some choices will simply be a matter of what looks good next to what, which will in turn raise the question of shared sensibility. Some groupings will expose a particular *problem*, or contradiction in the sensibility.

Limiting myself to twentieth-century American art, here are some examples. Of course, to be most convincing in one's juxtapositions, and to really visualize the mini-exhibition in your head, *specific* works should be cited, but the names alone are a start. Notice how each grouping produces a different vibration. Think of the artists as notes, and the triads or quatrains as analogous to musical chords.

In a further refinement of the game, which can also be played—is more fun when played—in a group, keep one artist as a constant and change the other "teammates," round-robin style, introducing a new name every third or fourth round. The first few groupings that follow are examples of the variation.

Albert Pinkham Ryder, Marsden Hartley, Clyfford Still
Marsden Hartley, Richard Serra, Myron Stout
Myron Stout, Robert Gober, Kiki Smith
Kiki Smith, Florine Stettheimer, Andy Warhol (early)
Robert Gober, Eva Hesse, Jasper Johns
Jasper Johns, Richard Avedon, Georgia O'Keeffe
Richard Avedon, Jackson Pollock, Alex Katz
Frank Stella, Josh Smith, Lucas Samaras
Josh Smith, Matthew Barney, Carroll Dunham
Carroll Dunham, Charles Burchfield, Maya Deren
Maya Deren, Catherine Sullivan, Nari Ward
Charles Burchfield, Terry Winters, Lee Bontecou
Terry Winters, Kara Walker, Philip Taaffe
Kara Walker, Lee Bontecou, Charles Burchfield
Walt Kuhn, Richard Prince, Robert Rauschenberg
Richard Prince, H. C. Westermann, Saul Steinberg
Saul Steinberg, Richard Prince, John Baldessari
John Baldessari, Paul Outerbridge, Louis Eilshemius,
 Craig Kauffman
Matthew Barney, Lucas Samaras, Weegee
Weegee, Carroll Dunham, Alice Neel, Amy Sillman

B. BUILD YOUR OWN ANALOGIES
The giant bean sculpture by Anish Kapoor in Chicago's Millennium Park is a work that says, "There will be ice cream."

Choose ten works of art, and for each one make a sentence that begins, "This is a work that says . . . ," and complete the analogy. Do *not* use only food comparisons.

C. THE FAMILY TREE
Build an imaginary family tree of resemblances around an artist of your choice. List all stylistic intersections and shared affinities you

can think of. The point is to jump over the obvious to reach beyond generational and national boundaries, material, or even philosophical identity. Each comparison creates a different shading, brings out a different side of the artist in question. Some will be obvious precursors; others will be second or third cousins; still others might simply be shadows that are momentarily cross the work's path. Be prepared to explain your choices. Example:

> Jeff Koons. Family tree: Warhol, Dalí, Lichtenstein, H. C. Westerman, Eilshemius, Courbet, Charles Ray, Duane Hanson, the Muppets, Larry Flint, Duchamp, Lynda Benglis, Walt Kuhn, Egyptian temple sculpture, Ray Johnson, Masters and Johnson, Howard Johnson's, and Johnson & Johnson.

D. COMPARE AND CONTRAST
Compare two works of art that are stylistically similar but are of different intensities—things that might be described in similar terms while talking on the telephone but are in fact quite distinct. Don't assume there is an a priori qualitative difference—arrive at it as a conclusion. Examples:

> Morris Louis and Paul Jenkins: Both artists pour paint. Louis makes structure out of gravity and chance. Jenkins's pouring results in . . .
> Cubist Picasso and Jean Metzengier
> Piero della Francesca and Balthus

E. SIMILES—WHAT'S IT LIKE?
Describe a work of art with a sentence that begins, "This is a work that puts me in mind of" The remainder of the sentence has to be from a different part of life than the work being described—i.e., the comparison cannot be another work of art. For example:

Wade Guyton's paintings *put me in mind of* the all's-well-with-the-world feeling you get buying unassailably correct penny loafers at a good preppy clothing store.

F. LITERARY EQUIVALENTS
Compare a visual artist to a literary one. Examples:

Rosemarie Trockel = Emily Dickinson
Jasper Johns = Hart Crane
Antoine Watteau = Sybille Bedford
Lucas Samaras = Paul Bowles
Richard Serra = Theodore Dreiser

G. PUTTING YOUR OWN WORK IN CONTEXT
Rudi Fuchs, the former director of Amsterdam's Stedelijk Museum, once had an idea for a show: Clyfford Still, Frank Stella, and myself. Come up with five groups of three artists each, with yourself as one artist in each group. You may be surprised at what this exercise reveals about your own work, and about your attitude toward it.

H. WHERE WOULD IT FEEL AT HOME?
We can get a pretty good idea of what a work's values are by imaging where it looks most at home. Where does it belong? What is its natural context? Is it rural or urban, uptown or down, velvet-rope private or public piazza? Imagine ten works of art of diverse styles and give the ideal place where each would be seen. Examples:

Tracey Emin neon world sculpture—upscale restaurant or bar
Anselm Kiefer—reform synagogue

I. DEBATE

This exercise requires two players, one to take the "pro" side, and one to argue against. Using whatever you can recall from Robert's Rules of Order, you will have fifteen minutes to debate a topic from the following list. The rest of the class, or the party, will vote to declare a winner.

Good art has a mythological dimension.

Good art should make clear its opposition to the dominant culture.

Photography is overrated.

Conceptual art obviated the need for painting.

The best art speaks to the greatest number of people.

Mechanical reproduction destroyed the aura of the unique artwork.

Good art should privilege identity politics—e.g., race, class, gender.

Good art should transcend identity politics.

J. BUILD YOUR OWN APHORISMS

Make an aphoristic observation or statement in response to the following six prompts. I have supplied some as examples. Once you get the hang of it, invent aphoristic sentences for themes of your own choosing. You may work in teams for this exercise.

On Bad Paintings: The actress character in Patrice Chéreau's film *Intimacy*: "My lack of talent won't kill me."

On Photography: Tip Dunham once said to me, "Oh, you're the guy who *let photography in.*"

On the Erotic: Philip Johnson once offered up this pearl: "That slight tumescence you feel is part of looking."

On Boredom: Boredom is what happens when the truth about something can't be told.

On Success: The old chestnut about not being able to argue with success—it's antithetical to art. You can, and should, argue with it plenty.

On Illustration: Illustration is painting with a foregone conclusion.

K. PREDICTIONS

George Trow wrote, "My prediction as to the visual arts is: a new set of proportions will evolve and seem true to the best minds, or they will not emerge and, as the best examples of twenty-first-century art, we will have crude (but vital perhaps) portraits of warlords."

Make up ten of your own predictions: five of the "new set of proportions will evolve and seem true" variety, and five of the "portraits of warlords" variety.

ART IS NOT A
POPULARITY CONTEST

A Commencement Address Given at
the New York Academy of Art, 2011

It seems just yesterday I was an enfant terrible, knocking on the door of the house of art. I don't even remember being invited inside. Nevertheless, time passes. Now I'm up here.

I think it's fair to say that failure is the last taboo in American culture, but what do success and failure mean in the context of art? These binary poles are really a matter of perception, and for an artist, producing aesthetically successful work, work that succeeds on its own terms, and being a popular success, are two different things—or at least they used to be. There seems to be some confusion about this now. It might just be my sensibility, but I've always been attracted to the idea of the noble failure; the attempt at something that was probably bound to fail at some point, but the contemplation of which is exciting nonetheless. But this archetype of the noble failure doesn't seem to have much currency anymore; in fact, it probably went out of fashion about the same time that the alienated hero was given a pink slip. If there's no honorable status in being alienated, then the meaning of failure changes. One of the things that happened following the collapse of the formalist hegemony that once dominated the

art world is that people began to want a kind of art that was more accessible and communicative—more popular. Art *had* to be more communicative—it had to earn its keep in the cultural marketplace, so to speak. And the people who wanted greater visibility, greater likability, for contemporary art got their wish. Which is fine, or even great—but it does come with a price. When I first began exhibiting my work, the idea of artists being known outside of the art world was a novelty that excited some people and offended others. Regardless of where one stands on this issue, there's no arguing the fact that today the audience for art has expanded exponentially, and one result of that expansion is that you can't always tell the difference between art and entertainment. How much this matters, I don't know; or rather, it will matter differently to different people. It's useful to remember, though, that when it comes to art, there isn't necessarily a clear relationship between popularity, however you measure it, and quality. Sometimes the most popular art is also the best, but it's not something you can count on. Popularity in art is similar to that in politics: the result of a simple message, endlessly repeated.

Some people seem to feel that artists are too malleable to retain their values if they come into contact with money and media attention, that popular culture's lure is too strong to resist. This is a silly idea; if you're an artist, these things won't change what you do, and if you're not an artist, the vagaries of the marketplace don't make much difference anyway. The belief persists that art is something that continues sending out signals longer than the forms of popular culture, and I hope this belief is never lost. Despite the art world's public transformation, things haven't changed much for artists. I still spend most days in my studio, alone, and whatever happens in the rest of my life flows from that. You could be driven mad by the discrepancy between what artists have come to stand for and what they actually do in the studio.

One of our core beliefs is that art is not a popularity contest. My

friend Eric Fischl recently published a memoir, and we can use his book as a starting point for talking about how to define one's relationship to the new, expansive, and contradictory art world. Eric's book is a nakedly honest account of one artist's struggle to find an authentic voice as a painter, mixed in with the bildungsroman narrative. He also shares his opinion of other artists' work, and dares to break an unwritten code that holds that artists must not criticize other artists in print. This is something all artists do in private, of course. In fact, there are really only three types of conversation among artists: complaining about critics, bashing other artists, and real estate. I'd encourage you to not be like that, but you'll find it hard to resist. Eric, in his mission of honesty and self-examination, wrote openly of his skepticism and occasional disdain for artists like Jeff Koons and Damien Hirst; while acknowledging their enterprise, he denigrated their reductivism and show-biz gloss. The kind of fait-accompli triumphalism surrounding this kind of work is seductive, and when there's an abundance of agreement, money, and cultural thrust propelling it to ever greater heights of public approbation, for one artist to publicly say "I don't think this is very much" takes nerve. Whether or not you share his opinion, Eric dares to argue with success, and that deserves our respect.

What does it have to do with us, here, today? Maybe only this: that an artist need not believe in the wisdom of crowds. On the other hand, an artist can all too easily hide his or her own shortcomings by rejecting out of hand whatever gods, false or otherwise, the crowd decides to worship. For artists of a certain temperament, it's too easy to dismiss large swaths of art as being beneath consideration, and one must make an effort not to fall into this us-versus-them trap. I don't happen to agree with Eric's assessment of Jeff Koons's work, but that's neither here nor there; the point is that the work has become a cultural signpost, and to ignore it would be willfully obtuse.

What this pluralistic expansion means for you is simple: never

before in history have more things been possible in the name of art. It's a vexing paradox you face: on the one hand, there are strict rules of engagement; on the other hand, anything you can get away with is valid. Contemporary art continues to be a highly elastic context. Be you a choreographer, cultural anthropologist, philosopher, fashion designer, techno inventor, or garden-variety autodidact freak, the art world, in its egalitarian generosity, will open its arms, and possibly even celebrate you, for the very otherness you project. There's always a berth for you here. Consequently, more people, from more parts of the globe, doing more extreme, sensational, and occasionally wonderful things, are calling themselves artists than ever before. This is great, but it also means that as young artists, your competition just went way up. If everybody can be an artist, where does that leave you? Maybe that's the way mankind was meant to evolve. Who knows? For now, though, let's acknowledge one truism: there will never be another Andy Warhol, and young artists can stop applying for the job.

Taking a few steps back, we find ourselves at the subject of art school. Art school is like every other kind of school, only more so. It's a kind of fiction that masks a challenging situation. Whatever your expectations about the world you're poised to enter, the simple truth is this: nobody is waiting for you to take a seat at the table of esteemed creators. Nobody's even waiting for you to take your place at the table of studio assistants. No one's waiting, period. You'll go from an environment where people regularly respond to what you do and who you are to a world where your calls probably won't be returned. There's likely to be no echo at all. This shift is more dramatic than you might imagine, and it will test your inner resources and very desire to be an artist. Chances are you won't have it easy—it won't feel easy, in any case.

At the same time, there's a powerful force at work in culture today that makes getting your voice heard much easier than it used to be. Although indifference still reigns behind the velvet rope of the posh

gallery, our culture—and art culture in particular—is heavily invested in anything made by, pitched to, or representing the young. It's an almost poetical contradiction. On the one hand, no one's waiting to embrace the full flowering of your specific, finely tuned sensibility; on the other hand, everyone's anxious to see what the next new thing will be. It's a schizophrenic hybrid of "Don't call us, we'll call you" and "What have you got for us, you interesting young person?!" Young artists today are the beneficiaries of a widespread belief in the power of youth to get it right, to not only refresh us but deliver and liberate us. Mind you, this blessed state will disappear when the next generation comes along with yet another slightly different idea of itself, but until then, you have an opportunity to bend the conversational focus your way. You will come to be seen as having oracular powers that allow you to see into the future and distill myriad vibrations and tendencies into what will be taken up as the new sensibility. It's pretty heady stuff, and some of you will catch the wave and harness its power to your own impulses, drives, and talents, and come up with something of lasting value. The downside to this process, however, is that while you may get to be a harbinger, you may not get to be anything much beyond that.

A brief historical perspective. Although my MFA graduating class of 1975 didn't know it at the time, the decades-long hegemony of formalist, minimalist-inflected art that had been championed by *Artforum* and so-called advanced museums was coming to an end. Sometime around 1974 I overheard someone ask the poet and critic David Antin, "What have you been doing these past years?" To which David, always quick on the draw, replied: "Waiting for minimalism to die." That's what many of us were doing, and it took a long time. A clear power structure had dominated the New York art scene, and by extension the international one, for years, and it operated in a narrow, exclusionary, hierarchical, and isolationist manner. The philosophical temperament underlying this aesthetic engineering believed in formal

progress; this outlook professed to be utopian but was authoritarian in practice. It was great if you were one of the five or six artists whose work was taken up, but it was misery if you were not among the elect. It took a long time for this structure to weaken, but once begun, the collapse came fairly quickly. The crack in that structure coincided with the same rumblings from the underground—feminism, gay activism, new social philosophy—that changed the rest of the world. It was also the beginning of a globalization brought about by widespread, affordable air travel, a new wave of more far-flung immigration that came with it, and, finally, an exhausted art economy that paradoxically opened the doors to all kinds of alternative behavior. If we weren't going to be able to make a living anyway, we might as well have fun doing it, whatever *it* is.

Coming to us from the fourteenth century is what may be the first art criticism on record. In *The Divine Comedy* Dante writes, "Cimabue held the field to himself—until Giotto came and put him in the shade." It could be a blog post or an item in the *New York Observer*. Being an artist means having critics, and part of learning how to be an artist in the world is learning to accept, with some measure of grace and equanimity, the fact that there are people who will use you to advance their own arguments and agendas. In releasing your art into the world, you offer a cultural sign that can be denigrated, and whose very validity can be questioned. It can take years for those of us lacking the temperament of the Buddha to overcome the natural human response of wanting to challenge those who denigrate what we've created; this is a waste of time, however, and you'll derive much more from any encounter you have with critics by offering a simple "thank you": thank you for the opportunity to learn something about my work and, by extension, myself. The inherent divide that separates artists and critics stems from the critic's basic orientation. As Aristotle said, "Art is concerned with production." In the simplest possible terms, the artist makes art within the purview of what is under his or

her direct control—and, believe me, this is a microworld, regardless of how expansive or broad one's working premises are. The artist's world is the aesthetic equivalent of the locavore who demands that everything be homegrown. The critic, on the other hand, takes a macroview of art and evaluates it within the context of the larger culture; this perspective is encouraged, if not demanded, by newspapers, magazine editors, and the public itself.

Since the dawn of modernism, we've been awash in theory, and theory is shaped by the vagaries of fashion. The specific buzzwords and phrases that seem so rich with meaning and information today—"identity," "appropriation," "gender politics"—are part of fashion, and no one will be uttering them a decade or two from now. Just as no one today uses phrases like "existential crisis" or "confronting the void," which were commonly heard in the '50s, other words and phrases will arise to replace them. It comes down to what kind of story we, as artists, want to tell about ourselves: from the physics of relativity early in the twentieth century, to Freud and theories of the subconscious of the '30s that led to surrealist symbolism, to the Marxist theory of the '40s that led to formalism, the Frankfurt school, and Theodor Adorno, to American minimalism, to the structuralists, poststructuralists and the Situationists in France in the 1960s, to Merleau-Ponty's phenomenology, to Walter Benjamin's critique of the unique object—modern art has always hungered for philosophical, theoretical, and verbal expression as an armature on which to hang what are primarily visual, nonverbal phenomena. And if reading something can help get you from one place to the next, liberate you, get you out of a rut of thinking and habit, that's a good thing. However, because of the high level of anxiety and uncertainty connected with being an artist, the theoretical and the philosophical can be counterproductive if they constrain rather than liberate the imagination.

When I hear an artist utter the words "This work is about . . . ," it

makes my heart sink. I've always felt that intentionality is overrated—
not that it's irrelevant but that it's been overstressed, and art schools
have encouraged this approach. In the '80s and '90s critics routinely
asked me, "Why do it in painting?" Which I felt was the wrong ques-
tion to ask, because it assumes that one chooses painting and uses it to
illustrate an idea. I don't think the medium one employs necessarily
defines the character of the art, any more than a form or genre of writ-
ing describes what a writer has to offer. Of course some people can't
wait to move into uncharted waters, but we don't, by and large, ask of
a novelist, "Why are you still writing novels?" What art expresses is
medium-specific to some extent, but in practice making art isn't like
selecting things off a menu. This might sound strange, and it may not
be true for everyone, but there is a way in which the medium, and
even the subject, chooses the artist, rather than the other way around.

How do you recognize a new paradigm, and would it really matter
if you could? How does one learn to really look at things? I think it's
a good practice when looking at anything to try to be aware of what
you actually find yourself thinking about—which is often different
from what you know you're supposed to be thinking about. We all
know what the message is supposed to be, but it's important to ask
yourself: Is this really true for me? Instead of reading the work as a
cultural sign, ask yourself: What is the rhythm of this artwork? What
does it love, and from what does it suffer? Is it asking more of the
audience than it gives? Where does its heart lie? These are the things
that define its character. An example of what I'm talking about is
something the critic Sanford Schwartz observed about Cindy Sher-
man. Reviewing her recent MoMA retrospective, Sandy wrote that
her work was "on par with her expressionist co-generation." That may
not sound like big news—it's a simple thing, almost obvious—but
it was the first time I'd heard anyone say something about the *inside
energy* in Cindy's work, distinct from what it has been taken to rep-
resent in terms of cultural politics, feminist theory, or the history of

photography. All those things are also true, and people believe them, but at this juncture, it's interesting when a perceptive writer like Sandy Schwartz, in the simplest, most direct way, digs underneath the partisan claims. What does Cindy's work express? The existential angst and loneliness in common with other artists of her generation.

So, what are we left with; where's the advice part? I'm not quite sure, but I can tell you that having good manners is always a plus. In regard to your own work, you must ask yourselves whether what you're doing feels like your life. Does it align with your highest self? Or lowest, which can also be interesting. Don't be afraid of the dumb idea, but don't be afraid to be smart. Just don't be afraid, period. Be patient, be brave, and be lucky. W. H. Auden once wrote: "We were put on this earth to make things." Beautiful line. You can trust it.

John Baldessari. *Portrait: Artist's Identity Hidden With Various Hats*, 1974.

QUESTIONS WITHOUT ANSWERS
FOR JOHN BALDESSARI

F or a very long time John Baldessari had the distinction of being
the tallest serious artist in the world. To paraphrase A. J. Lieb-
ling, John was taller than anyone more serious, and more serious than
anyone taller. As was inevitable, Baldessari's hegemony in the height
department has now been challenged by a handful of younger artists.
What, is there to be no progress? Paul Pfeiffer, Richard Phillips, and
certainly Mark Bradford have approached and possibly even surpassed
Baldessari's measure. If it is true that these artists can see farther than
their fellows, it is only because they have stood on the shoulders of
giants such as Baldessari himself (which, in Bradford's case, would
make him nearly thirteen feet tall).

John has been a friend for more than forty years. He was my men-
tor when I was a student at CalArts in the early '70s, and it's fair to
say that meeting him redirected my trajectory as an artist—as it did
that of innumerable others. His legendary class in Post-studio Art
bestowed on those of us with enough brains to notice a feeling of
unbelievable luck—of being in exactly the right place at the right
time. The *new freedoms* in art—we had arrived for the birthing.

From a somewhat less than auspicious beginning, art history has
turned out to be on John's side. He initiated a use of pictures, photo-

graphs mainly, often with words in counterpoint, that has influenced generations. A life in art is full of contradictions: an art born out of a desire to sidestep personal taste has become a universally recognized style—one that signifies a highly refined level of taste. Despite, or perhaps because of, John's contrarian nature, he is firmly in the canon. His art is about many things—intellectual and emotional; witty, acerbic even, at times also melancholic, poignant, and self-revealing. John has often used the form of the fable in his work—and his life has that same quality: a young man from nowhere-ville, with no obvious prospects, bends the course of art to his vision. Along the way, he makes levity and gravitas trade places.

I posed these questions to John at the Metropolitan Museum at the time of his exhibition there in 2010. Sitting in the greenroom, John and I had time for a little gossip before the floodgates opened and his public rushed in. The questions were later published—without answers—in the *Paris Review*.

I have always felt a deeply humanistic undertone in your work, despite its use of irony and obliqueness. But I am hard-pressed to account for it. Sometimes I think it's because I have known you for a long time. Where do you think it resides?

Is a conceptual artist different from any other kind of artist?

A lot of ink has been spilled about art as the new religion, with the museum as its church. Do you agree with that view? Do you crave a spiritual dimension to art, or are you a pure materialist? Conceptualism is closest to: (a) rationalism, (b) romanticism, or (c) symbolism? Where do you place yourself on that scale? (Hint: Romanticism insists on the primacy of the individual.)

Here's a fan question: How did you come up with the idea of singing LeWitt? I understand the desire to tweak the seriousness of conceptual art, but how did you arrive at the idea of the *singing*? And did you rehearse?

What's the one thing an artist must never do? And, apart from questions like these, what is your definition of a bad art idea?

Harold Brodkey once said that people don't like to be outshone—they'll kill you if it bothers them enough. How have you managed to avoid this in your work?

What is it that you most persistently and coherently think about in your work? What place do aesthetic effects have in your work? What's the most tenacious misconception about your work?

How important is intention in art? What did you do that was new?

Do you agree that you brought a new poetics to art? If so, how would you describe it? (Hints: the metonym, or synecdoche effect; the part for the whole, the fragment.)

In what way is your work American—does it have any strains of puritanism, transcendentalism, evangelism? Do you have any sense of nationalism in art?

Bruce Nauman once told me that the most useful piece of advice he ever got was from Bob Irwin. Irwin told him to always slip the head carpenter a $20 bill when showing in group shows—to ensure that his piece would get built in time. Did you get any useful advice from an older artist?

You have always been a very responsible guy—an immensely productive artist, generous teacher, devoted father, art-world citizen. Does it ever make you a little wistful not to have been more of a screw-up?

George Trow once wrote that every language has a secret moral history. Do you think it is also true for visual languages, and if so, what is the moral history of the visual language you have done so much to bring into common usage?

Who is smarter: a painter of average intelligence or a really smart dog?

You have courted obscurity in your work from the beginning— especially in the '70s—and you have also made works of striking literalness. What is the relationship between the two?

Do you feel you have left obscurity behind? If so, is that one of the benefits of working over a long time?

Are you nostalgic about anything? Do you ever feel like Dr. Frankenstein, having had such a role in creating the monster of "conceptual art" that has so taken hold of art education and academia?

What do you feel when you hear an art adviser say, "I'm interested in work with a strong conceptual bias"? This is an overheard conversation, verbatim.

André Gide famously said he did not want to be understood too quickly. Care to associate to that? What quality in your work do you wish you had more of? Less of? George Trow again: "The writer has to have a machine gun in his heart." Any thoughts?

Why do you think people insist on adding the word *practice* after the word *art*?

This question has been sent from the beyond by André Breton, the leader of the surrealist movement: "Could you ever make love to a woman who does not speak French?"

And the follow-up: How would you explain the continued, pervasive influence of surrealism even as the legacy of Freud himself seems to be fading? Psychoanalytically speaking, what are you trying to recover or replace in your work? Apollinaire wrote, "When a man wanted to imitate walking, he invented the wheel which does not look like the leg. Without knowing it, he was a Surrealist." I'm not sure why, but this kind of reminded me of your work.

If you were a songwriter/lyricist, would you consider it a crime to sacrifice meaning to rhyme?

Do you still claim to not know what art is? What if your family was being held captive, and you had to come up with a convincing definition to gain their release? Edmund Wilson wrote that Flaubert had more in common with Dante than with Balzac—someone who was his contemporary and who was using the same form, the social novel. Who is an artist you think you have something in common with who may not be the obvious one? Who would you like to be shown next to?

What are the sweetest four words in the English language? (Hint: better late than never.)

What is the difference between wit and humor? Apart from yourself, name two or three funny artists.

You once said something to me about a fellow student's self-loathing as the engine of their art—an idea that surprised me at the time. Is that something that you think about often?

What, if anything, did you learn from Ileana Sonnabend?

If a law were passed that artists were only allowed to work in pairs or groups of three—that is, if art could continue but the individual artist was outlawed—with whom would you want to form a team?

What, if anything, makes a work safe from "rust and larvae"? (Hint: not its social importance but its art, and only art, says Nabokov.) If continuing to make art meant that someone you didn't know would be physically hurt, would you stop? Or would you just find a way to make something that didn't look like art? What do you think you represent to the people who admire your work?

Do cultures go through fallow and fertile periods?

When you find your inspiration flagging, are there things you do to revive it? Have you shown a feminine side in your work?

How would you describe Duchamp's genius, and why do you think you found it so congenial?

Do you believe in the idea of a masterpiece, and what qualities must a work have to qualify as one?

What aspect of your personality has created the most problems for you in life, or in art? Do you think of yourself as brave? And if so, in what way? Do you think it's possible for art to lie—and remain art?

Sanford Schwartz described the persona in Philip Guston's work as "Am I a genius, am I a fraud, I'm dying." Where is the angst in your work? How would you describe your work to an extraterrestrial who had just come to Earth from another planet, one where they don't make art?

Which is better for an artist: to be loved or feared?

CREDITS

267

CREDITS

Page 64 Roy Lichtenstein, *Reflections (Wimpy III)*, 1988, oil and magna on canvas. Dimensions: 32 × 40 in. (81.3 × 101.6 cm). © Estate of Roy Lichtenstein.

Page 74 Jeff Koons, *Puppy*, 1992 or 1997, stainless steel, soil and flowering plants, 40 ft. 8³⁄₁₆ in. × 27 ft. 2¾ in. × 29 ft. 10¼ in. (12 m × 40 cm × 830 cm × 910 cm). © Jeff Koons. Photo: © FMGB Guggenheim Bilbao Museoa, 2016, photo by Erika Barahona Ede.

Page 84 John Baldessari, *Movie Scripts / Art: . . . One must act quickly . . .* , 2014, varnished inkjet on canvas with acrylic paint, 62¹³⁄₁₆ × 108 in. Courtesy of the Artist.

Page 90 Wade Guyton, *Untitled*, 2006, Epson Ultrachrome inkjet on linen, 90 × 53 in. (228.6 × 134.6 cm). Photo Credit: Larry Lamay.

Page 90 Rosemarie Trockel, *Lucky Devil*, 2012, wool, plexi, crab, 90 × 77 × 77 cm. © Rosemarie Trockel, VG Bild-Kunst, Bonn 2016 / resp. ARS Courtesy Sprüth Magers.

Page 98 Vito Acconci, *The Red Tapes*, 1977, Video, black-and-white, sound, 141.27 min., courtesy of Electronic Arts Intermix (EAI), New York.

Page 104 John Baldessari, *Four Events and Reactions* (detail showing *Touching a Cactus*). 1975, artist's book. 5 × 7 in. Courtesy of the Artist.

Page 116 Karole Armitage in *The Elizabethan Phrasing of the Late Albert Ayler* (1986). Set and costume David Salle. Photo by Julio Donoso.

Page 122 Julian Schnabel, *The Diving Bell and the Butterfly*, 2007 © Julian Schnabel.

Page 128 Malcolm Morley, *B25 Liberator Over Independence*, 2013, oil on linen, 67 × 74 in. (107.2 × 188 cm) © Malcolm Morley, courtesy Sperone Westwater, New York.

Page 138 Marsden Hartley (1877–1943) *Granite by the Sea*, 1937, oil and ink on composition board, 20⁷⁄₁₆ × 28⅝ in. (51.9 × 72.7 cm). Whitney Museum of American Art, New York; purchase 42.31.

Page 138 Philip Guston (1913–1980) *Cabal*, 1977, oil on linen, 68 × 116⅛ in. (172.7 × 295 cm). Whitney Museum of American Art, New York; Fiftieth Anniversary gift of Mr. and Mrs. Raymond J. Learsy 81.83 ©The Estate of Philip Guston Digital Image © Whitney Museum, NY.

Page 142 Urs Fischer, *Dried*, 2012. Aluminum panel, aluminum honeycomb, two-component epoxy adhesive, two-component epoxy primer, acrylic primer, gesso, acrylic ink, spray enamel, acrylic silkscreen medium, acrylic paint 97 × 72 × 1¼ in. (243.9 × 182.9 × 3.2 cm) © Urs Fischer. Courtesy of the artist and Sadie Coles, HQ, London. Photo: Mats Nordman.

Page 152 Jack Goldstein, *A Glass of Milk*, 1972, 16mm film, b/w, sound, 4'4" film still. Courtesy Galerie Buchholz, Berlin / Cologne / New York and the Estate of Jack Goldstein.

Page 158 Mike Kelley, *Catholic Birdhouse*, 1978, wood, paint, composite shingles. 22 × 18½ × 18½ in. © Mike Kelley Foundation for the Arts. All Rights Reserved / Licensed by VAGA, New York, NY.

Page 164 Frank Stella, *Jill*, 1959. © 2016 Frank Stella / Artists Rights Society (ARS), New York.

Page 182 André Derain, *Still Life with Pumpkin (La Citrouille)*, oil on canvas, 1939, 40 × 52 in. Santa Barbara Museum of Art, Bequest of Wright S. Ludington © 2016 Artists Rights Society (ARS), New York / ADAGP, Paris.

Page 192 Francis Picabia, *Femmes au bull-dog*, 1941–1942, oil on cardboard, 106 × 76 cm. ADAGP CNAC/MNAM/Dist. RMN-Grand Palais / Art Resource, NY / Picabia, Francis (1879–1953) © 2016 Artists Rights Society (ARS), New York / ADAGP, Paris.

Page 204 Barbara Bloom, *Spice Container*, Poland, first half nineteenth century, Silver. Traced, cast, pierced, 5½ × 2⅝ × 2¹⁄₁₆ in. The Jewish Museum, New York, Gift of Dr. Harry G. Friedman, F 3029.

Page 210 Richard Aldrich, *Two Dancers with Haze in Their Heart Waves Atop a Remake of "One Page, Two Pages, Two Paintings,"* 2010, oil and wax on linen, 84 × 58 in. Courtesy the artist and Bortolami, New York.

Page 222 Piero della Francesca, *Legend of the True Cross: Battle of Heraclius and Khosrow*—detail (bugler). Ca. 1450–1465. Post-restoration. Photo credit: Scala/Ministero per i Beni e le Attività culturali / Art Resource, NY.

Page 258 John Baldessari, *Portrait: Artist's Identity Hidden With Various Hats* (detail), 1974, black-and-white photograph, 19 × 93.5 in. Courtesy of the Artist.

TEXT CREDITS

"Alex Katz: The How and the What": Salle, David. "Alex Katz Interviewed by David Salle," *Alex Katz*, Klosterneuburg, Austria, Essl Museum, 2012: pp. 22–32. Salle, David. "Cool For Katz," *Town and Country*, March 2013: pp. 56–57.

"Amy Sillman: A Modern-Day Action Painter": Salle, David. "Amy Sillman and Tom McGrath," *The Paris Review*, no. 195, Winter 2010: 173–175.

"Christopher Wool: Painting with Its Own Megaphone": Salle, David. "Urban Scrawl," *Town and Country*, November 2013: pp 64, 68.

"The German Miracle: The Work of Sigmar Polke": Salle, David. "Polke Party," *Town and Country*, March 2014: pp. 64, 66.

"Robert Gober: The Heart Is Not a Metaphor": Salle, David. "Drainman," *Town and Country*, December 2014/January 2015: pp. 102–3.

"Dana Schutz: A Guy Named Frank": © *Artforum*, December 2011, "Dana Schutz, Neuberger Museum of Art, Purchase College, State University of New York," by David Salle.

"Roy Lichtenstein: Change Is Hard": Salle, David. *Roy Lichtenstein Reflected*, New York: Mitchell-Innes & Nash, 2010.

CREDITS

"The Art of Childhood: Jeff Koons at the Whitney": Salle, David. "Puppy Love," *Town and Country*, September 2014: pp. 110, 112.

"John Baldessari's Movie Script Series": Salle, David. "John Baldessari's Movie Script Series," *John Baldessari: The Stadel Paintings*, edited by Martin Engler and Jana Baumann, München: Hirmer Verlag GmbH, 2015: 68–71.

"The Success Gene: Wade Guyton and Rosemarie Trockel": Salle, David. "Cool For Katz," *Town and Country*, March 2013: pp. 56–57.

"Vito Acconci: The Body Artist": Salle, David. "Vito Acconci's Recent Work," *Arts Magazine* 51, no. 4, December 1976: p. 90.

"The *Petite Cinema* of John Baldessari": From *John Baldessari: Pure Beauty*, published by the Los Angeles County Museum of Art and Del Monico Books/Prestel.

"Karole Armitage and the Art of Collaboration": Salle, David. "The Performer: Karole Armitage" *Town and Country*, September 2015: p. 192.

"The Camera Blinks": © *Artforum*, February 2008, "The Camera Blinks: David Salle on *The Diving Bell and the Butterfly*" by David Salle.

"Old Guys Painting": Salle, David. "Old Guys Painting: David Salle on the Mature Painter's Letting Go," *ARTNews*, 10 September 2015: p 48.

"Urs Fischer: Waste Management": Salle, David. "Pedal to the Mental," *Town and Country*, June/July 2013: p. 40.

"Jack Goldstein: Clinging to the Life Raft": Salle, David. "Late Greats," *Town and Country*, September 2013: pp. 82–83.

"Sad Clown: The Art of Mike Kelley": Salle, David. "Casting Off," *Town and Country*, May 2014: p. 66.

"Frank Stella at the Whitney": Salle, David. "Modern Geometry: For Frank Stella, Inventing Minimalism Was Only the Start. The Whitney Surveys a Rebel's Long Career," *Town and Country*, November 2015: p. 112.

"Provincialism without a Capital: The Art of Thomas Houseago": © *Artforum*, October 2015, "Face Off: David Salle on Thomas Houseago," by David Salle.

"André Derain and Courbet's Palette": From *In My View: Personal Reflections on Art by Today's Leading Artists* edited by Simon Grant. Copyright © 2012 Thames & Hudson Ltd, London. Reprinted by kind permission of Thames & Hudson Inc., New York.

"Picabia, C'est Moi": Contains themes discussed between author and Cathérine Hug, as transcribed and published in Francis Picabia, *Unser Kopf ist rund, damit das Denken die Richtung wechseln kann*, Ausst.-Kat. Kunsthaus Zürich, 3.6.–25.9.2016 / Museum of Modern Art, New York, 20.11.2016–19.3.2017, Brüssel, 2016. Francis Picabia, *Our Heads Are Round So Our Thoughts Can Change Direction*, exh. cat. Kunsthaus Zürich, March 6–September 25, 2016 / Museum

270

of Modern Art, New York, November 20, 2016–March 19, 2017, Brussels, 2016.
Francis Picabia, *Notre tête est ronde pour permettre à la pensée de changer de direction*, cat. exp. Kunsthaus Zürich, 3.6.–25.9.2016 / Museum of Modern Art, New York, 20.11.2016–19.3.2017, Bruxelles, 2016.

"Structure Rising": Salle, David. "Structure Rising: David Salle on 'The Forever Now' at MoMA," *ARTnews*, March 2015: p. 44.

"Piero della Francesca": Salle, David. "Renaissance Man," *Town and Country*, April 2013: pp. 34–35.

"Questions without Answers for John Baldessari": Salle, David. "Questions Without Answers for John Baldessari," *The Paris Review*, December 13, 2010.